Contemporary Art Impacts on Scientific, Social, and Cultural Paradigms:

Emerging Research and Opportunities

Janez Strehovec
Institute of New Media Art and Electronic Literature, Ljubljana, Slovenia

A volume in the Advances in Media, Entertainment, and the Arts (AMEA) Book Series

Published in the United States of America by
 IGI Global
 Information Science Reference (an imprint of IGI Global)
 701 E. Chocolate Avenue
 Hershey PA, USA 17033
 Tel: 717-533-8845
 Fax: 717-533-8661
 E-mail: cust@igi-global.com
 Web site: http://www.igi-global.com

Copyright © 2020 by IGI Global. All rights reserved. No part of this publication may be reproduced, stored or distributed in any form or by any means, electronic or mechanical, including photocopying, without written permission from the publisher.
Product or company names used in this set are for identification purposes only. Inclusion of the names of the products or companies does not indicate a claim of ownership by IGI Global of the trademark or registered trademark.

<p align="center">Library of Congress Cataloging-in-Publication Data</p>

Names: Strehovec, Janez, 1950- author.
Title: Contemporary art impacts on scientific, social, and cultural
 paradigms : emerging research and opportunities / by Janez Strehovec.
Description: Hershey, PA : Information Science Reference, 2020. | Includes
 bibliographical references and index. | Summary: "This book explores the
 ways in which the present post-aesthetic art affects economics,
 politics, science, communication, social media, and everyday life"--
 Provided by publisher.
Identifiers: LCCN 2019059584 (print) | LCCN 2019059585 (ebook) | ISBN
 9781799838357 (h/c) | ISBN 9781799851578 (s/c) | ISBN 9781799838364
 (eISBN)
Subjects: LCSH: Arts and society. | Arts--Philosophy.
Classification: LCC NX180.S6 S795 2020 (print) | LCC NX180.S6 (ebook) |
 DDC 700.1/03--dc23
LC record available at https://lccn.loc.gov/2019059584
LC ebook record available at https://lccn.loc.gov/2019059585

This book is published in the IGI Global book series Advances in Media, Entertainment, and the Arts (AMEA) (ISSN: 2475-6814; eISSN: 2475-6830)

British Cataloguing in Publication Data
A Cataloguing in Publication record for this book is available from the British Library.

All work contributed to this book is new, previously-unpublished material.
The views expressed in this book are those of the authors, but not necessarily of the publisher.

For electronic access to this publication, please contact: eresources@igi-global.com.

Advances in Media, Entertainment, and the Arts (AMEA) Book Series

ISSN:2475-6814
EISSN:2475-6830

Editor-in-Chief: Giuseppe Amoruso, Politecnico di Milano, Italy

MISSION

Throughout time, technical and artistic cultures have integrated creative expression and innovation into industrial and craft processes. Art, entertainment and the media have provided means for societal self-expression and for economic and technical growth through creative processes.

The **Advances in Media, Entertainment, and the Arts (AMEA)** book series aims to explore current academic research in the field of artistic and design methodologies, applied arts, music, film, television, and news industries, as well as popular culture. Encompassing titles which focus on the latest research surrounding different design areas, services and strategies for communication and social innovation, cultural heritage, digital and print media, journalism, data visualization, gaming, design representation, television and film, as well as both the fine applied and performing arts, the AMEA book series is ideally suited for researchers, students, cultural theorists, and media professionals.

COVERAGE

- Geometry & Design
- Products, Strategies and Services
- Cultural Heritage
- Environmental Design
- Communication Design
- Design of Interiors
- Cross-Media Studies
- Visual Computing
- Arts & Design
- Design Tools

IGI Global is currently accepting manuscripts for publication within this series. To submit a proposal for a volume in this series, please contact our Acquisition Editors at Acquisitions@igi-global.com or visit: http://www.igi-global.com/publish/.

The Advances in Media, Entertainment, and the Arts (AMEA) Book Series (ISSN 2475-6814) is published by IGI Global, 701 E. Chocolate Avenue, Hershey, PA 17033-1240, USA, www.igi-global.com. This series is composed of titles available for purchase individually; each title is edited to be contextually exclusive from any other title within the series. For pricing and ordering information please visit http://www.igi-global.com/book-series/advances-media-entertainment-arts/102257. Postmaster: Send all address changes to above address. Copyright © 2020 IGI Global. All rights, including translation in other languages reserved by the publisher. No part of this series may be reproduced or used in any form or by any means – graphics, electronic, or mechanical, including photocopying, recording, taping, or information and retrieval systems – without written permission from the publisher, except for non commercial, educational use, including classroom teaching purposes. The views expressed in this series are those of the authors, but not necessarily of IGI Global.

Titles in this Series

For a list of additional titles in this series, please visit:
http://www.igi-global.com/book-series/advances-media-entertainment-arts/102257

Navigating Fake News, Alternative Facts, and Misinformation in a Post-Truth World
Kimiz Dalkir (McGill University, Canada) and Rebecca Katz (McGill University, Canada)
Information Science Reference • © 2020 • 375pp • H/C (ISBN: 9781799825432) • US $195.00

Cultural, Theoretical, and Innovative Approaches to Contemporary Interior Design
Luciano Crespi (Politecnico di Milano, Italy)
Information Science Reference • © 2020 • 459pp • H/C (ISBN: 9781799828235) • US $195.00

Handbook of Research on Combating Threats to Media Freedom and Journalist Safety
Sadia Jamil (Khalifa University, UAE)
Information Science Reference • © 2020 • 408pp • H/C (ISBN: 9781799812982) • US $265.00

Deconstructing Images of the Global South Through Media Representations and Communication
Floribert Patrick C. Endong (University of Calabar, Nigeria)
Information Science Reference • © 2020 • 469pp • H/C (ISBN: 9781522598213) • US $195.00

Handbook of Research on the Global Impacts and Roles of Immersive Media
Jacquelyn Ford Morie (All These Worlds, LLC, USA) and Kate McCallum (Bridge Arts Media, USA & Vortex Immersion Media, USA)
Information Science Reference • © 2020 • 539pp • H/C (ISBN: 9781799824336) • US $265.00

Handbook of Research on Multidisciplinary Approaches to Literacy in the Digital Age
Nurdan Oncel Taskiran (Istanbul Medipol University, Turkey)
Information Science Reference • © 2020 • 405pp • H/C (ISBN: 9781799815341) • US $265.00

For an entire list of titles in this series, please visit:
http://www.igi-global.com/book-series/advances-media-entertainment-arts/102257

701 East Chocolate Avenue, Hershey, PA 17033, USA
Tel: 717-533-8845 x100 • Fax: 717-533-8661
E-Mail: cust@igi-global.com • www.igi-global.com

Table of Contents

Preface... vii

Chapter 1
The Basic Paradigm Shift in Contemporary Art: From Stable Aesthetic
Artwork to Conceptual Service of Art ... 1

Chapter 2
After the End of Art: The Conceptual in Arts and Beyond 30

Chapter 3
Living in the Art-Like Reality: Trading in Derivatives vs. Derivative
Writing ... 53

Chapter 4
The Word-Image-Virtual Body: The Social Media Textuality and the Story as
Application .. 72

Chapter 5
The Politics Through Arts and Culture: On Slovenian Literary Nationalism...... 96

Chapter 6
The Subversive Affirmation as a New Device of Art Activism Deployed in
Post-Political Reality .. 111

Chapter 7
Remediating the New Media: Refashioning Film Through New Media
Textuality as a Model of Forming New Media Cultural Contents..................... 120

Chapter 8
Remediating the Social: Impacts of Historical Fascism on Academic
Fascism ...142

Related Readings... 163

About the Author .. 175

Index.. 176

Preface

Although numerous contemporary art projects and movements can be considered as fringe phenomena compared to media, finance, and mainstream politics, this book explains them as dry run milestones of the world to come. This monograph relates to the play of ubiquitous and simultaneous phenomena including contemporary art, economy, finance, (post)politics, civil society, science, creative industries, and social media that work hand in hand in their affordances to create new concepts and ideas that will enable today's individual to orientate herself in the present knowledge society. Contemporary art serves as a tool of today's state-of-the art literacy.

Art is a historical phenomenon in terms of production, reproduction, dissemination, perception, and understanding. There is no simple common denominator that links Hellenistic art, Renaissance art, Neo-Classicism, Realism, Modernism, Avant-garde, Neo-Avantgarde, and Postmodernism with contemporary art. Whereas numerous artistic movements, forms, and phenomena in art history can be explained by means of mimesis (an ancient Greek expression for imitation), Modernist art is based on the concept of poiesis (a Greek expression meaning "to make"), which this art explains as the creation and construction of fictious artificial worlds. Unlike by mimesis and poesis shaped art, the contemporary art is a broader field of creativity in which novel functions of art, including research, ethical (even humanitarian), political, and conceptual functions come to the fore. Rather than being a self-contained, finished, stable, and autonomous entity separated from other things and processes, the basic unit of contemporary art is art service, which is a product not of God-like genius, but of the artist as a cognitive worker. The art service (which is processual, performative, cognitive, and algorithmic) belongs to the present knowledge and information society, meaning that such service co-exists with, links to, and hybridizes with the services of other fields. The art cognitive service implies the cognitive nature of contemporary art embedded in present knowledge cultures.

Preface

By applying the research methodologies of media studies, art theory, philosophy, social theory, and cultural studies as a theoretical background, this book investigates the ways in which the present post-aesthetic art affects economics, politics, science, communication, social media, and everyday life. The processes introduced by art are also innovative and relevant to the theories of these areas, which means that fields that have thus far overlooked art — such as economics, molecular biology, chaos theory, particle physics, communication and political science — should begin to pay more attention to it. Such a challenge comes also from art activism, which in the present post-political period blurs the boundaries of the political and raises new subjects for the latter. This book demonstrates that phenomena significant to contemporary knowledge art — such as uncertainty, play, the conceptual, the ends of particular fields (of art, science, politics, economics), spectacle, creativity, narrative, performance, service, juxtaposition, montage, and disruption — are also essential to the extra-artistic reality. An understanding of the anatomy of contemporary art is a key for entering today's society and understanding its paradigms and movements.

Along with the expanded concept of contemporary art today, people can face expanded concepts of science (in terms of not-just-science), economics (the conceptual economics of financial markets beyond material wealth, from national bank independent cryptocurrencies), and politics (in terms of postpolitics, including novel subjects of public decision-making such as civil society organizations, citizen science, and art activism). By introducing the cognitive, algorithmically shaped art service as the key concept of contemporary art, this field as integrated into the present (postindustrial) service and knowledge society, meaning that the modernist separation of fields is over, and the basic areas of human activity go and work hand in hand. Joseph Beuys's expanded concept of art and Allan Kaprow's ideas on lifelike art are essential for an understanding of contemporary art as such a sophisticated and socially integrated practice.

Contemporary art is conceptual, not in the sense of the conceptual art movement associated with Sol LeWitt and Joseph Kosuth, among others, but referring first and foremost to different tendencies in contemporary and particularly new media art that explores its principles, intensifies itself, and addresses the repurposing of its functions. The conceptual is also an essential characteristic of other relevant fields today, such as science, politics, media, and economics. These fields attain the modality of the conceptual in the moment when they deploy autopoiesis and become symbolic and self-referential; they stop expanding outwards and instead turn inwards. We encounter:

Preface

- The production of experiences and events in art instead of the production of artifacts;
- The production of derivatives that presuppose the manipulation of value and money instead of the evaluation of material production (e.g., in the conceptual economy of financial markets); and
- The aestheticization and performativity of conceptual science, which, rather than discovering nature, produces principles for the models of alternative forms of nature (virtual worlds, augmented realities, artificial intelligence).

The conceptualization of an individual field is reflected in its autonomization and intensification, its orientation toward autopoiesis and self-reference rather than an extensiveness. This self-reflection is inherent in the field's "after the end" phase and its related conceptualization; nothing is considered self-evident from that moment on — everything could be different. Hence, a phase that such a field must include in its development is the phase of *l'art pour l'art* (*e.g.*, art for art's sake, politics for politics' sake, economics for economics' sake, science for science's sake). This is a phase of a field's liberation from a solely practical function. Only when these fields begin to deal with themselves can they attain a certain distance and freedom, become conceptual and enter *l'art pour l'art,* a notion similar to performer Allan Kaprow's concept of "artlike art" (1993).

Art has mutated, thereby giving up the nature of a completed and stable work of art (in the sense of the German *Kunstwerk*) and losing its aesthetic feature. Today, aesthetic items and processes in the sense of the beautiful are much more common in fashion, sports, jet set, commercials, pop music, video games, and even politics than in most of contemporary art. The aesthetic in the sense of intensive sensual stimulation is much more common in theme parks and their adrenaline-producing attractions (*e.g.*, roller coasters, bungee jumping, water park rides) than in art.

Flexibility in the field of contemporary arts makes it easy to follow the dynamics of the networked economy of financial markets, where new financial products bring new dynamics into the spectacle of the global, 24-hour marketing performance. Due to the fact that — at least in the short term — financial markets allow for significantly faster and larger profits, they continually generate new products that attract buyers and speculators. Hedge funds and derivatives (options, futures contracts) have a special place in these markets and bring new qualities to them. This is particularly true for trading in derivatives as financial instruments, the price of which depends

Preface

on the underlying asset (commodity, currencies, and securities), reference rate, or index to which they refer. There are situations when hedge brokers try to reduce the risk while speculators increase it in order to maximize their profits. In short, this is a situation where we have an indisputable value basis with which to increase our assets in the future (or to secure them in the present). With some projects of contemporary art, and in particular new media art, it is evident that also the artists focus on the "artistic" underlying asset and refer to it in order to secure their interests and even make a profit. They produce derivatives, in the sense that they refer to the indisputable value of the underlying reference work.

The art service co-exists with the textual, literary or post-literary service, which is articulated as an application intersecting verbal and visual culture. The common denominator of new textuality, from social media and text-based popular culture to electronic literature and text installations, is the word-image-body, which allows verbal content to enter into the trendy culture of concise, striking, visualized, and short formats, and also to compete for the leading position among (spectacular) images. Simply put, even the word-image-body is an image in a very particular mode and belongs to today's visual paradigm. Today we are witnessing the effort of the words themselves to transform into visual words that can compete with pure images and thereby participate in the struggle for mastery in the realm of the image.

Today, it appears that extra-artistic fields (from economics to politics) need the artistic surplus that helps them to control and master unpredictability, chaos, disruption, noise, and risk. By linking with art, these fields become, to a certain extended, artistic and conceptual; ambiguity enters their foundations. Many scientific practices now resemble art, because the science itself takes a performative turn. The scientist behaves as a performer during her public presentations at conferences; she attractively visualizes scientific paradigms and research outcomes; she writes stories about her achievements; she deals with phenomena that are well-known to contemporary artists (chaos, nomadism, unpredictability, noise, disruption, and black holes as a mode of implosion). The scientist needs the science as an event — for instance, the black hole photograph from April 10, 2019, or the discovery of the Higgs boson on July 4, 2012. Today, people can talk about the event in arts (such as a performance), in philosophy (as in Gilles Deleuze's notion of *event*), and in science (in such terms as "collision *event*" and *"particle adventure,"* or *the Event Horizon Telescope).*

There have been significant historical and ideological shifts in politicized art from early 20th century to the present. The projects of historical avant-garde

Preface

art from 1905 to 1933 in Europe differ from Marcuse's concept of society as a work of art in the 1970s, and the role of art in the Occupy movement and the activism of The Yes Men in the United States is something altogether different. After the Second World War, the relationship of art with politics became more important, whether art is politicized or contrasted with politics. The state (republic) as total work of art (intended within the Russian avant-garde movements) and the art state (proposed by *Neue slowenische Kunst* group) are projects that aim toward a utopian refashioning of social relations and social institutions according to the artistic features themselves, such as more creativity in society and the inclusion of art in education. Art activism from the 1990s to the present, is more strictly political. The revolutionizing of the social by typically artistic means gives way to pure political interventions with the use of very limited artistic devices such as pranks or irony. Art activism projects by Anonymous, the Janez Janša Group, and The Electronic Disturbance Theatre, among others, demonstrate that contemporary art, in its interactions with the extra-artistic reality, writes a story that can deserve the attention of contemporary social sciences and humanities.

Contemporary art — media art, first and foremost— is explored in this book as deeply embedded in the social, which relates to corporeal individuals, not just to posthuman machines and artificial intelligence. What we have today is an individual striving to consume as many intense stimuli as possible in the shortest possible time, whereby she pays attention only for a few seconds, or, depending on the content, a few minutes (the duration of a theme park ride). Even one minute can be too long; this is the amount of time that someone can focus on a YouTube video before her attention starts to decline substantially. Surrounded by a multitude of breaking news and events, the individual only remains open to the things that speak to her very loudly. It is not enough for something merely not to leave her cold; she pays attention to the things that get her high and that involve her. Being prepared for the extraordinary, shocks, disruptions, and defamiliarization (a concept taken from Russian formalism) is the imperative for the survival of a contemporary individual in the world, where events exceed our established expectations.

Drawing on the author's background in philosophy, this book offers research into an expanded concept of art embedded in the present reality, which is addressed through the conceptual apparatus of multiple disciplines. Rather than juxtaposing two fields (e.g., arts and economics), this book addresses the broader field of art's interactions and intersections with a number of other fields and disciplines: politics, media, science, philosophy, leisure, and social media. This study introduces new concepts and theoretical devices

Preface

including word-image-virtual body, derivative artmaking, art corrupted, second experience, center-framed tweet, textual editing, closeness that grows toward the user, art service, textual service, nomadic cockpit, contemporary knowledge art, visual cogito, expanded concept of text, and not-just-science. The research in art versus politics is contextualized through experience with and practice of Slovenian arts and culture.

ORGANIZATION OF THE BOOK

The book is organized into eight chapters:

Chapter 1 addresses the unstable nature of contemporary art processes and services by stressing profound changes, both in the very nature of contemporary art (a shift towards the research function and the status of art project as service) and in the recent world as it is defined by new (post)political subjects, (networked) economy, techno-sciences, issues of the Anthropocene, and techno-lifestyle. The societal position of contemporary art benefits from shifts in contemporary society — that is, post-industrial society driven by information, spectacle, events, breaking news, and software. Example of this shift include the increasing stress placed on knowledge, research, innovation, education, use of new technologies, and communication. This chapter identifies various movements and tendencies in contemporary art, which direct toward the conceptual, the scientific, and the political.

Chapter 2 explores the ways in which contemporary art in its expanded mode enters intense relations with modified science, politics, and economics through processes of interaction, adoption of methodological devices, hybridization, and amalgamation. It is important to recognize that art is not a passive and second-grade link in these interactions, but rather contributes artistic innovations to other fields that then become art-like. The expanded concept of (new) media art encompasses the drone and activist art based on repurposing advanced technology from military and commercial applications to ethical and humanitarian actions. Because such art projects are, as a rule, high-technological, there is at play Walter Benjamin's concept of second technology, which anticipates reconciliation between the individual, nature, and the cosmos, an actual "interplay" between these correlates. Challenged by the concept of second technology, this chapter introduces the second experience, which brings to the foreground play and playfulness, the individual's non-confrontational relation with nature and the cosmos, her corporeality, rich perception, and motor and proprioceptive arrangements.

Preface

Chapter 3 deals with the artification of financial markets and politics by researching art-like procedures in both areas. Contemporary art is being politicized, economized, mediaticized, scientificized, while at the same time, politics, economics, science, and media are becoming art-like, which means that either they accept artistic procedures, techniques, tools, and strategies, or they themselves produce similar *zeitgeist*-shaped tools. Especially when it comes to cognitive labor in a knowledge society, the differences between artists and non-artists are increasingly being erased. Both artists and non-artists function in a world of unpredictability and risk, all trying to be creative, often using the same tools and producing new ideas. In spite of troubles —which mainly accompany less-privileged artists and art theoreticians, critics and curators — art even plays a pioneering role, as it generates procedures that can later be applied in other fields. The events and processes of financial markets resemble art in their unpredictability, disturbances, and juxtaposition.

Chapter 4 identifies numerous modes of textual production in knowledge societies, where the digital text is shaped as a cognitive textual service directed toward contemporary storytelling, which is becoming distinctively performative and conceptual. Textual service generates novel forms of expanded narrative, shaped by means of new media textuality, advanced typography, and novel narrative devices. One of the most attractive modes of today's textual service is the application of stories in marketing strategies. A product is well marketed only at the moment when it is sold in a package together with a story written, performed, and shot about it. Contemporary verbal content is committed to the imperative of attracting as much attention as possible, so as to prepare for the (neoliberal) competition with other, rival content. Only the winners can count on the attention of the media (entry into the prime time), politics, and the economy. A printed text-as-we-know-it, arranged only in the verbal mode, is no longer competitive unless it assumes the attributes of trendy cultural content (e.g., from social media and the entertainment industry), meaning that it is also formed with the components of a video clip, animation, ride, spectacle, performance, or show. Readers encounter the expanded and ubiquitous concept of the textual service, which is visual, hypertextual, conceptual, auditory, multimedial, and adapted to new textual formats aimed at static or portable screenic devices.

Chapter 5 explores the expanded concept of the political at the intersection of politics-as-we-know-it (including the national state and the parliament) and the novel modes of expanded political including the activities of civil society, international organizations, and cultural institutions. One such example is Slovenian literary nationalism as one of the key Slovenian ideological state

Preface

apparatuses (Louis Althusser's concept) at play in the country's politics today, deeply affected by not-just-political agents from the economy, religion, lifestyle, and culture. Literary nationalism, in the present second-order mode, has nothing to do with literariness, poetics, aesthetics, or creativity. It is only interested in the ideology it constructs from literature, intended for political-propaganda purposes. Rather than being explored in literary studies and comparative literature, literary nationalism challenges research in cultural studies, critical theory of society, political theory, sociology of culture, and post-communism theory. Criticism of literary nationalism is not directed to the writers' concern for the Slovene language and its enrichment, but rather points out that writers are not immune to the irrationalism that accompanies euphoric exaggerations and pathetic rituals in their field. As a rule, writers are found among the critics of totalitarianism and of human rights abuses, but some have contributed to fascist ideologies and have called for ethnic cleansing.

Chapter 6 deals with the Slovenian activist art of the Janez Janša Group, which deploys subversive affirmation as a new device aimed at direct intervention in national politics. Whereas the historical projects of politicized art such as social sculpture (Joseph Beuys's notion), temporary autonomous zones (Hakim Bey's concept), and total work of art (deployed in *Neue slowenische Kunst* group) were accompanied by artists' explicit confidence in the liberating power of artistic creativity as the basis of their engagement, today's activists enter purely political "direct action," which often fits well with the daily practice of political parties. The Janez Janša art activism shaped project demonstrates that contemporary art, in its interactions with the extra-artistic reality, writes a story that deserves the attention of contemporary social sciences and humanities. What is happening in such art is worthy of the interest of political sciences and cultural and media studies, which could also base developments in their primary spheres on research in contemporary art and its avant-garde and neo-avantgarde predecessors.

Chapter 7 identifies the present role of remediation in media-based contemporary art and electronic literature. Remediation brings new dynamics into the institution of contemporary art by stimulating traditional and new media to refashion each other and generate novel hybrids at the intersection of several media. Refashioning electronic literature through film and visa versa is one of the key topics in this chapter; alongside remediation theory, the author also applies concepts and devices from other disciplines (technoculture studies, media studies, communication theory, social theory, philosophy of technology, and cinema theory). Bolter's and Grusin's concept

Preface

of remediation is deeply embedded in the world of technical advances and mainly pushes aside the basic links of new media and the social. In doing so, remediation authors remain tied to the positivistic approach to new media and the fascination with the digital.

Chapter 8 explores the application of remediation device (as important tool in generating media art contents) in the social theory of academic fascism as a contemporary mode of refashioned historical fascism. Academic fascism is devoid of concentration camps, but it invents new forms of segregation and disenfranchisement. The goal of academics is to single out and destroy the theoretician as scapegoat Other and *homo sacer* who thinks differently than they do, looks different, and does not adapt. And above all, they aim to discipline and eliminate the one who knows more than they do and who is more innovative than they are, thus jeopardizing their hard-won knowledge and its associated social place. Key theoretical devices introduced in this chapter include the researcher as scapegoat Other, academic cleansing, and smart technology instead of blood and soil.

Chapter 1

The Basic Paradigm Shift in Contemporary Art:
From Stable Aesthetic Artwork to Conceptual Service of Art

ABSTRACT

The difference between modern and contemporary art, which in the present enters the names of art museums, is based on the notions formed in art theory and art history: whereas modern art is tied to aesthetics, artistic autonomy, author, and the concept of stable and finished artwork, the more fluid and conceptual contemporary art foregrounds the links of the art with the social, politics, economy, everyday life, science, and media. This chapter aims to explore media-shaped contemporary art projects in terms of art services that are algorithmic, cognitive, and conceptual. The service presupposes a problem, a challenge, or an order to be solved or carried out. The artist as a service performer is always faced with a certain task, challenged to solve it in a sequence of steps, chosen as economically as possible. The service therefore ends with a solution of the problem (or its removal) and not with the manufacturing of a finished object.

DOI: 10.4018/978-1-7998-3835-7.ch001

Copyright © 2020, IGI Global. Copying or distributing in print or electronic forms without written permission of IGI Global is prohibited.

INTRODUCTION

The contemporary art is a broader field of artistic activity than so-called modern art defined by aesthetic modernism proclaiming the separation of art field from the social and other fields of a given reality. The profound changes in the field of artmaking as well are the result of constant efforts of contemporary artists how to define the field of their own quests and creations anew and time adequate. Contemporary art is considered as a problem, an unsafe field, an enigma, but it has neither vanished nor has it been abolished. In the sense of quantity, there is more art than ever, the only mistake is that we are often looking for it in the wrong places (just in traditional ones) and that we still judge art as-it-is-today by concepts and canons gained from experiencing the art as-we-know-it, namely as an activity linked only to artifacts (such as book, statue, painting, and also symphony and film), and to certain site specific institutions (galleries, museums, theatres, libraries).

The significant field of contemporary art that is "too pluralistic in intention and realization to allow itself to be captured along a single dimension" (Danto, 1995) are the new media art projects that occur at the intersection of contemporary art, networked economy, new (often beyond the state institutions driven) politics, technoscience, the Antropocene issues regarding the expanded concept of life and ethics, and new lifestyle. The new media art pieces are often only one click away from in the Web embedded sites and portals of political organizations, social media, big corporations, and e-commerce, meaning that here is a different situation as used to be common within the modernist paradigm based on differentiation of artistic realm from the social. The new media art includes digital and post-digital art, activism and hactivism based art, Internet and Post-Internet art, techno-performance, digital literature, and software art (Rush, 1999; Greene, 2004; Manovich, 2003 & 2013).

Today, the very nature of art is being steadily questioned and conceptualized anew, the artistic nature of art is getting more and more instant, fluid, and temporary. In a similar fashion as Hakim Bey (1985) has coined the expression *temporary autonomous zones*, one can talk today about the temporary art projects as activists' events and pranks that have artistic signification and justification for a very short period of time; they upspring in a very limited time, but in different time and contexts such projects could gain quite different signification and functions. They are multifunctional and their creators could by means of their artistic training and experience execute other, no strictly

The Basic Paradigm Shift in Contemporary Art

on art realm limited tasks either (as demonstrate the net artists, bio art artist, and activists).

While the traditional aesthetics begins by exploring the specificity of work of art and its crucial features (form, genre, creativity, author, aesthetic value), the contemporary art theory finds the artwork as non-self-evident issue; rather than being a stable and aura-based object (Benjamin, 1969) anymore, it is a process, an artistic software, an experience, a service devoted to solving a particular (cultural and non-cultural) problem, a research, an interface, which demands from its user also the ability for associative selection, algorithmic (logical) thinking and for procedures pertaining to DJ and VJ culture, such as (re)mixing, cutting, sampling, filtering, and recombination.

Art has mutated, thus it has given up the nature of a completed and stable work of art (artefact) and has lost its aesthetic feature; the aesthetic items and processes in the sense of the beautiful are much more common in fashion, sports, jet set, commercials, pop music, video games, and even politics (Benjamin 1969; Haug 1971; Welsch 1996) than in most of contemporary art. The aesthetic in the sense of intensive sensual stimulation is much more common in theme parks, and their attractions (e.g. roller coaster and star war simulators, bungee jumping, water park adrenaline devices), than in art. The traditionally conceived art's functions in terms of representation and aesthetic education have also been left aside. Facing the art projects from the first decades of the twenty-first century the key question is no longer What is art? but When is art? or even more directly, what conditions must be fulfilled that an event, a program, a process, an application, a service or an artificial world as a complex structure of relations begins to function as an art project placed in the art archives? This shift and redirection also include omission of art's ontology as the first and decisive field of philosophy of art and enables the transition towards the art theory as a critical social and political theory of power institutions judging the art field and distributing power in it.

This opening chapter aims to explore how the significant changes in the contemporary art implies numerous social aftermaths and raise questions which answers might be of big interest for broader artistic audience as well as for professionals (scholars, stakeholders) in other fields (from politics and science to economics and social media). One of the key chapter's objective is to promote the idea of art service as an original author's contribution to the basic understanding of contemporary art today. Notion on art service enables art to enter hand in hand to dialog and cooperation with other fields integrated in service and knowledge society.

In terms of methodology this chapter deploys the scientific approaches of cultural and media studies, art theory, cinema theory, electronic literature criticism, sociology of culture, critical theory of society, and technoculture studies. In order to come closer to the very specificity of contemporary, first and foremost media art and its social implications, the author of this chapter and the entire book was developed several new devices and concepts like not-just-science, closeness that grows toward the user, as-if art, art service, second order digital literature, text as application, nomadic cockpit, and digital tangible.

THE CLOSENESS THAT GROWS TOWARD THE USER

The media shaped contemporary art challenges art theory with paradigm shifts concerning the very art function and the ontological status of new media art projects. To discuss this issues the Julius Popp's *bit.fall* (2004) is addressed as a case of such an artistic project connecting art-as-we-know-it and the conceptual (information theory).

The title of *bit.fall* as a big waterfall and text-on-water drops based installation evokes both, the image of a natural waterfall as well as digital bit understood as the binary digit which refers to computer information sourced from live news feeds. In fact, both the water drops and information translated in words are falling in front of the viewer. The artificial world of flux is governed by two principles: the gravitation, which is a key law of nature causing a waterfall, and information theory referring to the social attention as recorded by statistics, which is in a background of falling keywords. The installation is a stage of two intertwined cycles: a water cycle as a physical structure on the one hand, and the conceptual cycle (referring to raining information as a part of highly technological system) on the other. The outcome of this encounter is a play and mutual interaction between the highly technological system and its natural counterpart. From a structure consisting of a series of countless valves, small drops of water fall with extreme accuracy at very short intervals. Like pixels on a computer screen, these drops form single legible words which are suspended in air for just an instant. Through connection to Google News, a real-time search algorithm finds the most relevant keywords, which are then transmitted to the cycle and formed for an instant by the falling drops. The speed at which information is sourced, exchanged and updated in our information society is almost inconceivable for human perception, so the Bit.fall is expected to translate this abstract process into an

The Basic Paradigm Shift in Contemporary Art

sensual experience. In this augmented reality installation the information is represented by words generated by a computer program, based on a statistical algorithm. The program filters relevant terms from the current stream of news on the internet and transmits the values to the control unit in installation. In a split second, the machine releases hundreds of drops at specific intervals, creating an analogized 'waterfall' of words. Bit.fall generates a metaphor for the unstoppable data flood in contemporary society, which is marked by accelerated and continuous communication though constant updates.

An encounter with the bit.fall demonstrates the sophisticated nature of contemporary new media shaped art and raises the question how can today's users come to terms with these projects of art and the radical turns (paradigm shifts) which brought them into being? How can they come closer to these projects, whose extreme forms and articulations profound impact the understanding of traditional works of art and more poignantly, the institution of art today?

It seems that such an art project can be understood as a dry run for new ways of perception, individual's orientation in the world, her literacy, and sensitivity. Above all, this project should be seen as a new means of communication in the world. A communication shaped by techno sensitivity and global connectedness. Here are some of the key concepts that determine the specificity of new media art: interactivity, tactility, immersion, total-data-work of art (Ger. Gesamtdatenwerk), participatory nature of digital media, non-trivial reception, "ludic" (game-like) nature of interactive environments, and time-based nature of digital works of art. The new media art projects are, by their nature, time-based in terms of their foundation in an event. Because within the paradigm of techno, time also has a distinctive spatial nature, such time is actually time-space. Along a fore-mentioned concepts the main features of new media art include:

non-trivial and risky perception,
temporal perspective: real time as a technical time-space,
spatial perspective: real closeness.

The media shaped art pieces or processes usually demand a sophisticated or even risky perception. A successful reader of a classic novel or a visitor of a traditional exhibition of visual arts might be disappointed or possibly even drawn back from an interactive Virtual Reality installation or electronic literature piece shaped as computer game mod or textual instrument (Wardrip-Fruin's concept). A traditional art audience often finds surfing through a

The Basic Paradigm Shift in Contemporary Art

more demanding project of net art to be an exhausting affair. In contrast to most traditional works of art, the new media art projects imply a certain amount of risk, some obstacles in approach, and one's readiness to go back and starts again. It is essential to know that to approach a work of new media arts efforts must be made on the part of the audience.

Specifically, one must be up to date with certain advances in technosciences and have a certain knowledge of art theory; getting through the instructions as new media shaped paratexts for the use of new media technologies applied in an art project can often be an exhausting affair that resembles to the problem-solving activity. One is expected to be ready for an intellectual engagement, which demands excellent motor and kinesthetic skills, speed, and mental agility. Concerning video games and cybertext, Espen J. Aarseth claims that: "The cybertext reader, on the other hand, is not safe, and therefore, it can be argued, she is not a reader. The cybertext puts its would-be-reader at risk: the risk of rejection" (p. 4). The emphasis here is on rejection, which may even cause the user to feel frustrated or embarrassed. In general, new media arts do not appeal to trivial users, but instead, to those who are prepared for the risky perception and are able to overcome the insecurity of choosing between diverse possibilities without a simple "easy way" through a project. The risky perception is stimulated with the very non-trivial nature of such artwork, i.e. with its design in the mode of the complex, non-trivial machine, that means that the output is not a simple consequence of the input but depends on its social interactions and contingent behavior.

The next problem of new media art is time. What is the nature of time in the cyberspace and augmented reality? Is it the time defined as Aion or Chronos, addressed in the context of Deleuze's work *Logic of Sense*; is it apocalyptic time like an uncertain dormer, supported with expectations, through which a Messiah can enter at anytime; or is it the real time characteristic of decision-making and function procedures which occur during the on-line processes?

Illustrative examples for understanding time in new media art pieces, which are distinctly time-based, are the projects of electronic literature which demand an active reader, directed toward reading as a supplement to the original "textscapes" and the creative voids within. Navigation through words-images-bodies (term coined by the author of this book) in "textscapes" takes place in a complex time. It seems that at the moment of linking (or turning the screens and mouseovers) "nows" start to load. These "nows" are torn out of temporal continuum and form a certain between, which is suspended for reading within a "textscape". This is the between, which is characteristic of the apocalyptic moment. One waits for the arrival of the unknown, the other

wants it. It seems that we are dealing with uncertain time following something no longer and preceding something not yet. This is a time of expectation, a time for nourishing the deepest dreams and mythic visions. Everything is left open. The link or button simulates a narrow door through which the messianic "word" may enter. The situation of "nows" loaded vertically, and therefore spatially, from a point in linear time could be viewed in this scheme:

Figure 1.

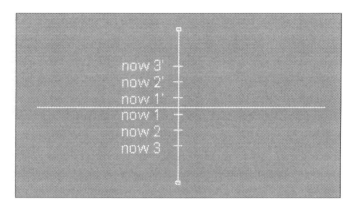

With "nows", loaded vertically, time is stopped, causing words and images to be suspended, and vie for space with a competitive distribution of different times. New media art is essentially connected to and dependent on smart machines, which were invented as "dams" to keep time from flowing away. State-of-the-art machines could actually be seen as ingenious devices for saving time. Video-recorders, samplers, and computers are all memory machines that enable us capture visual, audio, and textual recordings from different periods of time. All of these recordings are at our disposal (like Heidegger's "standing reserve"). In real time, these periods of time can be recalled and used in a technical sense. In other words, real time does not flow away from us of its own will like time in the natural world. Time, within a machine, is made possible by its own technical manipulation (addition, subtraction, multiplication, division, intensification) of times, and their various contents, centered around a vertical axis. Real time is artificial technical time and in many ways anti-natural. It owes its very existence to technical memories. Jean-François Lyotard argues: "The importance of the technologies constructed around electronics and data processing resides in the fact that they make the programming and control of memorizing, i.e. the synthesis of different times

in one time, less dependent on the conditions of life on earth." (p.62) The stress is laid on technical time's independence of the conditions on earth, which points to an area of artificial which is also possible outside our planet.

Such a time is a pure time focused on the being-in-time, experiencing-in-time, and listen-to-time. Being displayed around the vertical axis means to gain the spatial quality. In such a time also various components of e-literature come to the appearance – not as means of representation and emotions, but as manifestations of the cyberlanguage itself. They are seen as the letters themselves in terms of being freed from realistic, representational contents. They resemble to the pure line in the abstract painting, and the pure movement in dance.

Real time as technical time is not an exclusive short time, like a fleeting moment, perceivable only by machines. It is expansive and complex (in practice, it causes the feeling of augmented present). It is the time of all times (Lyotard' s concept of "the synthesis of different times within one time"), and it can be broken up into pieces to serve as an excellent material for the arts, which have been exploring the complexities of time for ages. The real time creative process based on the use of various memorizing devices allows the artist to employ different times or some sort of saturation of times as a painter might choose from colors on his palette. Therefore, we do never find ourselves without enough time to choose from as some might expect. It is also true that times within the physical processes of a machine are not necessarily bound to existence; they can act as "times liberated from the day's leaden weight", defined only by their own intrinsic qualities, e. g. purified time od moving letters in electronic literature.

FILLING THE GAP BETWEEN THE WORK OF NEW MEDIA ART AND ITS USER-VIEWER

A traditional work of art can be understood as a window considered as a departure point for the observer/viewer to step into the complex background of a work of art consisted of various levels of meaning. To understand this constellation Nicolai Hartmann's *Aesthetics* (1953) inspired by phenomenological aesthetics is essential. The founder of phenomenological aesthetics, which got its stimulations from Husserl's concepts of phenomenology and Kant's and Neokantian aesthetics alike, is Moritz Geiger with his essays *Beiträge zur Phenomenologie des ästhetischen Genusses* (1913) and *Zugänge zur Ästhetik*

The Basic Paradigm Shift in Contemporary Art

(1928); the contributions by Waldemar Conrad who published his article *The aesthetic object* already in 1908 are of significance as well. Among the more important followers of this tradition one should mention, besides Nicolai Hartmann, Roman Ingarden, and Merleau-Ponty, while close to this direction are also Martin Heidegger, Eugen Fink and Jean Paul Sartre.

What is a core of phenomenological aesthetics? According to Moritz Geiger's claims from his book *The Significance of the Art* is a main task of (phenomenological) aesthetics devoted to exploring aesthetic objects from their phenomenal aspect; they should be analyzed as phenomena by bracketing the issues of real existence (both, of the object and of the empirical ego). Geiger wrote even on "the purification of reality into a sphere of unreality" (p. 205) and suggested that the common structures (for instance the essence of the sonnet as such or of the symphony as such) and not particular objects are the main concerns of aesthetic approach to the arts. Talking today about the electronic literature with the main scope of phenomenological approach could be devoted to exploring a very nature of this practice – the e-literariness.

Among key achievements of phenomenological aesthetics is its criticism of naive empiricism, psychologism, and naturalism (for example as exclusion of interests of empirical self in aesthetic standpoint), discerning between (literary) work of art as a schematic artefact and its concretisations (this Ingarden's standpoint in fact became actual with hyperfiction that gave the reader a much greater competence as when encountering traditional texts in a printed, codex book), and the shaping of the original theory of ontological status of a work of art as a heteronomous formation, divided into layers, which participates in two areas of being, namely real and unreal.

Phenomenological aesthetics has destabilized the traditional concepts of reality: given, natural, material reality is not everything, but along with it co-exist also would-be-realities, unreal actualities, and unrealities, that also what Giles Deleuze in the *Logic of the sense* and by referring to the Alexius Meinong, who was also close to the phenomenology, named as impossible objects, that have a particular nature of existence, "they are of extra being" (p. 35). The present augmented concept of reality encompasses, metaphoricaly say, e-reality, dot.com reality, @-reality, and *a href* reality.

Typical example of phenomenological approach to the main features of a work of art is the aesthetics of afore-mentioned German philosopher Nicolai Hartmann. He introduced a radical distinction between the everyday activities in the sense of realization (stirring the lead weight of the real) and between the artistic approach, of which derealization is typical. Especially important is Hartmann's theory of many-layered structure of the work of art, having

real foreground and unreal background with a number of layers which go from more concrete towards to most abstract layers, towards the idea of the work. He found out six layers of background (in Rembrandt's self-portraits to be exact). The number of layers contributes to richness and endurance of a work of art, while the beauty of the work lies in their relations.

Can the audience come closer to the particularities of new media shaped art projects on the basis of Hartmann's approach, for instance cybernetic installations of Jeffrey Shaw and Monika Fleishmann or web based e-literary pieces like Mark Amerika's *Filmtext*? This answer can be answered in the affirmative, yet a closer look reveals a number of fundamental changes. The complex unreal background has now narrowed solely to the abstract layer of the idea of artwork (new media artworks are close to the conceptual art), real foreground has also narrowed (containing first and foremost hardware and software components), while new is a sphere of intermediate layers, mediating between real and unreal and which is not only accessible by imagination, but is also affecting the user physically with special effects. Hartmann's layers have now moved closer to the observer and are no longer as abstract as in traditional arts, on the contrary, they include the stimuli of tactile, visual and kinetic origin.

The model for this new constellation is a hologram as an optical memory unit that - metaphorically speaking grows towards the observer, filling the space between the wall and the eye. We witness here the effect of closeness that ''grows towards the user'', intensively filing the space between the installation (or the screenic interface) and the eye. Similarly, as we can talk about the real time as an action time in on-line communications, we can for understanding of cybernetic works of art introduce the term real space as a technical space, moulded with special effects as hologram closeness. Such space is shaped according to various geometries (Euclidian and Posteuclidian), that enable the occurrence of objects with more than three dimensions. Typical is the shaping of a ''technical view'' aside of them, which demands eye's deterritorialized view, which now takes the position on the mobile axis between the nondiscerned front and back, up and down, left and right and tries to see also the ''dark side'' of that object. The procedure Giles Deleuze established alongside Bacon's painting, deterritorialization of the eye namely, which accompanies the liberation from the representational function of modern art, comes to full value with the perception of e-literary pieces (e. g. Jim Rosenberg's *Diagrams*), that can even function as unreadable objects. Fredric Jameson also in his *Postmodernism* essay pointed to the effects of new depthlessness, that destabilizes viewers' optics, jerk the rug out from under

their feet along the next example dealing with the L:A: architecture special effects: "...a surface which seems to be unsupported by any volume, or whose putative volume (rectangular, trapezoidal?) is ocularly quite undecidable. This great sheet of windows, with its gravity-defying two-dimensionality, momentarily transfers the solid ground on which we climb into the contents of stereopticon..."(pp. 70, 71) New media are therefore productively stimulating perception, they invest a technical view that enters everyday life more and more; for example looking through the eye of a smart bomb and weather satellite (cam) eye. Especially the kinetic e-literary pieces demand viewer/reader taking virtually impossible position; her view must fall in the depth of the screen and approach from the back side of the screen (dark side of the moon position) to the fleeing words.

Immersion as one of the fundamental aesthetic concept of new media arts, can be explained on the following schematic structure of a multi layered work designed according to Hartmann's theory of a multi layered work of art.

Figure 2.

Arrow's direction illustrates the direction of the perception. Viewer/user penetrates from the material layer of the work's basic structure over intermediate layers of special effects (e. g. tapes of moving words-images in animated poetry) towards the abstract layer of the idea of work, which means that digital layers must be transparent; they are carried over hardware components and must enable the path to the idea of the work. Unlike the

traditional work of art, with new media work of art we are witnesses to a greater influence of direct sensory stimuli (transition from simulation to stimulation), because digital layers involve visual, audio and tactile effects, typical of digital total-data-work of art. The more complexly formed and densely spread these layers which contribute to the saturation of real space are, the more convincing are viewer's/ user's sensations of immersion into the "cyberwork" of art and e-literature.

The saturation, created by the so-called real closeness of the holographic simulated field in front of viewer's eyes, causes the user to experience total immersion. Due to the nonexistence of the distance between the organ of sight and the objects seen, we witness an immersion into the layers of special effects that are no longer objects in the traditional sense of the word. The objects are no longer placed in front of viewer's line of sight but, instead, intermediate digital layers (designed by hi-tech effects) "stick" themselves to the sight itself. These virtual "would-be-objects" being generated by the new media technologies, stick to the viewer-user of a "visual system". Therefore, the very active sense in this situation is touch, too. This leads to a number of consequences in defining the nature of new media artwork: its units are touchable (this holds true for both images and words - words of immersive digital literary pieces, i.e. touchable words, designed with different velocities), also in terms of the subtle digital tangible.

The velocity of the new media image which assaults the sight is an essential quality of immersion as a temporal activity. Immersion is fundamentally different from contemplation which functions under the timelessness of static seeing. Entering the process of immersion, the user moves slowly or quickly, setting changeable goals on a journey through a 3-D landscape. New media artworks have a complexly structured, multi-layered foreground, which allows immersion into various layers (and back). However, herein is found the risky nature of such works of art. It is not a given that the user will find all of the layers of the foreground or that the journey through the holographic closeness will be successful. As often happens, the viewer-user is about to arrive at some sort of "vanishing point" causing a state of vertigo.

There is one more effect of the saturation of technical space and the aesthetics of closeness to be discussed - the loss of illusion, discussed in Jean Baudrillard's essay *Objects, Images and the Possibilities of Aesthetic Illusion*. Baudrillard argues that the issue that we called real closeness generates an "obscene rapprochement" of the artistic object and the user. A hi-tech and hi-fi art object often leaves little to the imagination. It has a perfect saturation, a surplus of elements, and special effects which crowd the space between the

The Basic Paradigm Shift in Contemporary Art

object and the user. We are witnessing works of art which allow the image and the image-word (in e-literary pieces put on the web), to close in on the user and say "more than should be said".

The new media art projects (also applications, services) are defined in previous section as would-be-works of art due to their intrinsic nature, which is defined by such technical features as real time existence and real closeness, non-representation (a break with the tradition of mimesis), interactivity, immersion, communication value, risky perception, and ludic nature (closeness to the features of game). The expression would-be-work of art was coined by the author of this book to point out the specificity of this new creative movement as an art praxis which abandons the codes of traditional arts (the arts-as-we-know-them based on the tradition of stable artifacts and approached by perception in the mode of remote contemplation) and directs us toward a new paradigm of communication and sensitivity (techno formed aisthesis). The essential prerequisites for this new paradigm are knowledge (particularly of the technosciences and of intimate technologies), technical skills in computer mediated communications, a sense of game, a readiness for risky perception, an awareness of global interconnectedness (abandoning hierarchical ways of thinking), and a strong sense of cyberethics based on a respect and responsibility for the person approached by on-line communications, and protecting the novice and weak participants in on-line communication.

BEYOND THE CULT AND REPRESENTATION FUNCTIONS OF TRADITIONAL ART

In a significant part of contemporary (first of all conceptual and new media) art the artistic and aesthetic function has become obsolete or at least secondary. Today, to a very limited extent the traditional art takes part in production of cultural innovations, especially those establishing new cultural turns and paradigms. This issue is addressed in the following claim of Lev Manovich: 'Thus in my view this book is not just an anthology of new media but also the first example of a radically new history of modern culture – a view from the future when more people will recognize that the true cultural innovators of the last decades of the twentieth century were interface designers, computer game designers, music video directors and DJs – rather than painters, filmmakers or fiction writers whose fields remained relatively stable during this historical

period' (p. 16). This notion was written in his introduction to the *New Media Reader*, where computer scientists and technologists are proclaimed to be important artists of our era, and new media technologies are considered as the greatest present-day works of art. Is Manovich right? It is questionable to declare all great innovations in the field of software as works of art without any thorough reconsideration, however, if we think of cultural innovation demand, we can agree with Manovich. The mainstream culture of the last two decades is much more defined by the profound changes in the field of communication, design, and perception contributed by theorists, engineers and experts from the field of new media technologies and software as well as scientists that made concepts for the new scientific picture of the world than by contributions of traditionally oriented artists.

In this period, writers, poets, painters and musicians working in the acknowledged, traditional art genres and media have somehow fallen asleep. On the other hand, artists who instantly started seeking artistic connections to the new media technologies and started forming new genres and forms of the new media art, such as interactive installations, communication art, VR as art, as well as patches of video games, electronic poetry, hyperfiction, software art, bio-art, Internet and Post-Internet art, are praised as important cultural and artistic innovators.

The question then arises What is the new key function of contemporary art, and above all, of the art integrated with the new media technologies? What is it that comes to the fore and makes traditional art's functions less important or even unimportant? Which are authentic places of today's art, where must we look for works defining and expressing the new art's function?

Answering these questions makes us aware of the limitations deriving from generalization and introduction of stricter definitions. Both sharp and perfectly clear forms and hard and fast lines among the fields are rare, and frequently, there are no ideal types – only their co-existence within in-between spaces of hybrid and mixed realities. The key today's art movements occur in a culture of mixes, recombining, sampling, juxtapositions, hybrid forms, in-between spaces, side-by-side integrations of separated fields and repurposing of state-of-the-art technological platforms. New functions of today's art, which are addressing in this book, are by no means an ideal type. It would also be pretending by declaring them as final and unchanging. However, by taking into consideration several movements in the contemporary art – especially the art integrated with new media – one can expose the research function (in a mode of research service) as a crucial one for understanding new media art paradigms.

The Basic Paradigm Shift in Contemporary Art

Walter Benjamin's claim that in the case of traditional art stress was on its cult value (it was based on a ritual), while in the case of modern art stress is on its exhibit value, (Benjamin, 1969) can be complemented with a notion that the stress of the contemporary art – thus art integrated with new media technologies – lies on its research value. The research value and research function of such art projects (actions, performances, events) refers to a post-object new media artistic practice (which is integrated with molecular biology, informatics, robotics, communication sciences, and networked economy) devoted to public accessed critical science as it is opposed to the official one, executed just by means of professional scientists. The idea of public science (recent expression for such endeavors is citizen science) is based on efforts of some artists or groups (e.g. Critical Art Ensemble) who "contribute to making the meaning of scientific initiatives immediate and concrete, as opposed to the vague abstractions they tend to be" (Critical Art Ensemble, 2003, p. 135). Therefore, art is a research in order to demonstrate that research could be ordered and executed otherwise, not just within a frame of official science. Facing the artistic research practices one can even find out that contemporary artists pioneer in a field, which is in the most recent time considered as an action research. This is a kind of novel, problem-centred, client-centred and action-oriented activity. It involves the client system in a diagnostic, active-learning, problem-finding and problem-solving process. Art as research fits well to the realm of cognitive labor and knowledge society, too.

While the traditional art theory has introduced the concepts like form, content, creativity, author, style, and genre, the (new) media art theory and criticism have fore-grounded theoretical devices like activism, hybridization, recombination, (re)mixing, repurposing, and researching. And even artists themselves are getting more and more familiar in their statements with the expressions like research. Instead of forming and creating (from scratch) they find researching as a proper term devoted to intrinsic description of their within the new media condition shaped activity. Digital literature writer Mark Amerika argues that 'with *FILMTEXT* I take this surf-sample-manipulate research practice right into the bell of the beast, interfacing Hollywood with hypertext, video games with literary rhetoric, interactive cinema with image *écriture*' (Amerika, 2004, p. 9). The *FILMTEXT* demonstrates that text-making in terms of new media paradigm is surf-sample-manipulate research practice; rather than being an artist or author (written with capital letter), the textscape producer could be defined as a (new media) researcher dealing with the issues of the new media verbal.

The Basic Paradigm Shift in Contemporary Art

Research is a crucial function of the contemporary art, but it is by no means the only function of such an art that is getting interesting to audience, curators, critics, and scholarship. This function co-exists with several other functions, associated with contemporary art's heterogeneous nature taking place in the event space, within which interactions between scientific, technical, political and conceptual contents run. It is about a play of the scientific, the artistic, the technical, the political and the conceptual, including various shifts and transformations of its own constitutive links. The scientific, the technical, and the political are de-realized in social place of the art, they take a role of the spectacle (new technologies, for example) or they are integrated with the fictive (science, when generating and trying out various models), while the artistic and the conceptual are realized to some extent in the social spaces, they receive realistic predicates, they take part in the process of debunking the purely fictive (e.g. in art activism events). Technoscience, new media technology, design, new economy (e-commerce), and (post)politics are being redirected towards art, while art and the field of the conceptual take direction towards debunked reality; ethical correctives and societal questionings become even more important than pure aesthetic features as it is argued in Paul Virilio's book *Art and Fear* (2003). A big progress towards the ethical art is in the present challenged with the Antropocene issues. In her projects presented at Ars electronica festival in Linz 2019 (e.g. *Phytoteratology*) Slovenian artist Špela Petrič addressed overlooked plant ethics and urges us to extend our human-centric outlook to incorporate all living beings. On the other hand, with regard to the language art, the poesis implies the *poethics* (Retallack, 2019) and could be applied as a saving power against geoethical disasters.

The key issue regarding such art is how and under what conditions do we give to such interactions-processes-events-situations-installations very art-like features? How do they actually differ from the non-artistic processes? The question of form, which was dominating in the traditional art (for form is an interface preventing empirical elements from intruding into artwork infiltrated and unprepared), has now become secondary or even redundant. The question of organization of components and establishing the network of relations is of greater importance.

All kinds of elements taken out of technoscience, politics (activism, hacktivism), design, new economy, and lifestyle, which as such act dispersed, inconsistent, and arbitrary, meet in installations and artistic events as art

The Basic Paradigm Shift in Contemporary Art

worlds. At first glance these elements implicate relations and links that are as far away from artistic connections as possible. But in art these components enter into tensile and compact relation with each other, arranged in a way to produce a whole being that is more than just a sum of its components. What is essential at such projects placed within in-between spaces is the question of relation organization; in other words, how to organize the components with regard to time and space syntax, how to repurpose the technological and media platform in a way that contribute to art-shaped findings, when to place or exhibit such project and which function, depending on the situation, to set up into the dialogue with the research function – the dominant function of the art project as process, program or experience. Important are also density, energetic features, relations and – observed from the viewer standpoint – participations. Therefore, the significance of such art projects-processes-programs is in relations and complex structures rather than in transparence of their elements. The artist (or collective of artists) always arranges a dry run of interactions, which would take too long and would be too complicated in the non-artistic reality; in the artistic environments, however, they can function in a very fluid and even crystal clear form. It seems that a piece or process of art, conceived as an art world, establishes clear space for the articulation of laboratory pure and even archetype interactions.

ART AS THE DRIVE IN THE KNOWLEDGE SOCIETY

Along with the political vs. art issue, the interactions of 'scientific art' and artistic technosciences, technologies as culture, and new forms of politics are essential. Referring to alternative browser Webstalker, Mathew Fuller (1998) has coined the term *not-just-art*. This term seems to be proper for naming the very nature of the contemporary art-of-in-between spaces, and could be applied also in other fields. (Techno)science, which refers to other-than-science could be called not-just-science, and very similarly terms like not-just-technology and not-just-politics could be introduced as well. The basic interactions in the area that enable art as research, technology as art and culture, and both artistic politics and artistic (techno)science can be expressed with the following scheme.

Figure 3.

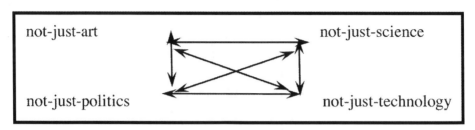

Contemporary technosciences as a kind of artistic 'soft sciences' are in dialogue with art, which consciously has given up the aesthetic (embellished, cosmetic) function and is not hiding behind the social irresponsibility. Art has ceased to be placed beyond the practice and everyday tasks, meaning it is becoming more and more lifelike, even in the sense as it has been defined by the performance artist Allan Kaprow, namely as opposed to 'artlike art' (Kaprow, 1993, p. 201). This is actually the contemporary art returning from the aesthetic would-be reality to the given, and by new media constructed and interpreted, event-driven reality, to reality (from the ontological point of view, it is a hybrid, mixed, and augmented) in which day by day everything is getting more and more real. As the field of the fictive is on the increase everywhere (even in technosciences, economy, media, advertisement, and politics), as the logic of theme parks more and more affects the everyday life, contemporary art has started to deal with the 'real' reality. Thus, it started to develop a unique artistically-theoretical approach. Contemporary art projects produced in the traditional or (first of all) new media (unstable) form are nowadays merely a part of a wider process of new knowledge, which means, they take part in a broader stream of simultaneous theoretic production of cultural values in a sense that "research has become a center of cultural innovation: its results are radically influencing life and thought" (Wilson, 2002, p. 3).

The contemporary, new media based art deliver new and entirely competent knowledge presented as an artistic surplus, which is complementary to the knowledge produced by citizen science, techno-science, humanities, and social sciences. One can encounter the issue of surveillance by taking into consideration contributions of information and social theory to this field, but the knowledge about this topic can be enriched also by artistic concepts of this issue in form of artist actions and hacktivism and net art events. As art exhibition devoted to the topic of surveillance one can mention the Open_

The Basic Paradigm Shift in Contemporary Art

Source_Art_Hack show in New Museum of Contemporary Art, N.Y. 2002. Hacking practices, open source ethics and cultural production were explored in an interactive group exhibition of artists who openly undermined the programming of everyday software tools. 'Open_Source_Art_Hack' featured a performance and walking tours by the Surveillance Camera Players; an installation by Knowbotic Research; a Free Radio Linux broadcast by r a d i o q u a l i a; a data body cloning project by LAN; a video by Harun Farocki; an anti-war game by Future Farmers' Josh On; packet-sniffing application by RSG; an "ad-busting" project by Cue P. Doll; and, a streaming media workshop with Superflex and Tenantspin.

If contemporaries would not encounter and perceive some of the new media art projects they would know too less and only in abstract form, they could even overlook a specific problem. This viewpoint can be expressed even more radically; today many difficulties regarding the issues of national state destabilization within globalization would fall away, if politicians were adequately informed about the agony of the 'state' in the field of art, thus with destabilization of artwork as artifact. So, if they took into consideration the unique story of contemporary art, which started to develop with Duchamp's intervention in the field of public presenting/exhibiting certain artifact as a work of art.

The novel art practices (performance art, installations, activism events, software and mobile art, and postinternet art) are creating new and changed demands for its audience, either. The user of this art is not affected only by multimedia and software requirements of new art, changing her into an uncertain and hybrid reader-viewer-listener. Her attitude is also defined by demands deriving from the complex concept of contemporary art and reality outside the art. Having only an aesthetic standpoint and thus the capability to switch to art-as-we-know-it mode is by no means enough; it is necessary to have the capability to smoothly switch to given reality and to percept it in its entire complexity, including the social.

The traditional art receiver/user accustomed only to the aesthetic standpoint is forced to suddenly take into account a broader field of mind and meaning, she has to adjust herself to demands of sophisticated interpretation and understanding. She has to shift from the beautiful appearance to concepts, issues of *Zeitgeist,* and the reality problems. The user of contemporary art is therefore challenged to take part in an cognitive and knowledge making process and even to do interdisciplinary research. She always strives for a 'more' – a surplus – and, why not, for a 'less'. She is directed towards the art's research function in the sense that contemporary art projects-processes-

events give the users more time and space and wider semantic field for their answers. The user's activity frequently requires interpretation of already finished path in the direction of comprehended-experienced work/process/ service of art; she draws sketches, schemas and notes of already performed links, motion direction of certain objects-messages in their interactions during observing-reading-listening, she also needs to percept such a work more than only once. Her participation is often based on goal-oriented and decision-making activities.

The connection of contemporary art to the processes of new knowledge making and the necessity of a certain pre-knowledge for understanding of art projects-events-processes are expressed also in the artist's statements for the proper understanding of contemporary artistic projects. It seems that today's artists are literally forced to restore not only their project but also their author's explication and interpretation of it. Today's visitors of contemporary art exhibitions and (multimedia) performances are enforced to read artist's statement, even before viewing the work of art. They are convinced that merely on the basis of their 'naïve' viewing, they would know too little of the work of art, if they had not reached for its theoretic explication.

Contemporary art is a highly contested, questionable, and politicized field that has mutated, we are witnesses of great changes painful and shocking to the traditionalists; although the world stage is weakening under the weight of old scenery, the play on it is irrevocably a new one. Life in milieu of smart machines, algorithmic culture, and on the basis of Internet communications has irrevocably infected not only the everyday life but the way of thinking and perception as well. The procedures such as (re)mixing, sampling, shortcuts into the databases and compositing of elements into new wholes regarding the daring associations – in other words – an activity characteristic for DJs in their procedures of synthetic music (and VJs in making their visual palimpsests) is entering the everyday life where every individual frequently tries to follow the algorithmic logic in order to perform certain tasks successfully (in playing video games for instance). Logic of smart machines is getting under our skin and influences the way we think, communicate, and create, and even code languages of machines are being more and more integrated into the netspeak (as language of the on-line communications) as well.

The Basic Paradigm Shift in Contemporary Art

NEW MEDIA ART SERVICE

This chapter aims to address the unstable nature of contemporary art processes and services by highlighting profound changes, both in the very nature of contemporary art (a shift towards the research function) and in the recent world defined by new (post)political subjects, networked economy, technosciences, social media, and techno-lifestyle. The shift from industrial production and manufacturing artefacts to the service sector in the economy of post-industrial societies affects the contemporary art; its societal position benefits from changes in contemporary (post-industrial, information, spectacle, event-driven, breaking news-driven, and software) societies – an example would be the increasing stress placed on knowledge, research, innovation, education, use of new technologies, communication, and spectacle. In the knowledge society the (big) data and intangible, abstract entities, immaterial products and services, mobility, flexibility, decentralization, rhizome-like order of organization, and cognitive labor, are gaining importance. The role of the national state is at stake in the globalized networking based (post)politics, more and more affected by the multinational capital and international institutions; similar shifts of paradigms can be observed in science (destabilization and relativization of the concept of subject-independent nature, natural laws, and objective truth) and networked economy of financial markets (the shift from the tangible wealth towards services and information).

Rather than being a production that objectifies itself into a material 'finished' product, the art-making embedded in a new condition of immaterial cognitive labor finds its own purpose in problem-solving and research activities, which bring something into the world that is not there: an alternative mode of knowledge coded in a way that discerns itself from the common scientific methods. Such activities are embedded in a present condition of post-Fordist labor and in a realm of immaterial production that privileged the (intellectual) and innovation based services at the expense of finished material artefact. Paolo Virno as a theoretician dealing with the new mode of intellectual labor refers to the artistic performance as an activity, which becomes the quintessence of the present labor in general: 'Let us consider carefully what defines the activity of virtuosos, of performing artists. First of all, theirs is an activity which finds its own fulfilment (that is, its own purpose) in itself, without objectifying itself into an end product, without settling into a 'finished product,' or into an object which would survive the performance. Secondly,

it is an activity which requires the presence of others, which exists only in the presence of an audience' (Virno, 2004, p. 52).

The (new media) art is about processes, immaterial entities, relations, performances, software, goal-oriented and problem-solving activities, and services. Such an art that increasingly exceeds the manufacturing of artefacts and is crossing over to a field that can be called a service of art – meaning a part of contemporary art (especially the new media one) is crossing into the service sector of (new) economy in the post-industrial, information, spectacle, and software society. Its services are – in terms of social justification – equal to those in the field of education, management, counselling, finance, and politics; they are then equal to the activities based on knowledge (e.g. cognitive labor) and are as flexible as possible.

Contemporary, especially new media art as an art service opens up the question what is a service? It is by no means an artefact, a completed product, it is essentially an activity, a practice, a process, an exploration, an intervention (inside things, states or processes), and performance. The service is not so much the manufacturing of things as it is a process of reshaping the thing, moving it, repurposing it, connecting it and incorporating it into new relations, (re) combinations and contexts. The service presupposes a problem, a challenge or an order to be solved or executed. The performer of the service is always faced with a certain task, challenged to solve it in a sequence of steps, chosen as economically as possible. The service therefore ends with a solution of the problem (or its removal) and not the manufacturing of an object.

The service always presupposes a procedure that has to be as rational as possible, economical, divided into phases, steps, operation and commands needed for it to be carried out. This kind of procedure – an exactly defined, planned procedure, executed through an economical sequence of steps – is called an algorithm. The algorithm has for some time no longer been an exclusive domain of the mathematical operations, it is the core of all sophisticatedly defined processes intended for performing certain tasks, solving problems, researching the state of things. It would not be an exaggeration to say that art services are algorithmic by nature; by the moment art begins to position itself beyond the aesthetic and becomes oriented towards tasks, research and problem solving, it is forced to carefully elaborate the procedures and to define the instructions to be carried out in order to get to the solution quickly and through economical phases.

A lot of contemporary art projects can be understood as interventions and services within different states of things, they have an algorithmic nature and are often stimulated by non-artistic motives – for example with regard

The Basic Paradigm Shift in Contemporary Art

to political, research, and communication needs and interests. As an example of such a shift towards research based contemporary art, the project-service *Free Range Grain* (2003) by Critical Art Ensemble, Beatriz da Costa and Shyh-shiun Shyju can be mentioned. This project took place in Schirn Kunsthalle Frankfurt, Germany, within the art show *At Your Own Risk*, and was organized as a live, performative action placed in a portable, public lab devoted to test foods for the more common genetic modifications. People (the art show audience) bring in the museum foods that they find suspect for whatever reason, and the artists-researchers test them over a 72-hour period to see if their suspicions are justified. The authors of this project claim, that 'within a very brief period of time, anyone who is modestly literate can learn the fundamentals of scientific study and ethics' (Critical Art Ensemble, 2002) meaning that even non-scientists could use much of advanced technologies and apply them in a public, more democratic research (e.g. the citizen science).

The use of the service in terms of goal-oriented activity constitutes the artist as the performer or executer of the service, but at the same time often includes also the person who had placed the order for the service or at least the person who had initiated it. An example of this are the contemporary curators and art directors of big festivals and exhibitions, who – along with the 'Call for Entries' – often also define a theme to which the artists are supposed to respond with their practices. As an example of such an order can be mentioned the CODeDOC project of the Whitney museum of American Art, 2002; the curator Chistiane Paul published a call for software tenders, dependent upon an exactly defined order. The participating artists were prescribed the choice of programming and scripting languages, the code had to move and had to connect three points in space, could not exceed 8 KB and had to be interpretative. The transfer from the artefact to the art service and the artist as the one who executes the service (the service depends on certain instructions, software, algorithmic approach) is also on its way to abandon the metaphysics of artistic creativity and genius. The artist is the one who executes service, performs certain tasks, solves problems, does research, defines commands, executes algorithms and does not wait for the divine inspiration to come upon her.

The art service actually moves art closer to the new (networked) economy, that has customization as adaptation of the service to the user's preferences as one of its key concepts. The power to control, to navigate, to form and to finalize that in the traditional paradigm belonged exclusively to the author, is now being transferred also to the user; the term 'user friendly', although worn out and trivialized, does have a certain content. It is by no means solely

The Basic Paradigm Shift in Contemporary Art

the artefact that is customized – it can apply to the service as well: a software artist can, for example, create a program as an open – as much as possible – scheme to be concretized and finalized by the users, according to their personal preferences. We are facing the condition as it was far-reachingly described by Brian Eno, a musician, in his interview with Kevin Kelly:

What people are going to be selling more of in the future is not pieces of music, but system by which people can customize listening experiences for themselves. Change some of the parameters and see what you get. So, in that sense, musicians would be offering unfinished pieces of music – pieces of raw material, but highly evolved raw material, that has a strong flavor to it already. I can also feel something evolving on the cusp between 'music,' 'game,' and 'demonstration' – I imagine a musical experience equivalent to watching John Conway's computer game of Life or playing SimEarth, for example. (1995)

Introducing the lifelike art (Allan Kapprow's term) as a service (intervention, open system, experience, research, and communication) means also the abolishment of the Modernism based concept of art autonomy; it challenges the basic Modern, aesthetic shaped art canon demanding art to be fully separated from the everyday reality and practical purposes. Such a turn also presupposes a broader art inclusion in everyday life, which appears to be interesting and significant also for other fields and disciplines. Today the techno-science, citizen science, design, social gathering, clubbing, social media, and fashion are becoming more and more challenged by social functions, procedures, and interventions of contemporary art. As a striking and even intriguing example the genetics can be mentioned as a scientific field striving to gain artlike autonomy as it used to be applied within Modern art; these efforts towards artlike 'licentia poetica' being at value in the field of science are provoked by surveillance strategies pertaining to genetic field as they are executed by institutions of politics, media, and ethics.

Defining the new media art in terms of (cognitive, post-industrial) service means that the traditional art autonomy is left behind (together with its participation on the realm of aesthetic values), while other features and functions are gaining on their importance. What counts within this novel condition of art integrated with the broader field of the cyber-societal and networked economy, is the ability of art for linking, sharing, creative participation, doing a research together with the non-artistic subjects and

The Basic Paradigm Shift in Contemporary Art

organizations (e.g. the European Arts at CERN as the leading art and science programme fostering the dialogue between artists and physicists).

Within such a novel condition a question is being raised, could the artist produce projects that are both the pieces considered as art and as (commercial) products with non-artistic use value. By considering art as (post-industrial) cognitive service, the art-making is actually challenged to produce pieces/processes/projects/performances that simultaneously participate on art realm and on other fields (e.g. politics, citizen science, media, economy, and civil society), meaning that they abandon the traditional notion of the art's pure autonomy. And the current practices in contemporary art demonstrate that such a boundary-blurring platform foregrounds the novel art-making, which is directed to not-just-art projects.

Here we can mention the theoretician Machiko Kusahara (2008), who refers to Japanese artists involved in the process of making the so-called device art, which means that the device, designed in a playful fashion becomes the essential content of art piece, enabling it to be launched as commercial product free of special maintenance. Device art can be sold both as art and for practical purposes shaped device; it gains the practical use value or shortly the device value. Such an art which could be placed beyond the limited context of museums and galleries, and presupposes artist's involvement in broader fields such as entertainment, design, and commercial production, is based on artist's positive attitude to the state-of-the-art technologies as the key foundation of new media art.

A very challenging approach to the current art vs. economy problem is also found in the practice of *Electroboutique* as both the laboratory for studying new strategies in art, and the gallery-slash-gadget shop selling distorting screens and other high-tech toys, founded by Alexei Shulgin and Aristarkh Chernyshev (2005). Their practice is called *CritiPop* due to their more critical attitude to blurring the art vs. economy boundaries issue. Such a commercial protest seems to be the *realpolitics* in the today's societal condition, for the present artists are challenged to make product that would fit well both to the realm of art and the realm of economy, meaning it can be used for practical purposes and sold. Rather than dealing with the issues of big ontological (and ideological) problems of the human – the Modern art was about, the contemporary artists find their essential tasks in establishing the innovative and creative relationship to the market even in terms of inventing their own economy.

'We wanted to create media works that were plug-and-play and zero-maintenance. Furthermore, we wanted to distance ourselves from media

The Basic Paradigm Shift in Contemporary Art

activism, which had hit a dead end. Since art equals consumption in the conditions of the unipolar capitalist world, we decided to make a commercial object. We put protest and critique in its body. That's how we arrived at our style, which we called commercial protest. Then we added exciting shapes and sound. And that's how we got CritiPop.' (Droitcour, 2008) In the moment, when the art (on the Web or beyond it) is just click or two away from the commercial, political, and societal, the artists are challenged to reinvent their very personal and temporal tactics, even in terms of a kind survival kit, referring both to the institution of art and their individual existence. Most recent examples of the (new media) art that blurs the boundaries between the high and popular, aesthetic and business are found in the Post-Internet art (e.g. project *Nested Exchange*, 2018 by Harm van den Dorpel).

CONCLUSION

The introduction of art service as a key concept of contemporary art enables a novel understanding of art as a cognitive, high-skilled, and performative practice oriented towards tasks, research, knowledge-making, and problem-solving activities. As a cognitive practice, art works hand in hand with other fields of the knowledge society and brings competitive knowledge to the world, knowledge that differs from the knowledge produced by the science-as-we-know-it and is set in the nearness of the knowledge produced by the activities of citizen science and civil society. The contemporary art service can also be applied to political tasks; such service is more subtle than traditional political devices and can be used as a significant tool in civil society engagement (e.g., art activism). The devices of art activism, such as subversive affirmation, making strange (defamiliarization), and detournement (introduced by the French Situationist movement), can be deployed in civil society and social media political struggles as well. Devices that are of importance in the inner life of art institutions, like branding and referring to art projects formed by canonic artists (as a kind of underlying asset), can be significant in financial markets, too. Rather than being an artist-genius separated from everyday people, the contemporary artist is a cognitive worker included in the hacker class (Wark, 2004) and the knowledge society.

A big part of this chapter deals with the (new) media art as a significant field of contemporary art that intersects with tactical media and state-of-the-art scientific development (e.g., particle physics, molecular biology, informatics, and artificial intelligence). In doing so, this chapter introduces

new theoretical devices (the closeness that grows toward the user and the technical time-space) that are useful in clarifying the very specificity of media art. Along the ontological—first and foremost phenomenological—analysis of media art foundations, a big stress is put on the social embeddedness of contemporary art that in its most recent mode (not-just-art) interacts with not-just-science, not-just-politics, and not-just-technology (in terms of these fields' expanded concepts). The outcome of these interactions is the present augmented and sophisticated reality, crowded with the new generation of hybrid cultural contents shaped as in-between entities with software, algorithmic, and artificial intelligence components.

REFERENCES

Aarseth, E. J. (1997). *Cybertext. Perspectives on Ergodic Literature*. Baltimore: The John Hopkins University Press.

Amerika, M. (2004). Expanding the Concept of Writing: Notes on Net Art, Digital Narrative and Viral Ethics. *Leonardo, 37*(1), 9–13. doi:10.1162/002409404772827987

Barbrook, R. (2005). *The High-tech Gift Economy*. Retrieved May 19, 2019, from http://www.firstmonday.org/issues/issue3_12/barbrook/

Baudrillard, J. (1997). Objects, Images and the Possibilities of Aesthetic Illusion. In N. Zurbrugg (Ed.), *Art and Artefact*. London: SAGE Publications.

Benjamin, W. (1969). The Work of Art in the Age of Mechanical Reproduction (H. Zohn, Trans.). In H. Arendt (Ed.), Illuminations. New York: Schocken Books.

Bey, H. (1985). *T. A. Z. The Temporary Autonomous Zone, Ontological Anarchy, Poetic Terrorism*. New York: Autonomedia.

CODeDOC. (2002). *Exhibition in Whitney Museum of American Art, New York*. Retrieved January 18, 2020, from https://whitney.org/exhibitions/codedoc

Critical Art Ensemble. (2002). *Molecular Invasion*. Brooklyn: Autonomedia.

Critical Art Ensemble. (2003). GM food. It's everywhere you want to be. In M. Heinzelmann & M. Weinhard (Eds.), Auf eigene Gefahr. Frankfurt: Revolver – Archiv für aktuelle Kunst.

Danto, A. C. (1995). *After the End of Art. Contemporary Art and the Pale of History.* Princeton, NJ: Princeton University Press.

Deleuze, G. (1990). *The Logic of Sense* (C. V. Boundas, Ed.). New York: Columbia University Press.

Droitcour, B. (2008). Interview with Alexei Shulgin. *Rhizome.org.* Retrieved February 18, 2019, from https://rhizome.org/editorial/2099

Electroboutique. (2005). Retrieved January 18, 2019 from http://www.electroboutique.com/

Feyerabend, P. (1993). Die Natur als ein Kunstwerk. In W. Welsch (Ed.), *Die Aktualität des Ästhetischen.* München: Wilhelm Fink Publishing House.

Fuller, M. (1998). *A means of Mutation.* Retrieved February 1, 2019, from https://bak.spc.org/iod/mutation.html

Geiger, M. (1986). *The Significance of Art, A Phenomenological Approach to Aesthetics* (K. Berger, Trans. & Ed.). Washington, DC: CARP and University Press of America.

Greene, R. (2004). *Internet Art.* London: Thames & Hudson.

Hartmann, N. (1953). *Ästhetik.* Berlin: Walter de Gruyter & Co.

Haug, W. F. (1971). Kritik der Warenästhetik. Frankfurt: Suhrkamp.

Ingarden, R. (1973). *The Cognition of Literary Work of Art* (R. A. Crowley & K. R. Olson, Trans.). Evanston: Northwestern University Press.

Jameson, F. (1993). Postmodernism, or The Cultural Logic of Late Capitalism. In T. Docherty (Ed.), *Postmodernism, A Reader.* New York: Columbia University Press.

Kapprow, A. (1993). *Essays on the Blurring of Art and Life.* Berkeley: University of California Press.

Kelly, K. (1995). Gossip is Philosophy. *Wired 3.05.* Retrieved January 18, 2019, from https://www.wired.com/wired/3.05/eno.html?pg=4&topic=

Kusahara, M. (2008). *Making Art as Commercial Products: An Ongoing Challenge of Device Art.* Singapore: ISEA 2008 Proceedings.

Lash, S. (1990). *Sociology of Postmodernism.* London: Routledge.

The Basic Paradigm Shift in Contemporary Art

Lyotard, J.-F. (1991). *The Inhumain, Reflections on Time*. Stanford, CA: Stanford University Press.

Manovich, L. (2003). New Media from Borghes to HTML. In N. Wardrip-Fruin & N. Monfort (Eds.), *The New Media Reader*. Cambridge, MA: The MIT Press.

Manovich, L. (2013). *Software Takes Command*. London: Bloomssbury Academic.

Popp, J. (2004). *bit.fall*. Retrieved February 1, 2019, from https://www.youtube.com/watch?v=gg9LWsfqqrk

Retallack, J. (2019). Hard Days Nights in the Anthropocene. *Electronic Book Review*. doi:10.7273/hfb3-gk94

Rush, M. (1999). *New Media in Late 20th-Century Art*. London: Thames & Hudson.

Van den Dorpel, H. (2018). *Nested Exchange*. Retrieved January 17, 2020, from https://www.youtube.com/watch?v=GMgsU_a3TVQ

Virilio, P. (2003). *Art and Fear*. London: Continuum.

Wark, M. (2004). The Hacker Manifesto. London: The Harvard University Press.

Welsch, W. (1996). *Grenzgänge der Ästhetik*. Stuttgart: Reclam.

Wilson, S. (2002). *Information Arts*. Cambridge, MA: The MIT Press.

Chapter 2

After the End of Art:
The Conceptual in Arts and Beyond

ABSTRACT

The philosophical concept of end of art opens up the ends of other fields (i.e., the end of science, politics, and economy that are in the present modified into not-just science, not-just-politics, and not-just economy). Contemporary art (considered as the not-just-art, art after the end of art, and would-be-art) enters intense relations with modified science, politics, and economics through processes of interaction, adoption of methodological devices, hybridization, and amalgamation. It is important to acknowledge that art is not a passive and second-grade link in these interactions, but rather contributes artistic innovations to other fields that then become art-like. There are a number of common denominators among the crucial fields of contemporary knowledge society.

INTRODUCTION

This chapter relates to those features of everyday life which are affected by contemporary, first and foremost the new media (digital) art and hence are changing, becoming in a certain perspective artistic. Instead of aestheticization of politics (Benjamin, 1969) and everyday life (Welsch, 1996; Haug, 1971), the artification of the principal areas of today's social reality is addressed. This chapter examines the recombination, appropriation, reusing, repurposing, and transfer of artistic procedures/tools from one context or field to another.

DOI: 10.4018/978-1-7998-3835-7.ch002

Copyright © 2020, IGI Global. Copying or distributing in print or electronic forms without written permission of IGI Global is prohibited.

After the End of Art

Contemporary, first and foremost new media and smart technologies based art is a drive of many changes that modern sciences, economy, media, and political theory should pay attention to. Indeed, other than a (delayed) derivative of, art is more of an initiator of today's significant economic and conceptual changes, paradigm shifts, and innovations.

Contemporary art is the art after the end of art. This statement relates to German philosopher Hegel's notion on the end of art from his book on aesthetics (1828). The end of art addressed and conceptualized both in Hegel's *Lectures on Aesthetics* as well as in series of other texts published in 20th century (by Adorno, Benjamin, and Baudrillard) rests on the original Hegel's notion – i.e., the end of a particular narrative on art (Danto, 1995) and its interpretation which in a particular historical moment enabled the identification of a special cultural practice as the art.

This is about the end of recognition and understanding art in the sense of an exclusive form of representation (mimesis) in a sensory medium, in Hegel's words "Art no longer affords that satisfaction of spiritual needs which earlier ages and nations sought in it, and found in it. Consequently, the conditions of our present time are not favorable to art. In all these respects art, considered in its highest vocation, is and remains for us a thing of the past." (Hegel, 1975, pp. 10,11) This notion doesn't deny the possibility of further art development, but rather questions its position in the field of absolute spirit as the supreme domain in Hegel's philosophy. In fact, rather than being founded in empirical analysis of art development and dissemination in Hegel's time, the notion of end of art is an outcome of internal philosophical evolution in his philosophical system. However, the development of modern, postmodern, and contemporary art in 20th century has re-actualized this notion also with regard to the current movements in arts and literature.

The Hegel's notion on the end of art does not imply the end of art production (numerous new movements and works arise over the decades), but means that the art as an essential way of revealing the truth is over and is replaced with the art, which is intended to novel functions and purposes. Such an art is an uncertain field in which the question *What is art* functions as a drive of art institution itself. What is art is a philosophical question, it implies conceptual answers, and a big portion of contemporary art is conceptual. It is art after the end of art, which opens up a very beginning of new art forms and movements. Today, a very similar paradigm shift takes place also in other fields of present social reality.

After the End of Art

Instead of traditional science, politics, media, and economics we have witnessed the emergence of more conceptual science, social media, postpolitics, and networked economy as new practices that co-exist with the traditional forms at their social positions, hybridize with them, remediate them, or occupy new positions in regard to them (places and times). We are entering a hybridized and recombinant reality defined by performative turn (Fischer-Lichte, 2004), spatial turn (Foucault, 1986, p. 22), ubiquitous computing (Ekman, 2013), and the Internet of things which anticipates the transformation of things into sensory and supersensory entities ever more resembling software units. The internet wants to absorb and interiorize all cultural contents (the phenomenon of googlization), it is directed to things, appropriating and transforming them into malleable and controlled entities. People are also challenged by embedded intelligence based on a growing network of connected devices. The individual also undergoes huge transformations; the self is physical and simultaneously influenced by data, sharing, and networking. The paradigm of post-Cartesianism has given way to a redefined Cartesianism which anticipates the coupling of a body and software-supported module (e.g. in Stelarc's techno-performances). In this reality, the significance of in-between spaces and hybridization is increasing; due to their software-data layers integrated with the body, all beings are becoming connectible (and consequently also the Heideggerian "standing reserve"). This is also the reality of the processes, algorithm culture, goal-oriented, and problem-solving activities. This reality is not averse to art as a flexible field which is opening to the paradigm shifts, connecting with the modified sciences, politics and economy, and at the same time autonomously generating fundamental changes. This chapter will address both aspects:

1. Artistic adaptation and appropriation of procedures developed in other fields;
2. The appropriation of artistic approaches, strategies, devices, and procedures in (post)politics, everyday life, economics, new technologies, and science.

After the End of Art

THE CONCEPTUAL IN ARTS, POST-POLITICS, AND NETWORKED ECONOMY

The understanding of art as a historical phenomenon (Belting, 1994) enables exploring the new functions of contemporary art which often deploys digital media and is stored and disseminated on the Internet. Today we are also contemporaries of noticeable changes in new media art as a field which shares some basic features with the electronic literature. Digital and net art have evolved into postdigital and in particular postinternet art (Kholeif, 2018) that abandon the hype of early new media and especially the Internet, including the ideology of cyberpunk, cyborg, techno-escapism, and posthuman. Today, if cultural content has the attribute *Internet*, this doesn't say much. In fact, most today's contents is self-evidently related to the Internet, and the Web is just one of a number of media used by contemporary artists active both in a white gallery cube as well as online. However, the Web is also a mind shifter; it shapes one's cognitive abilities meaning (in a case of new media shaped writing) that "after the Web, we would never write the same way again" (Goldsmith, 2015).

Art after the end of art is conceptual, which doesn't refer to the conceptual art movement with Sol LeWitt and Joseph Kosuth among others, but in particular to different tendencies in contemporary and particularly new media art which explore its principles, intensifies itself, and address the repurposing of their functions. The conceptual is also essential characteristic of other relevant fields today – science, politics and economy. These fields attain the modality of the conceptual in the moment when they deploy autopoesis and become symbolic and self-referential; they stop expanding outwards, turning instead inwards. We encounter:

- The production of experiences and events in art instead of production of artifacts;
- The production of derivatives which presuppose the manipulation of value and money instead of evaluation of material production (e.g. in the conceptual economy of financial markets);
- The aestheticization and performativity of conceptual science which rather than discovering nature produces principles for the models of alternative nature (virtual worlds, augmented realities); such a science writes stories about its research and visualize its outcomes.

After the End of Art

Politics is also becoming conceptual not only in its post-politics orientation (Virno, 2004; Mouffe, 2004), but also in modifications based on redirecting attention from clearly expressed political alternatives and state power to novel subjects of political that often work on fringe within the visionary projects.

Conceptualization of an individual field is reflected in its autonomization and intensification, its orientation to autopoesis and self-reference rather than extensiveness. An "after the end" field and its related conceptualization are deployed in self-reflection; nothing is considered self-evident from that moment on – everything could be different. Hence a phase that such a field must include in its development is the phase of *l'art pour l'art* (e.g. art for art's sake, politics for politics' sake, economics for economics' sake). This is a phase of the fields' liberation from a solely practical functioning. Only when they began to deal with themselves, did they attain a certain distance and freedom, become conceptual and 'l'art pour l'art' and similar to artlike art (term coined by the performer Allan Kaprow).

In the second phase – the transition through autopoiesis – the field turns into the modality of aestheticization. Not only politics (the views of Benjamin in the essay *Work of Art in the Age of Mechanical Reproduction* and Kracauer in *The Mass Ornament*), but also science, religion, technologies, economy, sport, fashion, and the everyday are also *aestheticized*. For example, science is *aestheticized* through performativity and narrativity upon the realization that its solutions and outcomes expressed in the language of science don't add to its bigger public recognition; it must engage in telling striking stories about its inventions. In technoscience, this role is played by the ideology of the techno-imaginary (Medosch, 2005) by employing advanced and persuasive forms of demonstration such as PowerPoint, which transforms an scientist during a demonstration into a genuine performer. This tool is less about the report than a means of demonstration in the form of performance (Stark & Paravel, 2008). In short, aestheticization refers to the use of striking procedures with the rich sensual effects to attract and stimulate the consumer.

A field that has undergone both phases now has the freedom to enter the "artlike mode" when openness and liberty are confronting the unpredictable, the risky, and innovative. The conceptual networked economy (driven by high-frequency algorithmic trading) is such an example, with conceptual marketing and conceptual markets, in particular financial markets involved in the manipulation of value, betting on money, and including more and more derivatives (futures, options, swaps) whose movements have no reference whatsoever with real wealth. Early conceptual marketing was discussed by Naomi Klein in her *No logo* in the sense that rather than their products, large

34

After the End of Art

multinational corporations market their logos. Regarding multinationals such as Nike, Microsoft, Tommy Hilfiger and Intel, she argued that "producing goods was only an incidental part of their operations, and that thanks to recent victories in trade liberalization and labor-law reforms, they were able to have their products made for them by contractors, many of them overseas. What these companies produced primarily were not things, they said, but images of their brands. Their real work lay not in manufacturing but in marketing". (p. 4) The cryptocurrencies' market is also conceptual and art-like; expressions originated in art theory and contemporary philosophy like rhizome, networking, and fold (Deleuze, 1993) could be applied in description of blockchain technology and its products. The present cognitive capitalism is shaped by semioticization and conceptualization; the products and services give way to signs, concepts and hidden manipulations.

ON DRONE ART

The art of the socialist/communist countries was often discussed at political forums (the views of artists and writers were a subject of intelligence service investigations, for example in Yugoslavia) and even at the congresses of the central committees of the communist parties, which means that art also performed a political function and was treated accordingly. When today, more than three decades after the fall of the Berlin Wall, people look back at that period, it strikes them as something very distant because they are the contemporaries of the changed societal role of art and its relation to other fields in the non-artistic reality. As regards politics, we are faced with a conglomerate of political and postpolitical discourses contributed by different subjects, including art activism and hacktivism (e.g., Critical Art Ensemble, Anonymous, Electronic Disturbance Theatre, The Yes Men), but they are out of range of the elite politics and politics-intended (prime time, breaking news) media coverage. However, we definitely come across post-aesthetic art that abandons traditional artistic attributes addressed by philosophical aesthetics (appearance, beauty, the fictional, make-believe) and enters the field of ethics challenged by the Antropocene; to put it simply – it tries to help people. Despite great differences, this tendency relates the dissident, socially critical art of the real socialism to those projects of today's technology (both digital and post-internet) art which are in the service of disclosing - i.e., making visible what is concealed, filtrated, and marginalized.

35

After the End of Art

Today's reality is no alien to the issues and phenomena that are concealed or subject to a very biased media interpretation. They enter the breaking news but their explication by rule fits the interests of global political subjects, including the multinational corporations. This is an opportunity for art to take the role of de-aestheticization, debunking, revealing the prevalence of commonsense and start as an ethical practice drawing attention to the tragic forms of today's societal reality. This opportunity has actually been seized by some artists who believe in the socially critical role of art. This new artistic paradigm which presumes a transition from the aesthetic to the ethical and even humanitarian is addressed in numerous artworks based on modern technologies and media. Among the first was the activist intervention *#NotABugSplat* staged in Pakistan in 2014.

Smart bomb eye view (i.e., a view of the approaching target of destruction through the camera equipped guided missiles) available to the widest audience watching the CNN breaking news coverage of Desert Storm (Gulf War, 1990–1991) military operations, is today upgraded with a drone view based on mobile aerial footage of military and civil objects. Both the smart bombs and drones enter our visual field from above, enriching our normal viewing point with a bird's eye view that captures the objects in a very new fashion. However, the primary use of drones today is by the military; the strikes of military drones on the targets of the Taliban rebels (and terrorists) in Afghanistan and Pakistan which cause considerable casualties are publicly known. In Pakistan, more than 3,000 civilians have been killed by drones, including a large number of children. This instigated the artists-activists to stage the art project *#NotABugSplat* in 2014, designed as a gigantic poster with the face of a boy who lost his parents and two siblings to a drone attack. Its purpose is to create empathy among drone operators; they should think twice, examine the context and effects of their actions before pressing the kill button. This project is artwork in the field of drone art (Davies Crook, 2013); it belongs to artworks that are actually interventions, actions, services, and applications aimed at criticizing the aggressive and corrupted politics.

ART THAT HELPS PEOPLE IN THEIR EVERYDAY TASKS

One of drone socially critical art is James Bridle's *Dronestagram*, which repurposes Google Earth into a visual cartography of actual drone strikes, including their location, frequency, and timing, thus precisely mapping that in our civilization driven by the visual cultural advances, hidden from the eyes.

After the End of Art

Dronestagram's data are available on several social media, from Instagram to Twitter. Another striking project of Bridle's is *Drone Shadows* (prepared in collaboration with Einar Sneve Martinussen), consisting of chalk drawings of drone shadows in the streets of many cities of the world. This project also embraces the idea of art pointing to the forbidden and secret matters of today's war machine and disclosing them for the public. The drone's specificity is not being visible - the artist disturbs this war machine's ambition, rendering its shadow. Mention should also be made of George Barber's *Freestone drone* and Trevor Paglen's *Drone Vision*. Both projects use post-aesthetic art to reveal dark sides of reality rather than adorn the environment.

An ever more radical role (i.e., humanitarian, therapeutic, and social) in the field of activist art, new technologies and media based arts is performed by the application *Transborder Immigrant Tool* (2015) by the Electronic Disturbance Theatre aimed at Latino immigrants while crossing the Mexico-US border. It is a mobile phone application that helps the illegal migrants crossing the border in the desert to find water sources, aid stations and locate points of orientation in the unknown territory.

The function of these projects is the use of advanced technology and its repurposing from military and commercial applications to ethical and humanitarian actions. Due to the fact that these are high-tech based projects, it should be pointed out that here is at play Benjamin's concept of second technology, which anticipates reconciliation between the individual, nature, and the cosmos, an actual "interplay" between these two correlates.

The drone and activist art projects have been mentioned to highlight great changes pertinent to today's art as a field opening up to other fields (science, politics, media, economy) as well as to ethical alternatives and correctives. Both socialist dissident art as well as contemporary activist and hacktivist - in particular new media (digital) - art presuppose the interplay of the political and artistic, including the phenomena of culture jammings and pranks - i.e., practices that can be traced back to the Situationist *detournement*. Today, instead of politics, a major role is assumed by the economy which takes over the role of a cultural dominant; it seems that rather than dealing with politics through art and culture, people currently deal with economy through a number of fields (undoubtedly including politics and art). Equally significant toward understanding both contemporary art and social flows, as well as the cultural paradigms thereof, are the relations of art with techno and bio sciences.

The shift from politics to economy (in particular the networked and algorithmic trading shaped economy) doesn't come as a surprise because at present large corporations shape the political domain and have a bigger

After the End of Art

influence on the life of everyday people than the decisions of national parliaments. The replacement of the political dominant with the economic is also related to the conceptualization of the economy itself with its increasingly inward orientation over the last decades, reflecting its own premises and entering the stage defined mainly by finance capitalism with its intensifying abstraction. The object dematerialization is not only characteristic of modern art, but also of present economy crowded with conceptual and abstract instruments.

We are confronted with an economy in which attention assumes the role of money; a notion very close to contemporary artists, in particular those engaged in new media and technologies. "He was, above all, an economist of attention" wrote Lanham (2006, n. p.), about the futurist Marinetti, and these efforts were even more pronounced on the part of artists, from Duchamp and Dali to Warhol and Koons. The artists' obsessions with novelties, concepts, daring ideas, and innovations, their tiger jumps first to the past and then to the futurist scenarios; their value games, by quoting preceding artists-brands (Strehovec, 2012), are procedures to be addressed by the theoreticians and practitioners of new economy as well. Here one can mention Andy Warhol, who was not only an innovative pop artist but also a philosopher of a new paradigm of star glamour. Rather than referring to fine art, his statements on business, the surface, and fifteen minutes of fame actually referred to Hollywood and trendy popular culture.

Going back to the issue of finance capitalism, one may notice that its principal characteristics (e.g., dematerialization, abstraction, and semiotization) also appear in the field of culture and art. In his *Mass Ornament,* Kracauer pointed to the relation between assembly-line work (Fordism, Taylorism) and the dance of the Tiller Girls on the vast stadium spectacles of the Third Reich: the result was abstract, flesh-liberated movement in ornament figures which correspond to the abstraction of assembly-line work and capitalism itself.

"The hands in the factory correspond to the legs of the Tiller Girls." (Kracauer, 1995: 79) This theoretical point is central, as the dancers involved in the ornamental, desexualised, and highly abstract dance of the mass spectacle (ranging from the rituals of the Third Reich to more contemporary versions such as former Yugoslav Tito's Youth Relay and North Korean Kim Il Sung's ceremonies) do not reflect anything but rather works hand in hand with the workers behind factory assembly line whose movements are trained within Taylorist fashion and adapted to machines.

The abstraction from physical reality (as well as the wealth of language, its ambiguity) is also evident in the informatization of cultural contents when a

After the End of Art

story gives way to the information (Benjamin's claim in *The Storyteller*). The ornament as play with forms in the sense of signifiers liberated from meaning is also characteristic of aestheticization as a procedure which is increasingly less essential for contemporary art (which is generally post-aesthetic, and often deals with the ugly in a performance) but still serves as a stimulant of the exchange value of the political, economic, fashion, and sport contents (the aestheticization of politics, commodities, fashion, and sport to promote the marketing of contents related to these fields).

Similar to a number of projects of new media and postinternet art as well as electronic literature, entering into the conceptual level is also a principal characteristic of the financial markets' networked economy. The derivatives are conceptual, and trade in derivatives presumes the managing and manipulation of values. It is also a kind of appropriation in the sense that the broker relates to underlying assets as the artist or writer to available artistic material or text. It is about the reusing of art projects and texts in novel structures and processes. Moreover, the function of derivatives (as financial instruments) is to insure against price movements (hedging), which is similar to artists in their constant striving to insure against substantial changes in the art institution where they place their works.

ART AS A FIELD AFFECTING OTHER FIELDS - ARTIFICATION

Today, the contents of art, (citizen) science, economy, media, creative industries, and politics enter and connect in the in-between spaces (Puncer, 2018), which results in the emergence of hybrid fields such as bioart, artificial life theory, drone art, art activism, and hacktivism. Sometime these fields are closer to art and articulated within art, while other times they move towards the fields of (post)politics, science and economy. The question is, what allows fluent transitions between different fields which were strictly separated in the modernist paradigm? Simply because they have all changed and become conceptual, they intensify, reflect on themselves and enter the after-the-end paradigm (e.g., the end of art) – in short, they share a series of common denominators: they were infected with the artistic tendencies of creativity, autonomy, attention drawing, and storytelling. In certain fields of art and literature, the artist is even challenged to inaugurate with any original and sophisticated new artwork a new genre (for example in new media art

and e-literature). No less important a common denominator is the research nature of these fields. Non-representational art has become researchable, like science (which has always been), economy, politics, and media. Today, a number of fields strive to attain legitimacy by self-declaring their research function; for example, journalism. In contemporary art, the audience comes across statements that generally begin with 'In the exhibited work, the artist explores...'

The new media and technological foundations usable in all these fields further contribute to flexibility, fluidity, rhizomatic effects, and dispersity; today, crucial are the paradigms of digital, code (social) networking, global connectivity, and sharing. In this paradigms art isn't some less relevant derivative, but takes the central role. Currently, a lot of social fields seem to be interested in art because it is an area of innovation; it includes creative risk and insecurity; it grants privilege to creativity; it fosters embodied experience which is alternative to the logic of (abstract) information. One of the results of these efforts is the artification of certain fields in the sense of intensification, attractive visualization (for example, scientific theories and achievements referred to at *Deep Space 8K*, 2015, at the Ars Electronica Festival in Linz), presenting its achievements as stories, and fostering intensive experience.

The term 'artlike art' used by the performer Allan Kaprow for intensified art reflecting upon itself (in contrast to lifelike art) could be paraphrased and applied to other areas that enter into a relationship with art which can be illustrated by the scheme shown in Table 1.

What is at play here is a double art-likeness: the first regarding the actual likeness with the art strategies and procedures, and the second which is metaphorical and directed to the artistic self-reference, intensities, self-reflection, crossing boundaries, juxtapositioning, destabilization of the canon and the conceptual which often emerge in other fields under different names. Due to the flexible intertwining and hybridization of the fields, a similar scheme could be drawn for science, economy, and politics, while art-like could be replaced with science-like, economy-like, and politics-like.

This chapter is primarily focused on the role of art meaning that an innovative artist has been a model for the scientists and designers in other fields. The same is true for the art institutions with their collections as value archives; designers from other fields also want to place their products in them. Let us just mention the presentations of prestigious car brands, from Ferraris at the AUTObodies show in MoMa New York (2002), to the Mercedes concept car F 015 at the festival Ars Electronica 2015. The situation with fashion designers is similar; for example, Hussein Chalayan' creations in the Museum

After the End of Art

Table 1. Transfer of artistic procedures and tools from artistic field to extra-artistic reality

Artistic Procedures	Manifestations in Arts	Aplications in Other Fields
esteticization	beauty of nature, body, and soul; stylization, beauty in fine arts	esteticization of politics, comodity, fashion, sport, and youth
dematerialization	dematerialization of art object; artistic service, process, and app. instead of stable artwork	dematerialization of financial services, money, labour, capital, interpersonal relationship, mcdonalized language
destabilization of expectations, making of unpredictible	making strange, parallel editing, stain, subverzive affirmation, overidentificatio n,juxtapositing, pastiche, collage, parody, vertigo, uncertainty	culture jamming, situacionist detournement, pranks, activism, hactivism tactical media as cultural practices with political goals; electronic disobedience, business disruption, political spin
musealization and documentation	musealization of objects, documentation of performances, readings, actions, processes	musealization of fashion and design artifacts, cars, technical inovations, blockchain technology
intenzification	concentrated arangement of attractive, narrative and metaphisical atmospheres within as short as possible intervals	music videos, elevator pitch in economics and public relations, roller-coaster rides
semiotization	play of signifiers in the arts and literature	semiotization of capital, logo gains advantage over material artifacts in state-of-the-art marketing
narrative	literary, cinematic, TV, new media,video games shaped narrative	representation of new scientific paradigm by means of storytelling
playing and gaming	performing arts, video and computer games	games in mathematics, economics, popular culture
derealization and the conceptual	fictive aesthetic forms in the as-if mode conceptual art	derealization of nature, history, politics in theme parks attractions and digital arcade conceptual postpolitics, conceptual economics, criptocurrencies
disruption	shock, alegory, cut-up, juxtaposition, montage, stain	special effects in cinema and commercials, business disruptions, cultural innovations as break and shift of paradigm
appropriation	remixing, reusing, repurposing available artistic material and texts (e.g. remake, pastiche, remix)	appropriation of underlying assets in conceptual derivative trading

of Contemporary Art, Tokyo, 2010. (Post)political activists and hackers also locate their actions in the art context (it provides them with security and an alibi), and scientists appreciate their collaboration with artists in the context of the contemporary, in particular new media and postinternet art. Many IT engineers (programmers) and scientists have made a name in the world of art by developing software and hardware components for successful artists who have exhibited at international festivals (such as Art Electronica, ISEA, and Siggraph). Moreover, the scientists are interested in the artistic visualizations

of their achievements and the stories used to present their achievements in the sense of the attractive techno-imaginary (Medosch, 2005: 22).

One of the institutions of the media and techno art that constantly strives to establish connections between the world of art and science is the Ars Electronica Centre and Festival with its Deep Space and the collaboration with Cern (laboratory to study fundamental particles, founded in 1954 near in Geneva). The Collide@CERN Ars Electronica Award continues a very successful collaborative relationship between CERN and Ars Electronica. Three residencies have been staged over the past three years under the aegis of the Collide@CERN program. Impressive satellite imagery of Earth and the information that can be gleaned from it about our home planet occupy the focal point of an exhibition produced jointly by the European Space Agency (ESA) and Ars Electronica. Spaceship Earth provides insights into the ESA's earth observation Program. In 2015, the Collide Award was granted to *Semiconductor* (Ruth Jarman and Joe Gerhardt), which drew attention with the *Magnetic Movie* back in 2007, visualizing (as if were special effects of SF blockbusters) the secret lives of invisible magnetic fields that are revealed as chaotic ever-changing geometries. This is an example of the artistic endeavor to illustrate and visualize scientific laws, to reveal what is hidden to the eyes and to humanize it to some degree. Today's conceptual and art-like science needs such visualizations and stories that belong to its public appearance.

Also specific to the contemporary, in particular new technologies and media based art, is its emphasis on a rich and complex structured experience which is different from the routine, indigent perception in a breaking news driven society. Hence the key task of contemporary art is to enable (a rich, intensified) experience beyond limits set in everyday life. What is scarce in everyday life, such as intense stimulations, high adrenaline sensations, metaphysical qualities (Ingarden, 1973), is arranged in art in a condensed, intensive, crystalline form. Although a series of contemporary art projects still builds its visibility on allowing an experience of "extraordinary atmospheres" and extreme intensity, the artistic tendencies for an extreme and intense experience have become essential in other fields, too. The creative and culture industries and popular culture have focused on this intensity, on the events arranged in short temporal intervals - for instance, two to three minutes, the duration of a rollercoaster ride in theme parks and slightly shorter than the duration of popular music videos. Technocultures and rituals in particular invest artistic intensities, acceleration, and density. Such experiences and events developed in the non-artistic fields (digital arcades, theme parks) are today entering the experience-driven society.

After the End of Art

Intense experience favored mainly by art before the development of new technologies is today accessible in extra-artistic arrangements. In this chapter have already mentioned the creativity, risk and insecurity that are currently the attributes related to the creativity in science, decision-making in (post)politics and business in economy, as well as the artistic application of disruptions in different modalities thoughtfully applied by networked economy and finance capitalism. A number of procedures developed by net art (such as networking, formation of communities, pranks, disruptions, insecurity, paradoxes, tricks, do-it-yourself, looking for holes in the system) were applied by the net culture, social media, and economy of financial markets so that, metaphorically speaking, *The Californian Ideology*[1] also applies to them.

The parallels between contemporary art and the conceptual networked economy were also addressed by Tatiana Bazzichelli: »Since the Avant-gardes, artists have concentrated on the effect of producing the unpredictable, while generating new forms. But in the neoliberal era, business logic deals with the unpredictable as well, generating disruption and adopting the same language and strategies as counterculture. Artists and hackers can respond by appropriating the concept of disruption in the business framework (2013: 63-64). It seems that disruptive innovation is here and there, in the arts and in economy and vice versa.

It should be noted though that because we live in the reality of the intertwinement and hybridization of different fields' (and an increasing filling of the in-between spaces), art also constantly follows the changes in the non-artistic reality with a special interest in the following characteristics of the politics, technoscience, and algorithmic trading based economy:

- Evaluation and revaluation processes in the stock market, value games;
- New procedures and devices of financial markets trading;
- Rituals of political gatherings and manifestations of the postpolitical, flashmobbing, activism;
- Events in temples, stadiums, public spaces, networks, non-places, airports, terminals;
- Biopolitical research of bodies and life and their appropriation;
- Discoveries of technoscience and their applications.

The new media based installations and performances as the key modality of service of art in the present require special technology (hardware and software); thus let us first draw attention to that type of technology which is deployed in such an art and enables its authentic experience in its conceptual

phase. This is the so-called second technology (mentioned yet at our reference to *Transborder Immigrant Tool* by the EDT Group) introduced and discussed in the theory of Walter Benjamin. The works of new media art and e-literature in its post-hypertext phase are auto-reflective and they establish a dry run for playing with different modifications of both art and technology. The technology applied in techno art (e.g. electronic, digital, postdigital, and postinternet art) and techno textuality to some degree 'dissect' art, compelling it to self-reflect and demonstrate its intrinsic surplus. It has to show that something "extra" in order to be considered different from the technology deployed in (usually commercial) applications in other fields. Rather than being hidden as in the previous modes of art, new media art deploys technology that is shown within its projects. The perfectionist use of technology is otherwise the domain of global corporations with huge capital allowing them to invest heavily in engineering (such as the companies *Pixar* and *Industrial Light and Magic* when it comes to special effects in Hollywood blockbusters). On the other hand, art provokes technology into assuming new roles which deconstruct its primary functions. This puts technology in a role that demonstrates the possibility of different functioning, as well as revealing its dark sides, "das unheimliche" (the uncanny) of technology itself. In the field of net art the issue of glitch, noise, and malfunctioning of high-tech was addressed by Jodi's seminal project *OSS*.

TOWARD PERFORMATIVE AND PLAYFUL CONCEPT OF SECOND TECHNOLOGY

The nature of technology applied – i.e., the technology entering and revealed within new media art and electronic literature – makes us consider broader issues raised within the context of the philosophy of technology. In order to understand the nature of the contemporary technology, we shall refer to the role of technology as discussed in the works of Walter Benjamin, who examined the issues of the loss of experience in the period of information media and perceptual shocks informed by modern urbanization, transport, and work on an assembly line. In a series of essays, Benjamin explored the nature of modern technology and attributed it a similar role as his contemporary Heidegger, who in the essay *The Question Concerning Technology* (1950) made a distinction between the instrumental use of technology and the

After the End of Art

essence of technology (as to the revealing, episteme and alethea – i.e., the fundamental and fatal matters of human existence).

In his works published around the time of Heidegger's essay, Benjamin also introduced a contrast between two concepts of technology. He addressed a first technology on the one hand, which is intended to – put simply – dominate nature; a paradigm illustrated by Heidegger with the functioning of the hydroelectric plant on the Rhine River (Heidegger, 1977, p. 334). By contrast, the second technology anticipates reconciliation between the individual, nature and the cosmos, an actual "interplay" between these two correlates. Benjamin articulated his view of a second technology which is – as already argued in the case of cinema in his essay on artwork – therapeutic in the text *To the Planetarium*, published in *One-Way Street* (Ger. *Einbahnstrasse*):

In technology, a physis is being organized through which mankind's contact with the cosmos takes a new and different form from that which it had in nations and families. One need recall only the experience of velocities by virtue of which mankind is now preparing to embark on incalculable journeys into the interior of time, to encounter there rhythms from which the sick shall draw strength as they did earlier on high mountains or on the shores of southern seas. The "Lunaparks" are a prefiguration of sanatoria. (p. 147)

Technology is not considered a means to control or dominate nature, rather takes a significantly less aggressive role of a mediator and play. In several texts, Benjamin sees the origin of the second technology in play, determines its role as an interplay between nature and humankind, and critically opposes the form of play of the second technology to the National Socialist principle of blood and soil (Ger. Blut und Boden). The second technology opens playful and ecological possibilities of cohabitation and alternatives to the dominating model of technological industrialization and fascist aestheticization of technology. To understand technology, Benjamin refers to the experience of speed (the fascination with speed can already be observed in Italian Futurism as well as some other art and literature experimenters from Burroughs to Ballard) by virtue of which mankind is preparing to embark on therapeutic journeys into the interior of time to encounter healing rhythms. The conclusion of these futurist hypotheses are the "Lunaparks" as a prefiguration of sanatoria by which Benjamin anticipated the reality of the experience society (the concept of Ger. "Erlebnisgesellschaft" introduced by Gerhard Schulze) from the late 20th and early 21st century with the emergent trend of theme parks including a series of attractions headed by a roller coaster as the archetype of a vertigo

After the End of Art

game (the modality of vertigo games classified by Roger Caillois in his book *Man, Play and Games* under ilinx). Today, the ride (fast, accelerated, arranged in a compressed time) seems to have become a model for striking arrangement of cultural content (Strehovec, 2014).

Benjamin even attributed the field of contemporary, in particular technology-supported, art a therapeutic quality which brings him close to Heidegger's views on the role of art in understanding the essence of technology in his aforementioned essay – i.e., art is the medium through which the essence of technology torn between threat and saving power is revealed in its enframing (Ger. Gestell) mode. Benjamin mainly refers to film addressed in his *Work of Art* essay: "Film is the art form corresponding to the increased threat to life that faces people today. Humanity's need to expose itself to shock effects represents an adaptation to the dangers threatening it. Film corresponds to profound changes in the apparatus of apperception – changes that are experienced on the scale of private existence by each passerby in the big-city traffic, and on a historical scale by every present-day citizen." (1938-40, p. 281, n.42)

Illustrative of both its dark and bright sides in the sense of something essential to the individual, Benjamin's differentiation between the first and the second technology points to the question whether such dichotomy, between the two modes of technology, can further be applied to the differentiation between, say, the first experience and that which is fundamentally different and called the second experience by a technical term. In Benjamin's essays on Baudelaire and in his writings on Parisian arcades, the first experience is a historical experience subject to atrophy and constantly threatened by transport, urbanism, new technologies, military structure, and industrial labor, whereas the second would assume a connection with the second technology (a very broad field which also includes Benjamin's concept of collective innervation) and therefore recognized as being on the rise with the emergence of new technologies and having a therapeutic function (similar to Benjamin's Lunaparks and films). And similar to the second technology, we could argue that new media art and e-literature allow such experience to form and be played with. In a certain respect, it has the function of a laboratory.

Benjamin didn't actually write about the second experience; therefore it can only be discussed as an alternative view, following the analogy of those new media art projects' specifics which evade abstractness and decontextualization, and were questioned by Benjamin in his essay *The Storyteller* (1936) and Lyotard's *The Inhuman: Reflections on Time* (1991) in relation to the information culture. Promoted by the challenges of the second technology, the second experience should put to the fore play and playfulness, the individual's

After the End of Art

non-confrontational relation with nature and the cosmos, her corporeality, rich perception as well as motor and proprioceptive arrangements (also in the sense of the aforementioned collective innervation). The body-interface becomes essential for the new experience of objects, processes, time and space, motion and concepts. An interface (Johnson 1997; Galloway 2013) is a filter allowing us to see more sharply those things that otherwise escape our attention, as well as those that we normally – without interface – don't even see; it brings them closer and allows us to see them in a different light, thereby pointing to their hidden and dark side.

In addition, the new media technologies render possible the individual's remote presence – i.e. to "be there" through avatars and robots. With a user being placed in a non-natural, information environment formed by a series of artificial stimuli, they also allow immersion effects. Through interfaces we also encounter immaterial objects in a new, not yet experienced way; for example, the emergence of the digital tactile (Strehovec, 2013, p. 153). The proprioceptive and tactile sense of a performer are re-addressed through on-screen communication with the virtual images of dancers who might in real time be several thousand kilometers away and invite her to dance. It is an experience shaped through encounters with the entities which are either virtual or hybrid, similar to software or in a screen mode, and still stimulate the user to engage a choreography of movements in a manner different from that of a physically close dancer (for example the movement of the Wii video games users).

The immersion into the medium and the experience of immaterial content in a form of game and a ride is also essential for this experience (Strehovec, 2016). The new media introduce us to the augmented reality combining physical reality and virtual realities which are evermore intertwined. An individual's fluid participation in different realities is a condition for her functioning in the present time. Hence the second experience is discussed as an extension of a physical experience in the era of new media and technologies, and as such confronted with the diminishing (and threatened) experience attributable by Benjamin to the shocking effects of technology and information. Consequently, the second experience is a positive mode of experience, though it's not our intention to simplistically and forcefully relate it to Benjamin's experience of the therapeutic technology from his afore-mentioned text *To the Planetarium*, in which technology is viewed as a medium that allows humankind to establish a contact with the cosmos which actually assigns technology a genuine eschatological role.

The second experience is also the modality of experience that opens up to the works of the conceptual electronic literature and new media art, i.e., the project's playfulness in the sense of Gadamer's philosophical views of the play. According to him, the essence of play is the "to-and-fro movement which is not tied to any goal which would bring it to an end; rather it renews itself in constant repetition" (p. 99). The emphasis is put on the "to-and-fro movement", a repetitive movement, often articulated as a loop which is constantly renewing and thereby generating a particular intensity. In to-and-fro movement, one always returns to, as do the authors of new media art and e-literature whose every project is an attempt to redefine new media art and e-literature and invent new modifications.

CONCLUSION

The thesis of the flexible connections of the fields that contemporary art enters with a noticeable and anything but subordinate role can be used to argue that by emphasizing knowledge, software, code, attention economy, attractive visualization, storytelling, creative and knowledge industries we agree to the current status quo (unified, one-dimensional world without alternatives) and deny art its critical potential. Due to common denominators with other fields, the (globalized, economized, dematerialized) art should be integrated in the neoliberal mainstream. Fully aware of this risk, we mentioned in the opening section of this chapter the projects of drone and activist art directed to the ethical issues and helping people, which means that the placement of art in the principal flows and fields of today's reality, as well as its new media and technology basis can be used for extensive interventions in other fields - e.g., interventions that exceed its role within artistic specificity. To put it simply – new media and post-internet art move to fields outside of art, they abandon the canon, aesthetics, and institution of art. It is the common ground with other fields and extreme flexibility that allow for a more efficient politicization, socialization, and a critical reaction in public. Fluent activity in new spaces and hybrid fields allows art better operability within the non-artistic reality.

Contemporary art consequently resists abstraction (the phenomena of mass ornament by Kracauer), the abstract language of information; it searches for corporeality beyond abstract relations (poetry delivers the wealth of language, its ambivalence); performance art performs a therapeutic and preventive role, as well as settles accounts with politics that substantiates and justifies

After the End of Art

such capitalism which is demonstrated by a number of activist and hacktivist projects. Art acts from within, assuming the procedures of financial companies (because *they* assume art procedures), looks for holes in the system (net art practice), causes insecurity and disruptions in the system (e.g. hactivists' interventions), employs glitch and noise.

The possibility of resisting the abstract nature of finance capitalism was noted by Franco Berardi in his work *The Uprising: On Poetry and Finance.* "Poetry is language's excess: poetry is what cannot be reduced to information in language, what is not exchangeable, what gives way to a new common ground of understanding, of shared meaning—the creation of a new world." (2012). It is not just the linguistic medium of poetry to resist the mainstream language of (finance) capitalism. No less anti-abstract is the language of body deployed in the contemporary, first and foremost feminist performance as an eminent postaesthetic art which foregrounds the ugly and vulnerable.

REFERENCES

Adorno, T. W. (1997). *Aesthetic Theory* (R. Hullot-Kentor, Trans.). Minneapolis: University of Minnesota Press.

Arns, I., & Sasse, S. (2005). Subversive Affirmation. On Mimesis as Strategy of Resistance. In East Art Map. Irwin.

Barbrook, R., & Cameron, A. (1995). *The Californian ideology*. Retrieved January 19, 2019, from https://www.researchgate.net/publication/249004663_ The_Californian_Ideology

Bazzichelli, T. (2013). *Networked Disruptions. Rethinking Oppositions in Art, Hacktivism and the Business of Social Networking*. Aarhus: Digital Aesthetics Research Centre Press.

Belting, H. (1994). *Likeness and Presence: A History of the Image Before the Era of Art*. Chicago, IL: The University of Chicago Press.

Benjamin, W. (1969). The Work of Art in the Age of Mechanical Reproduction (H. Zohn, Trans.). In ArendtH. (Ed.), *Illuminations* (pp. 217–251). New York: Schocken Books.

Benjamin, W. (1972). Zum Planetarium. In *Gesammelte Schriften, IV* (pp. 146–148). Frankfurt am Main: Suhrkamp.

After the End of Art

Berardi, F. B. (2012). The Uprising: On Poetry And Finance. Los Angeles: Semiotext(e).

Danto, A. C. (1995). *After the End of Art. Contemporary Art and the Pale of History*. Princeton, NJ: Princeton University Press.

Davies-Ctook, S. (2013). Remote-controlled vehicles now spy, kill and film porn in secret. So what are artists doing about it. *Dazed*. Retrieved February 1, 2019, from https://www.dazeddigital.com/artsandculture/article/16183/1/art-in-the-drone-age

Deleuze, G. (1993). *The Fold: Leibniz and the Baroque* (T. Conley, Trans.). Minneapolis: University of Minnesota Press.

Ekman, U. (Ed.). (2013). Throughout. Art and Culture Emerging with Ubiquitous Computing. Cambridge, MA: The MIT Press.

Electronic Disturbance Theatre. (2015). The Transborder Immigrant Tool/La herramienta transfronteriza para inmigrantes. *CTheory.net*. Retrieved February 14, 2019, from http://www.ctheory.net/articles.aspx?id=744#bio

Fischer-Lichte, E. (2004). Ästhetik des Performativen. Frankfurt: Suhrkamp.

Foucault, M. (1986). Of other spaces. *Diacritics*, *16*(1), 22–27.

Gadamer, H. G. (1975). *Truth and Method*. New York: Seabury Press.

Galloway, A. R. (2013). *The Interface Effect*. Cambridge, MA: Polity Press.

Goldhaber, M. H. (1997, April). The Attention Economy and the Net. *First Monday*, *2*(4), 7. https://firstmonday.org/article/view/519/440

Goldsmith, K. (2016). Post-Internet Poetry Comes of Age. *The New Yorker*. Retrieved January 13, 2020, from https://www.newyorker.com/books/page-turner/post-internet-poetry-comes-of-age

Hansen, M. B. (1999, Winter). Benjamin and Cinema: Not a One-Way Street. *Critical Inquiry*, *25*(2), 306–343. doi:10.1086/448922

Haug, W. F. (1971). Kritik der Warenästhetik. Frankfurt: Suhrkamp.

Hegel, G. W. F. H. (1975). *Aesthetics* (T. Knox, Trans.). Oxford University Press.

Heidegger, M. (1975). The Origin of Work of Art. In *Poetry, Language, Thought* (pp. 15–87). New York: Harper & Row Publishers.

After the End of Art

Ingarden, R. (1973). *The Literary Work of Art* (G. G. Grabowic, Trans.). Evanston, IL: Northwestern University Press.

Johnson, S. (1997). *Interface Culture*. New York: HarperCollins.

Kaprow, A. (1993). Essays on the Blurring of Art and Life (J. Kelly, Ed.). Berkeley, CA: U. of California Press.

Kholeif, O. (2018). *You are Here. Art After the Internet.* Manchester: Cornerhouse & SPACE.

Klein, N. (2009). *No Logo*. London: Macmillan.

Kracauer, S. (1995). The Mass Ornament. In T. Y. Levin (Ed. & Trans.), Weimar Essays. Cambridge: Press.

Lanham, R. A. (2006). *The Economics of Attention, Style and Substance in the Age of Information*. Chicago: U. of Chicago Press. Retrieved February 19, 2019 from https://www.press.uchicago.edu/Misc/Chicago/468828.html

Medosch, A. (2005). *Technological Determinism in Media Art.* Retrieved February 19, 2019, from http://archive.thenextlayer.org/files/TechnoDeterminismAM_0/index.pdf

Mouffe, C. (2007). Artistic Activism and Agonistic Spaces. *Art & Research, 12,* 1-5.

NotABugSplat. (n.d.). Retrieved February 19, 2019, from http://notabugsplat.com

Puncer, M. (2018). *Medprostori umetnosti* [Interspaces of art]. Ljubljana: *Sophia*.

Stark, D., & Paravel, V. (2008). PowerPoint in Public: Digital Technologies and the New Morphology of Demonstration. *Theory, Culture & Society, 25*(5), 30–55. doi:10.1177/0263276408095215

Strehovec, J. (2012). Derivate writing: e-literature in the world of new social and economic paradigms. In S. Biggs (Ed.), *Electronic literature as a model of remediating the social creativity and innovation in practice* (pp. 79–83). Edinburgh: University of Edinburgh.

Strehovec, J. (2016). Text as Ride. Morgantown: Literary Computing, VW University Press.

After the End of Art

Virno, P. (2004). *A Grammar of the Multitude. For an Analysis of Contemporary Forms of Life* (I. Bertoletti, Trans.). New York: Semiotext(e).

Welsch, W. (1996). *Grenzgänge der Ästhetik* [Limits of aesthetics]. Stuttgart: Reclam.

ENDNOTE

[1] We refer to the essay written by Richard Barbrook and Andy Cameron on a compact social paradigm when high-tech entrepreneurship connects with the ideology of the counterculture avant-garde and new sensibility.

Chapter 3
Living in the Art–Like Reality:
Trading in Derivatives vs. Derivative Writing

ABSTRACT

This chapter aims to address the artification of financial markets and politics in a way of researching art-like procedures in both areas. The events and processes on financial markets resemble art in the sense of unpredictability, disruption, and flexibility; in this, art does not turn out to be an area that would be endangered or even destroyed by neoliberal capitalism; on the contrary, it also applies capitalist logic, in particular when it comes to accumulation, ideology of growth, and the surplus-value making. Art is a machine that consumes and totalizes all available components. There is nothing that could not enter into its drive. Contemporary activist art can also act as an explicit political force. It develops devices to achieve political goals, thereby completely abolishing artistic and aesthetic functions.

INTRODUCTION

In contemporary art, the artistic autonomy gives way to interactions between the contemporary art and various fields of non-artistic reality. There is an intense two-way traffic between art on the one hand and politics, economy, science, lifestyle, popular culture, social media, and the science on the other. Art is being politicized, economized, mediatized, commercialized, however,

DOI: 10.4018/978-1-7998-3835-7.ch003

Copyright © 2020, IGI Global. Copying or distributing in print or electronic forms without written permission of IGI Global is prohibited.

on the other hand, politics, economics, and media are becoming art-like, which means that either they accept artistic procedures, techniques, tools, and strategies, or they themselves produce similar *zeitgeist* shaped tools. Especially when it comes to cognitive labor in knowledge society the differences between artists and non-artists are increasingly being erased. Both artists and non-artists function in a world of unpredictability and risk, all trying to be creative, often using the same tools and producing new ideas. In doing so, they are limited by precarity which requires considerable flexibility and is also a 'companion' of workers in creative industries. In spite of problems, which mainly accompany deprivileged artists and art theoreticians, critics, and curators (postcolonialism, machismo, academic fascism), art even plays a pioneering role, as it generates procedures that can later be applied in other fields.

Contemporary art is defined by a strong tendency towards conceptuality; such tendencies, which presuppose the dematerialization of an object, also accompany the economy of financial markets which is connected to contemporary art with branding and trading in derivatives, while also being marked by extended accumulation and new production modality. Following the example of Beuys' expanded concept of art, we can talk about the expanded concept of economy as well as the expanded concept of politics. In both areas, we also encounter disruptive innovation (Bazzicheli, 2013).

For a greater part of the 20th century the political engagement of art had a bad reputation (for example, Soviet socialist realism and German "Nazi-Kunst"), because it was understood as propaganda art which tried to elevate and popularize the ideas of the political mainstream within its medium. On July 19, 1937, Degenerative art exhibition with more than 650 pieces of modernist and avant-garde art intended for ridicule was not the only one seen in Munich, as a few weeks later in the Haus der Deutschen Kunst (Museum of German Art) the Grosse deutsche Kunstaustellung (Great German Art Exhibition) opened, presenting an exhibition of works by artists favoured by the German National Socialist state whose works were intended to glorify the German race and corresponded to the criterion of blood and soil. In the Soviet Union, as a socialist superpower during the two world wars, a special art was considered as the state representative, namely the socialist realism. The books of certain writers of this movement were mandatory reading for loyal citizens. Both Nazi-Kunst and socialist realism were therefore in bad books of the art theory and criticism after World War II. Only with contemporary art and its institutions (curators, theorists, museums) was there a paradigm shift in the sense that also the art that is functioning politically started to be

Living in the Art-Like Reality

regarded as a relevant part of contemporary art and its development in the direction of social interventions was even encouraged.

It is essential to realize that art intervening in the broader social reality is not one, but that we are rather contemporaries of a noticeable turn in this very art, which encompasses everything from utopian projects and related movements to purely political art, committed to exclusively social, humanitarian, and political goals. As an example of the previous, the utopian artistic orientation, let us mention the Joseph Beuys' concept of social sculpture, as the examples of the latter, include projects that are explicitly political and only slightly visionary, intervening in an extra-artistic reality in a way that has little to do with art (e.g., the Electronic Disturbance Theater and The Yes Men). Both artistic orientations coincide with two fundamentally different social contexts; the first corresponds to May 68 and the manifestation of new sensibility in terms of a political and liberating factor (from the hippie movement to counter-culture), while the other corresponds with the Occupy Wall Street movement and the rise of neoliberal capitalism, as well as nationalist right-wing movements in Europe and the United States.

Table 1. The new social movements and their artistic responses

Social Movements, Cultural and Technological Paradigms and Events	Artistic Responses and Projects
May 1968, counter-culture, New left, student movement, Situationists	Society as Work of Art, Social Sculpture, Expanded concept of Art, Lifelike Art, Neo-avant-garde of 1960s and 1970s
Cyberpunk of 1980s and 1990s, Californian ideology, technoculture, World Wide Web, Virtual Reality	Cyberpunk films and literature, by technodeterminism shaped utopia, netart, technoplatonism, technoescapism
September 11, War on terror, algorithmic culture, Cloud computing, Blockchain technology, conceptual financial instruments	Occupy Wall Street movement, activism, hactivism, artistic dystopia, stock exchange as topic of art, conceptual art projects

In this chapter, we will therefore pay attention to the transition of activist art from the utopian projects of the society as a work of art into its present phase which involves serious political engagement and the abandonment of romantic attempts to transfer artistic sensitivity to extra-artistic reality. Projects such as social sculpture, temporary autonomous zones (Hakim Bey) and "Gesamtkunstwerk" (Eng. total work of art) were accompanied by explicit confidence of artists in the liberating and creative power of art (e.g. Neue slowenische Kunst), the peculiarities of which it was sensible to use

as building blocks of a new social, transnational reality, while the projects of the Critical Art Ensemble, Electronic Disturbance Theater, Anonymous, Janez Janša group and The Yes Men are much more explicitly political (and at the same time effective), and on the other hand also somewhat artistic and visionary.

The techniques, devices and processes used by art activism are effective and mobilizing; they encourage a large part of the public to think and decide, which is otherwise not reached by professional politics with its convencional strategies, media and tools. It would make sense for official politics to pay more attention to them, and it is also time for political science to include them in its research. Art activism is in the present namely still mostly interesting to the institution of art and the media. Systematically organised and transparent documentation on activist events is first and foremost kept by art archives, and not by archives of media, political, and scientific organisations.

ARTISTIC DEVICES AND CONCEPTS PERVADE EXTRA-ARTISTIC REALITY

Theories of modern art have defined artistic autonomy in the sense that aesthetic art has its own specificity which differs substantially from the special features of science, politics, media, popular culture, and everyday life. Among these theories, neo-Kantian aesthetics and phenomenological aesthetics were particularly far-reaching. The phenomenological aesthetics emphasized that art derealizes (the concept of "Entwirklichung" by Nicolai Hartmann), neutralizes, abstracts, introduces things into the modality of the unreal and play; it is the silence of the world, in it, the purification of the effects of a given reality toward the as-if reality (Geiger, 1986) comes to the fore. It seemed that the infinite lightness of being was the true companion of art that is bound to the world of opened opportunities. This means that we have to deal with phenomena that are liberated from the lead weight of a given, physical, "dirty" reality.

Today, it seems that these views are giving way to those which emphasize the much more active role of contemporary art which now interferes with the state of things, forms, links itself with the media, economy, science, and politics (activism). This change is related to the new social position of art in times of new media, algorithms (including algorithmic culture, identity and high-frequency algorithmic trading), derivatives and neoliberal capitalism.

Living in the Art-Like Reality

The latter also includes in its sphere of interest the contents from the worlds of entertainment industry (including affective labor), art, mass culture, and leisure activities.

In this respect, it is essential that processes which are typical for art, involving disruptions, interruptions and juxstapositings, today do not act as something negative but are, on the contrary, fully integrated into the logic of business and finance. Risk and uncertainty are characteristic of both art and financial capitalism. "Transgression is normative". (Shaviro, 2015, p. 71) Popular culture also incorporates critical processes and tools of art into its own drive and, with this very inclusion (for example, Hollywood blockbusters), takes away their sharpness, characteristic of their functioning in the original, artistic context.

Common Characteristics of Digital Art, Culture, Science, Politics, and Networked Economy

- **Conceptual:** Self-reflection, intensification, extension of set borders, destabilization of applicative functions, repurposing;
- **Research:** Activities directed toward innovations, playing with daring hypotheses, reaching beyond the canons;
- **Attention economy:** Closely related to the presence of stars - e.g., in the media, culture, politics, sport, science, and art;
- **Code:** Internet is expanding to the Internet of things; software components are integrated in a growing number of objects and devices;
- **Storytelling:** Scientific inventions, cultural values, huge investments and political programs also need to be presented in a narrative form;
- **Visualization:** Attractive 3-D illustration of scientific findings, cultural contents, innovations, discoveries;
- **Creativity:** Expanded concept of creativity (beyond the artist-genius and scientist-inventor) deployed in creative and knowledge industries, DIY practices, and media culture;
- **Connectivity:** All things, devices, business, skills, and fields are connecting, which results in the new, networked economy, the Internet of things, as well as networked culture, based on social networking, politics, and art;
- **Knowledge:** Things that count today are involved in production, reproduction, sharing, and dissemination of knowledge as a drive of knowledge society;

- **Openness and Freedom:** Blurring the boundaries not only in the field of art and culture, but also in mass media, science, the entertainment industry, social networks, and economy; emancipation of the signifier from its referential role in literature and art; emancipation of money as a financial signifier from the artefacts in industrial production;
- **Performance:** Along with performers in the performance art and performing arts, scientists (while delivering a presentation) and politicians (while campaigning, giving interviews) also act as performers.

Artists and hackers use disruptive techniques of networking in the social media and web-based services to generate new modalities for using technology, which, in some cases, are unpredictable and critical; business enterprises apply disruption as a form of innovation to create new markets and network values, which are also often unpredictable. Disruption therefore becomes a two-way strategy in networking contexts: a practice for generating criticism and a methodology for creating business innovation. (Bazzichelli, p. 12)

The author of this notion draws attention to the interaction of various agents and the coexistence of opposites and disorders in different, sometimes irreconcilably opposite areas, which also leads to a paradoxical situation where those who criticize the economic system (trying to sabotage the neoliberal capitalism) contribute to its propagation and flourishing, as they are, in fact, business innovators. Whereas the contemporary, post-aesthetic art is also behaving like neoliberal capitalism, the capitalism (especially that of financial markets) behaves as art. The worlds of material and immaterial goods and transactions are visualized, archived, involved in the global spectacle. Industrial artefacts (for example, cars with innovative designs) strive for entry into museums, creativity in all areas is entering the networked economy linked to social media. Innovation in the fields of media and science imply a fictional surplus and the imaginary. Alongside them, stories are made.

Today, the key scientific discoveries above all generate stories that help to increase their exchange value. Such are the stories that were created around the cloned female domestic sheep Dolly (July 5, 1996 – February 14, 2003), the black holes in outer space, and the discoveries of the Higgs boson (in the Cern research center). In April 10, 2019, a great story was written about the first image of black hole as an object in space with incredible mass packed into a very small area. All that mass creates such a huge gravitational tug

Living in the Art-Like Reality

that nothing can escape a black hole, including light. Scientists "uncovered part of the universe that was off-limits to us" (Doeleman, 2019).

Advanced computer science has undoubtedly benefited from the cultural movement of cyberpunk in order to enter the consciousness of the broad audience Gibson's and Sterling's novels and Sci-Fi blockbusters have popularized new technologies. This quote relating to cyberspace from the *Neuromancer* has been useful also in non-fiction for decades: "Cyberspace. A consensual hallucination experienced daily by billions of legitimate operators, in every nation, by children being taught mathematical concepts. A graphical representation of data abstracted from the banks of every computer in the human system. Unthinkable complexity. Lines of light ranged in the non-space of the mind, clusters and constellations of data". (Gibson, 1989, p. 128) It looks like that connecting high-tech, new sensibility, and techno-imaginary nowadays goes hand-in-hand. The black holes astrophisics, theory of chaos (fractal geometry of nature), nanotechnology, and genetics also require promotion in the form of stories and visualizations.

Knowledge, innovation and creativity, formerly characteristic primarily for Promethean art, are becoming the core of many (extra-artistic) spheres, and alongside them new narrative modalities are formed that accompany today's innovations. It is not enough to produce a product, it is necessary to sell a story about its groundbreaking appearance and function, which means that the product is well-marketed only at the moment when it is sold in a package which also includes a story about it. This revolution into the world of technologies and business comes hand in hand with contemporary art which is becoming distinctively performative and conceptual, abandoning the production of a stable "Kunstwerk". Instead of an artefact, we encounter a dematerialized, performative service, which performative features are discussed in Virno's theory on postpolitics and immaterial labor.

It should also be noted that the current popular culture (bestsellers, high-budget movies, TV series, popular music, music videos, attractions in theme parks, musicals, snapchat photographs) applies a number of procedures developed in the so-called high, elite art, while its content influences the various movements and forms of contemporary art. The Futurist *'parole in liberta'* are encountered in various screen based popular media, the authors of which focus not only on the informative function of digital texts, but also on their visual appearance. They consider text as a film (for example, center-framed tweet). When generating suspense, they use parallel editing, defamiliarization, juxtapositing, interruption, spots of indeterminacy (Ingarden, 1973), and gaps (Iser, 2006). Social media practice is also influenced by the achievements

Living in the Art-Like Reality

of artistic avant-garde and especially net art, which can be seen in hybrid practices that we encounter in tweets, selfies, stories as applications, and blogs.

Contemporary art is linked to the economy of financial markets and business by many common features, which are not exhausted by only using similar tools, disruptive innovation and creativity. Among the common features of both fields, we should mention in particular the risk and uncertainty that accompany both artistic worlds and movements as well as financial markets, where we are also contemporaries of the dematerialization of artefacts and the transition to the phase of conceptuality of the field, and of its "end". Also, the stock market paradigm functions in both areas, especially when it comes to derivatives, i.e. trading which refers to "underlying" and the tendency to insure against uncertainty (hedge).

Many areas of capitalism (e.g., financial capitalism) function similarly to art: they abstract from material bases and bring spectacular images/figures into its drive. Today, we are becoming the contemporaries of a significant transformation of an industrial economy based on material production into an economy of knowledge, cognitive labor, services, and finances. The latter is a far more abstract and conceptual economy, where the production and exchange of material commodities is replaced by a series of new financial instruments, including derivatives; more than with stable artefacts, we encounter the unstable immaterial items, concepts, ideas, and code. The financialized economy is a self-feeding machine, driving more and more abstractly is situated in algorithmic culture, where the stress is laid on pure instrumental operations of high-frequency algorithmic trading, where algorithms are used "to execute orders faster than human perception and seem to interact in quite unpredictable ways« (Lange, 2016, p. 102) In drawing attention to paradigm shift toward the abstract and conceptual, let us point out that those involved in the analysis of contemporary culture and art are no strangers to the above. If there is any field that is constantly subject to destabilization, volatility, introduction of the new, hybridization, mixing and remixing, the promotion of (surplus) value and the rapid decline of particular trends (and values), it is contemporary art, in which the object's dematerialisation plays a similar role to that played in the field of the economy, by the transition from a (material) production economy to an economy of (far more abstract) financial products, marketing, and services.

However, contemporary art did not just passively follow the changes shaped by social and economic shifts in 20th century but accomplished a pioneering work itself. Just think of Marcel Duchamp and his ready-mades (as everyday objects that are displayed as artworks in a museum), that drew

Living in the Art-Like Reality

attention to the relevance of the author-brand (as a potential logo) in the field of contemporary art (and the marketing with signs), as well as the broader effects of the institution of art as the one having the mechanisms to promote the exchange-value of certain products and push others to the margins and beyond. That artistic context, and its formation through branding, allows an ordinary object manufactured for a specific use to enter a completely new and different life; this was Duchamp's message with his 1917 project, *Fountain*.

Flexibility in the field of contemporary art finds it easy to follow the dynamics of the network-supported economy of financial markets, where new financial products and instruments bring dynamics into the spectacle of the global, 24-hour market. This market can be considered as a Debordian spectacle in which the relationship between numbers is mediated by the images. Due to the fact that - at least in the short-term - financial markets allow significantly faster and larger profits, they generate new instruments that attract buyers and speculators. Hedge funds and derivatives (options, futures, forward contracts, swaps, warrants) have a special place and bring a new quality to said markets. This is particularly true for trading in derivatives, the price of which depends on the underlying asset (commodities, currencies, stocks, and securities), reference rate or index they refer to. The investors deploy derivatives to increase, speculate or hedge their portfolios. A derivative investment does not presuppose the ownership of underlying asset, but the bet on the asset's price movement in the limited future determined by contract. Surplus-value is generated by the play with the contractual timing of more and more sophisticated transactions, executed by the decisions of an algorithm. There are situations when hedge brokers try to reduce the risk whilst speculators increase it in order to maximise their profits. An investor can buy a put option on a stock she owns to protect against the possibility the stock's value will fall.

The lack of grounding in the stable foundation of an underlying asset (including national banks and stock exchanges) accompanies the today's trading with crypto currencies like Bitcoin and Ethereum that run on speculative energy. Dealing with such conceptual and speculative instruments presupposes our entry in the world without reference in stable assets of known, experienced value. This is the world of pure uncertainty that run on speculative bet on the future.

In the contemporary art crowded with media based and conceptual art projects the social role of the artists can be understood in terms of speculative investments either. With some works of contemporary and, in particular, new media art one can notice that artists also focus on the "artistic underlying asset"

Living in the Art-Like Reality

and refer to it in order to secure their interests and even make a profit. They produce artistic derivatives in the sense that they refer to the indisputable value of the underlying reference work (taken from the high-valued and canonical artistic and literary tradition), which indirectly - through its "branding surplus-value" - also guarantees the branding of their derivatives. Let us mention the Slovenian new media artist Marko Peljhan, who, in collaboration with Carsten Nikolai and Canon Artlab, created the *Polar* project (2000), thus entering into a creative dialogue with Stanislaw Lem's novel *Solaris* (1961). Despite being rooted in a significantly transformed world of the information society and new narratives, *Polar* strives to establish links with the unquestionably recognised *Solaris*, which functions here as an underlying artistic asset. Also performance artist Maja Smrekar (The Golden Nica winner at Ars electronica festival 2017) refers in her project *I hunt nature and culture hunts me* (2014) to Joseph Beuys performance *I like Amerika and America likes me* (1974). The commonalities between projects are not just in the names of both pieces (in fact, Smrekar's is a paraphrasis of Beuys's), but refers also to the content of both performances.

The hedgers (brokers of hedge funds) speculate (in order to secure their investments) and so do artists; they keep counting on the spectator, reader or listener who is not here yet but who will add surplus-value to their product in the future. They bet on the future, they live by and in their insecurity, they speculate and bet on it; they are convinced that the course of future events will add surplus-value to their work. Their virtual option contract refers to some point in the future; they reckon the situation in the market or art scene will change toward their interest. They make artworks oriented to the new and at the same time their basic intention refers to the institution of art, to its "approved" works (applied as quote, remake, remix), which gives them a certain amount of security. We are entering into the world of art-making in terms of far-reaching investment. For example, Natalie Bookchin's art project *The Intruder* (1998-1999) produced in the instant and insecure media of artistic video games, establishes a reference to Borges' novel *La Intrusa* in order to provide added-value to an uncertain, new media work (a so-called "mod", e.g.: art derivative of a commercial video game).

Bookchin's project can be explained with the theoretical apparatus of electronic literature as an insecure field of text-based digital installations (Strehovec, 2016), which extends beyond hyperfiction towards different genres (from video games to performance) positioned at the intersections of e-literature and new media art. In this domain we are contemporaries of different e-writers' strategies for drawing attention to their work and inventing

Living in the Art-Like Reality

their own economies. Many of them decide, for example, to engage writing and programming in the sense that they refer to the indisputable value of the underlying reference work, generated by a well-known artist. Here we can mention several authors, from Simon Biggs and Neil Hennessy to Alison Clifford and J. R. Carpenter, whose e-literary pieces relate to famous predecessors' texts taken from the world of literature-as-we-know it. Simon Biggs' *The Great Wall of China* not only borrows Kafka's title, but appropriates the whole body of his text, taking the multiple individual building blocks that make up the story and feeding each word into a generative computer program that re-assembles them into new sentences.

BEYOND THE SOCIETY AS WORK OF ART

The decision of e-literature writers to write (and programme) texts that can be considered as to a certain extent analogous with derivatives on financial markets (due to their "underlying") and thus to some speculative and conceptual practice, is certainly not pejorative. Rather than being considered as imitation, such an activity reflects the very nature of an e-literary (and artistic) field that is full of uncertainty, in the sense that authors, once they begin creating such projects, always find themselves facing the unknown and searching for ways to secure their creative investments and highlight in them something that will attract the future readers and critics. Connecting to other works, in the form of "derivative writing" or "derivative artmaking", allows them to add value to their works, which often implies an entry into the valuable archives of literature and art, whose common denominator is a surplus in the field of creativity and innovation. Thus, derivative writing and artmaking presuppose creativity, which deploys such an underlying asset to help the author to enter the valorised archives of the art and e-literary world. The role of the artist and author looks like a role of the hedge fund broker who tries to minimize the risk of her financial instrument.

At a symbolic level, we can also draw parallels between the trading in warrants issued by corporations, and artist's links and contracts with the funding agencies and national ministries of culture. The latter allow grants and residencies to reduce the risk of an artist who finds herself in the sphere of art without the protection of large companies or patrons. It goes without saying that such an artist is bound to the set deadlines (which relate to the production of the project and reports on it), as if this would be about options on the forward market.

Living in the Art-Like Reality

In the sphere of politics, where art activists intervene, the situation is different because new devices are at play which are completely incompatible with (aesthetic) art, signifying the hallmarks of great changes in both stakeholders. The "artification" of politics that interests us in this chapter doesn't mean its aestheticization, it has nothing to do with design, a beautiful and attractive form, stimulation of the senses. It has nothing in common with spectacle, attractive images, visualisations, marketing of political ideas packaged in beautiful wrappers (conventions, rallies, parades, activities of The Beauty of Labor organisation known from German National Socialism). "Artification" of politics represents the use of specific artistic procedures for the achieving of explicit political goals. We are confronted with activism that is not directed at revolutionising of art institution (Peter Bürger's notion), it does not attack the latter (as was the case with the avant-garde art), it leaves it alone; the one thing this activism is directed against lies outside, in the everyday political reality. And it does not attack the latter with procedures inherent to (aesthetic) art, but rather with those developed by activist artists precisely in order to effectively change political reality. The present art activists are not interested in the society as a total work of art, they do not transfer the artistic procedures into the social, they are not interested in the aestheticisation of politics.

The focus on society as a work of art (this concept was developed by the sociologist Herbert Marcuse) was a visionary project of theoreticians and artists who did not understand themselves as activists or act and behave as such, but they nevertheless created revolutionary visions about the artistic transformation of (social) reality connected with the entry of art into the *'Lebenswelt'*. For sociologist Marcuse, it is a utopian project which presupposes a transition from Marx to Fourier and is based on the view that "the new Sensibility has become a political factor." (p.22), and on the understanding of "the aesthetic as the possible Form of a free society" (p. 38). Marcuse discovered the traces of new sensibility in non-artistic reality, for example in hippie rituals and in rebellion of May 1968, but he also linked the aesthetic dimension to art and its beautiful form. His notion of aesthetic marks the new quality of the creative process under the sky of freedom. In order for art to interfere with an extra-artistic reality a change in its fundamental function is required, which leads to its abolition in terms of an exclusive action in the aesthetic sphere, while at the same time this 'Aufhebung' does not merely mean the "end of the segregation of the aesthetic from the real, but also end of the commercial unification of business and beauty, exploitation and pleasure (p. 27)."

Marcuse's vision of a free society, formed with regard to sublime sensuality, imagination, artistic creativity, beauty and enjoyment, is incredibly optimistic,

Living in the Art-Like Reality

especially because it was formulated by a representative of the Frankfurt School, who was the author of *One-Dimensional Man*. A great effort to create an alternative organization of social life is also found in certain artists (from the neo-avantgard movement of the 1960s and 1970s), especially with in this chapter already mentioned Joseph Beuys (1921-1986), as Marcuse's contemporary, who expressed the vision of alternative social life made-to-measure for artistic creativity with the concept of social sculpture (Ger. Soziale Plastik) referring to society as a Wagnerian "Gesamtkunswerk", enabled by expanded concept of creativity performed by the individuals as artists.

The art that enters into such a revolutionary project is anthropological and not modern, its primary environment is the individual's workplace, not a museum or gallery. Beuys developed this vision (its origins can be found already in Schiller's *On the Aesthetic Education of Man in a Series of Letter*, 1983) in the 1960s and 1970s, when he was also socially engaged and worked as a lecturer and performer, thus paving the way for the idea of the expanded concept of art (Ger. Erweiterten Kunstbegriff). Let us mention his participation in the 5th *documenta* (1972) exhibition when he advocated direct democracy based on people's decision-making (Ger. Volksabstimmung).

The visions of theorists and artists (from that period, we should also mention Alan Kaprow with the concept of lifelike art, as well as the French Situationists) were upgraded in the later period, linked to the Internet culture and cyberpunk, by theorists and practitioners of hacking and engageing in new forms of network rebellion, including the Critical Art Ensemble with the text of the *Nomadic Power and Cultural Resistance*, Hakim Bey (Temporary Autonomous Zone, 1991), P2P Initiative and McKenzie Wark's *A Hacker Manifesto*.

Hakim Bey has striven for islands in the net and a free enclave, for places of freedom that escape the drive and control of the state of spectacle and simulation.

TAZ is like an uprising which does not engage directly with the State, a guerilla operation which liberates an area (of land, of time, of imagination) and then dissolves itself to re-form elsewhere/else when, *before* the State can crush it. Because the State is concerned primarily with Simulation rather than substance, the TAZ can "occupy" these areas clandestinely and carry on its festal purposes for quite a while in relative peace. Perhaps certain small TAZs have lasted whole lifetimes because they went unnoticed, like hillbilly enclaves–because they never intersected with the Spectacle, never appeared outside that real life which is invisible to the agents of Simulation. (Bey, 1991, n.p.)

Living in the Art-Like Reality

Much more stable and realistic than Bey's concept of free enclaves was the *Californian Ideology* project (Barbrook and Cameron, 1995), which links hippie sensitivity and imagination to yuppie entrepreneurship and trade in the Silicon Valley. In any case, these phenomena are also characterized by the vision full of utopias and techno-imagination, however, the aesthetic dimension and artistic creativity are replaced by intelligent machines, software, algorithms, and related stories, or there exist links between the two spheres (the example of Californian Ideology). Here, we should recall the early expectations about the revolutionary nature of the virtual reality (the document on the atmosphere regarding VR was Brett Leonard's film *The Lownmover Man*, 1992) which in the last instance implied society as a Virtual Reality, and scripts about the liberating role of the network, which led to techno-Platonism and techno-escapism. Although cyberpunk at the end of the 1980s and during the early 1990s did not refer to May 1968, it in many respects represented its revival, which was documented by the techno-utopias from that time. The Promethean artist was replaced by the character of a hacker.

Things began to change significantly after September 11, 2001, and the War on Terror. The Occupy Wall Street movement (September 17, 2011) brought the beginning of different times, full of dystopia and resignation, as well as completely rational forms of resistance. For artists, the slogan "We are the 99%" is by no means so inspiring at the level of imagination and artistic and aesthetic creativity as was the new sensibility of the hippie movement in May 1968, or the techno-imagination of the 1980s and 1990s encouraged by cyberpunk. The slogan mentioned implies deprivation, subordination, the awareness that we are manipulated, that the institutions of power which are delineating the individual's freedom act in a non-transparent manner. The Wall Street, with its nonstop trading rituals, is itself more aesthetic (in terms of sensual stimulation and spectacle of ups and downs) than the Ocuppy, which was the movement of rational demands based on the results of scientific analyses about social inequality.

Nevetheless, the Occupy movement also included artists, such as the performance by Zefrey Throwell entitled "Ocularpartion Wall Street" (August 1, 2011) which was actually the first event of the Occupy project. They answered the lack of transparency on Wall Street with the transparency of the undressed bodies of 49 performers who took part in this event.

Instead of a (global, transnational) concept of the society as a work of art, the targets of art activists in the beginning of the 21st century are much smaller, specialised, and narrow. Since the essential features of art have been appropriated by other areas, contemporary art needs to invent new tools,

66

Living in the Art-Like Reality

strategies and tactics, procedures and devices. One of its original directions is therefore activism (including hacktivism as a movement of artists who set the targets, while hackers prepare tools and attacks on them).

Art activism abandons visionary practice following the example of the society as a '*Gesamtkunstwerk*' and focuses on the visible, very profane political goals; in doing so, it uses procedures that have little artistic features (e.g. irony, stain, parody, paraphrasis, making strange, disruption, prank). In art activism, it is important to open up new political spaces and try to actualise and solve political issues during the post-political phase. Activists strive for antagonism in the clear space and for the expansion of the political into new spaces of the artistic public and civil society. This is a positive aspect of art activism, which Chantal Mouffe regards as:

Counter-hegemonic interventions whose objective is to occupy the public space in order to disrupt the smooth image that corporate capitalism is trying to spread, bringing to the fore its repressive character. Acknowledging the political dimension of such interventions supposes relinquishing the idea that to be political requires making a total break with the existing state of affairs in order to create something absolutely new. Today artists cannot pretend any more to constitute an avant-garde offering a radical critique, but this is not a reason to proclaim that their political role has ended. They still can play an important role in the hegemonic struggle by subverting the dominant hegemony and by contributing to the construction of new subjectivities. (p. 5)

There is an important emphasis here on the new subjectivities mobilised for the revival of the political in terms of the space of positions and counter-positions, as well as the antagonistic engagement realised beyond the technocratic politics linked to market economics. Namely, Mouffe is critical toward the post-political in terms of repression of antagonism, which links her with Rancier's criticism of post-democracy. What else is essential for art activism? The today's generation of activists and hacktivists exploit art mostly as an alibi which would help them if someone tried to persecute them politically and criminally. Also, the starting point in art allows the artistic apparatus to document and archive data from their performances, while also allowing for their exhibitions within the art spaces (museums, galleries). The activists of the present generation, which is as radical as possible, stem from the implicit supposition that utopian, predominantly visionary projects (such as society as a work of art) were aestheticizing things too much, thus neutralising their critical potential. They were also far too abstract, therefore the today's

67

generation of activists are focusing on more precisely defined, fully concrete, operatively manageable goals. Here we can mention the pranksters activists The Yes Men' s project *Unpresidented*. On Jan. 16, 2019, three days before the Women's March, approximately 10,000 copies of a fake *Washington Post* print edition were distributed at select locations in Washington, including the White House. With the headline, "Unpresidented," the paper, post-dated May 1, 2019, announced the departure of the president. The report said Trump fled the White House and left his resignation on a napkin in the Oval Office. The fake eight-page newspaper depicts the rise of political support for progressive legislation. The media activist group, the Yes Men, as well as writers Onnesha Roychoudhuri and L.A. Kauffman, took credit for the action hours after the paper surfaced. Official statement from the Yes Men says that Trump's imagined resignation is the result of a women-led, multi-racial grassroots resistance.

This activist intervention demonstrates that the reality itself has changed noticeably. The year 1968 allowed for utopias and daydreams, while the period after Ground Zero and War on Terror is the harbinger of another reality where things are dead serious. And the art enters this reality to make more noticeable changes in it.

CONCLUSION

The interactions between the arts and the key fields of present reality are affected with profound shifts of paradigms in contemporary art, where the stable, material, temple (Heidegger, 1975), and auratic (Benjamin, 1969) artwork is giving way to art services such as performances, processes, actions, applications, codeworks, manifestations of glitch, and disruptions. The political power articulated in the visible centers (presidential palaces, parliaments, site-bound army commands) is giving way to (post)political processes, actions, flash mobbing, art hacktivism and activism, media manipulations, networked corporations, and social movements. Moreover, new modalities of the political can also be found in the field of art and cultural practices, e.g. in detournements (Situationists' device), pranks, reality hacking, subversive affirmation (Arns, Sasse 2005), and jammings. Today, many artists are aware of representing a standing reserve of precarious workers; they connect and collaborate with other cognitive workers from creative and knowledge industries into new social movements against neoliberal domination. "Pure" laboratory and institutional academic science (science for the sake of science)

Living in the Art-Like Reality

has given way to military and police science and secret research on locations in countries lacking democratic control. Likewise, an essential sector of natural sciences (for example research in the chemical and pharmaceutical industries) is in the service of large corporations, while the social sciences in the post-socialist European countries produce theoretic platforms for the political activity of parliament parties (for example in Slovenia) and thereby provide a service for daily politics.

This condition differs significantly with regard to the role of autonomous aesthetic art in the (European) socialist countries (from Czech, Poland, and Yugoslavia to the Soviet Union) before the fall of the Berlin Wall where for dissident authors and artists, art actually functioned as asylum (and alibi) enabling them to criticize the political reality. Autonomous aesthetic art was considered a platform for arguing against mainstream politics, to engage taboo issues, draw attention to human rights violations, as well as the absurdity of the walls and the insulation from the non-socialist world. Before the fall of the Berlin Wall (November 1989), the information on concentration camps in the socialist countries (for instance in Soviet Siberia and Yugoslavia's Goli Otok) came to public attention mainly through literature (and to some extent films and plays).

When the politicians from these countries tried to identify people from real life in the characters from novels and theatre plays and consequently persecuted and exiled the writers (for example, Alexander Solzhenitsyn in the Soviet Union) under the pretense that they insulted politics defending the interests of socialism and communism, the writers and other artists sought asylum in the autonomy of their work, in the *licentia poetica* and the specific nature of the aesthetic objects and situations which are not to be confused with real ones. According to Theodor W. Adorno (p. 8) art is "the social antithesis of society" and the theoreticians of the so-called Marxist aesthetics (e.g. Kosik, 1976; Fischer, 2010), argued that the specificity of the aesthetic realm cannot be reduced to the practical and social reality. Their arguments were supported by phenomenological aesthetics (Moritz Geiger, Nicolai Hartmann, Eugen Fink) and its understanding of the aesthetic figures as-if-real, meaning that they are the effect of derealization (as-if activity) which implies their separation from the "leaden weight" of the real and therefore also from moral and legal responsibility. "We grasp in phenomenological reflection that fictional artistic objects are presented to us as 'quasi-existing in the neutrality modification of being'" (Husserl 1988, p. 262).

REFERENCES

Adorno, T. W. (1997). *Aesthetic Theory* (R. Hullot-Kentor, Trans.). Minneapolis: University of Minnesota Press.

Arns, I., & Sasse, S. (2005). Subversive Affirmation. On Mimesis as Strategy of Resistance. In East Art Map. Irwin.

Barbrook, R. & Cameron, A. (1996). The Californian Ideology. *Science as Culture*, 6(1), 44-72.

Bazzicheli, T. (2013). Networked Disruptions. Rethinking Oppositions in Art, Hacktivism and the Business of Social Networking. Aarhuus: Digital Aesthetics Research Center.

Bey, H. (1991). *The Temporary Autonomous Zone, Ontological Anarchy, Poetic Terrorism*. Retrieved February 18, 2019 from https://hermetic.com/bey/taz3#labeltaz

Biggs, S. (1996). *The Great Wall of China.* Retrieved February 18, 2019 from https://www.digitalartarchive.at/database/general/work/great-wall-of-china.html

Bookchin, N. (1998-99). *The Intruder.* Retrieved February 18, 2019 from https://vimeo.com/30022802

Doeleman, S. (2019). *Seeing is believing: Four lessons of the new black hole image*. Retrieved February 18, 2019 from https://phys.org/news/2019-04-believing-lessons-black-hole-image.html

Fischer, E. (1963). The Necessity of Art: A Marxist Approach. London: Verso.

Geiger, M. (1986). *The Significance of Art, A Phenomenological Approach to Aesthetics* (K. Berger, Trans. & Ed.). Washington, DC: CARP and University Press of America.

Gibson, W. (1989). *Neuromancer*. New York: Berkley Publishing Group.

Husserl, E. (1988). *Ideas pertaining to a pure phenomenology and to a phenomenological philosophy: First book. general introduction to a pure phenomenology. In Second half binding. Complementary texts (1912-1929).* The Hague: Martinus Nijhoff.

Ingarden, R. (1973). *The Literary Work of Art*. Evanston, IL: Northwestern University Press.

Iser, W. (2006). *How to Do Theory*. Malden, MA: Blackwell Publishing.

Kosik, K. (1976). *Dialectics of the Concrete*. Dordrecht: D. Reidel.

Lange, A.-C., Lenglet, M., & Seyfert, R. (2016). Cultures of High-frequency Trading: Mapping the Landscape of Algorithmic Developments in Contemporary Financial Markets. *Economy and Society*, *45*(2), 149–165. doi:10.1080/03085147.2016.1213986

Marcuse, H. (1969). *An Essay on Liberation*. London: The Penguin Press.

Mouffe, C. (2007). Artistic Activism and Agonistic Spaces, *Art & Research*, *I.2*. Retrieved February 18, 2019 from http://www.artandresearch.org.uk/v1n2/mouffe.html

Nicolai, C., & Peljhan, M. (2010). *Polar*. Retrieved February 19, 2019 from https://www.youtube.com/watch?v=WppRoOgK4kM

Schiller, F. (1983). On the Aesthetic Education of Man In a Series of Letters (E. M. Wilkinson & L. A. Willoughby, Eds. & Trans.). Oxford: Clarendon Press.

Shaviro, S. (2013). Accelerationist Aesthetics: Necessary Inefficiency in Times of Real Subsumption. *e-flux, 46*. Retrieved February 18, 2019 from https://www.e-flux.com/journal/accelerationist-aesthetics-necessary-inefficiency-in-times-of-real-subsumption/

Shaviro, S. (2015). *No Speed Limit: Three Essays on Accelerationism*. Minneapolis: University of Minnesota Press. doi:10.5749/9781452958552

Smrekar, M. (2014). *I hunt nature and culture hunts me*. Retrieved February 18, 2019 from https://vimeo.com/112481726

Strehovec, J. (2016). *Text as Ride*. Morgantown: Computing Literature, West Virginia University Press.

Chapter 4

The Word–Image–Virtual Body:
The Social Media Textuality and the Story as Application

ABSTRACT

In the present knowledge and innovation society, including creative industries, DIY practices, and citizen science, it is not enough to produce solely a product; it is necessary to sell a story about its groundbreaking appearance and function, which means that the product is well-marketed only at the moment when it is sold in a package together with a story written, performed, or shot about it. This turns into the world of arts; sciences, technologies, and business goes hand in hand with the contemporary storytelling, which is becoming distinctively performative and conceptual; rather than making a stable "textwork," it directs to textual service, which is integrated in the trendy service economy. Textual services generate novel forms of expanded narrative, shaped by means of new media textuality and novel narrative practices. One of the most attractive modes of today's textual service is a story as application.

INTRODUCTION

After the short-cut music videos of the 1980s and a short story which is becoming a popular genre in contemporary literature, for example the 300 word stories of Brady Dennis (Weinstein, 2006), short and condense formats are

DOI: 10.4018/978-1-7998-3835-7.ch004

Copyright © 2020, IGI Global. Copying or distributing in print or electronic forms without written permission of IGI Global is prohibited.

The Word-Image-Virtual Body

entering the cultural production of today's media. The news in the traditional and on-line journalism is short (a comment or column with a maximum of 1,000 words), short formats are characteristic of popular culture (2-minute ride on a roller coaster in the theme parks), Instagram videos are limited in time (duration of 3 to 60 seconds), selfies are short, the textuality of tweets and text messages is determined by a limited number of characters (140).

Among the constraining criteria in the production of trendy cultural contents, mention should also be made of the average elevator ride duration to the top of the American towers which accompanies a compelling speech on either a person (self-presentation at the interview) or a product or service (the phenomenon termed as the elevator pitch). In the time at disposal something needs to be presented and promoted persuasively, otherwise the person to whom the presentation is aimed will get bored and the effort will be counterproductive. With the elevator pitch is considered the culture whose producers are familiar with the psychology of the contemporary individual whose way of acting is determined by an increasingly reduced attention span paid to the persons, objects and events in her field of perception.

What we have today is an individual striving to consume as many as possible intense stimuli in the shortest possible time whereby she pays active attention only for a few seconds, or, depending on the content, a few minutes (rides in theme parks). Often one minute is a lot; this is the time that she can be focused on a YouTube video before her attention starts to substantially decline. Surrounded by a multitude of breaking news and breaking events, the individual only remains open for the things which speak to her very loudly. Saying that things don't leave her cold is not good enough. She pays attention to what gets her high and what involves her. With regard to an aesthetic experience, the phenomenologist Roman Ingarden introduced the concept of preliminary emotion. It is of crucial importance for aesthetic attitude and involves extremely intense attention which implies a difficult transition from the practical attitude to an aesthetic one. Similarly, the return from an aesthetic to a practical attitude is also sophisticated and even stressful (1973, p. 193). Being impetuously hit by a series of contents which compete for one's attention is today integrated in the individual's perception and practical attitude. With their constant inflow, breaking news is no longer something special. Being prepared for the extraordinary, the shocks, the disruptions, and defamiliarization (Rus. ostranenie, a concept taken from Russian formalism)

is the imperative for the survival of a contemporary individual in the world, where events exceed our established expectations.

BACKGROUND

Contemporary popular culture shaped by the social media has expanded short formats (tweets, selfies, Instagram and Snapchat videos and photographs) which suit the short attention span of today's individual. The trend towards economical and intense cultural contents results in texts full of abbreviations, neologisms, smileys, and emojis, and consequently hybrid digital textuality based on words-images-virtual bodies. This is also applied to hybrid stories (composed of verbal and non-verbal signifiers) which find expression in new types of narratives, including Twitter and Facebook novels, blogging fiction, novels with PP slides, gaming narratives, and stories for mobile phones in which the main character makes decisions based on hits suggested by search with applications. The digital text becomes obscene, profane, striving to tell more than it actually can; mysteriousness, the untold, ambiguity and blanks are withdrawing from the trendy textscape. Rather than addressing only the formal innovation of digital textual contents (create by montage, remix, and mash-ups), this chapter aims to discuss their corresponding world shaped by the new cultural, philosophical, perceptual, and socio-economic paradigms.

According to the exponential function curve $f(x) = e^x$, in the present, people are witnessing the exponential increase of cultural contents created with different procedures in different media as well as their hybrids and amalgams (for instance 500 million tweets and over 210 million snaps per day). The texts with visual signifiers (smiles and emojis, images and animation) are also included in the multitude of other textual units which compete for the reader's attention. The Internet with its social media is a typical venue of cultural contents' competition for the attention of viewers, readers, and listeners. By no direct means do these contents make part of art and literature; many of them are conformist and display their trendy and mainstream orientation; however, their organization, storytelling as well as spatial and temporal grammar constituted through them affect contemporary arts and literature. On top of tweets and blogs, story as application enters today's fiction, not only on the level of the formal organization of writing; the medium as the mind-shifter also affects the content construction of the story and the language which is influenced by netspeak (Crystal, 2001& 2011). In this respect, mention should be made of Egan's novel *A Visit from the Goon*

The Word-Image-Virtual Body

Squad, 2010, in which one chapter is written as a PowerPoint slide diary, and there are netspeak abbreviations, for instance "if thr r children, thr mst b a fUtr, rt?". Blogging has also been incorporated in some contemporary novels, for example in Mira Grant's *Feed* (2010) where blog posts are included among chapters and sections. New textual media shaped piece is also Astro Teller's novel *Exegesis* (1997), written in e-mails as well as first Facebook novel *Zwirbler* (2010) written by Gergely Teglasy.

These textual contents challenge digital humanities, social linguistic, narratology, the Internet studies, semantics, literary criticism as well as today's marketing strategists with innovative typography, visual textual components, expanded punctuation (e.g. hashtag), novel narrative devices, and animated textuality (e.g. in commercials and TV breaking news). This textuality is a basis of today's narrrative which deploys the new media procedures in forming the plot and the suspense of modern stories arranged as blogs, Twitter novels, and (mobile) applications. Doing a research in social media shaped textuality is essential for the basic understanding of the Internet which is arranged with striking and fascinating visual effects. The social media users passionately look at the Internet text as it were a naked body, and such a text is able to return a gaze; suddenly, it looks at viewers and makes them caught in the multimedia shaped textual dispositif.

THE VERBAL COGITO: I TWEET, THEREFORE I AM

What makes people high and involved these days? Other than breaking news, these are striking the individual's perception-stimulating events that the individual deliberately takes part in; e.g. when she assumes strains which cause dizziness on the rides in theme parks and high-adrenaline activities. She seems to select such activities first and foremost in order to more easily confront evermore demanding tasks in the daily routine. What counts is the ride and the video game (in particular of the First Person Shooter type). Apparently, the ride and the video game (Galloway, 2006) are becoming the modalities of contemporary cultural contents which impetuously attract and involve the individual. The designers of social media count on them and they help us understand a number of current phenomena, including selfies and snaps. They both articulate part of the visual culture in intense short formats.

In the Snapchat and Instagram culture the Cartesian *I think, therefore I am* gives way to the visual cogito *I take a picture, therefore I am* (and I record, therefore I am). And a person recording ever more often takes pictures of

75

The Word-Image-Virtual Body

herself, which is demonstrated by popular selfies; these are by no means just the new-age portraits, but reflect a more complex philosophy including their therapeutic and control function. Selfies constantly refer to the body; they substitute the view of the other and simultaneously complement it with a more individualized mirror image. Current studies show that especially young women prefer taking selfies, rather than sharing them, which means that they serve personal objectives, for instance the control and correction of the body image (Wagner, Aguirre and Sumner, 2016). Therefore the logic of the first person shooter moves from the video games (historical best-sellers in this genre were *Doom* and *Quake*) to other areas where everything revolves around an individual who assumes the role of the main character in the world of the followers (which is the definition of a fellow human being in the culture of social media).

It is of key importance that an individual selfing herself is no longer alone but constantly has her instant image by her side. She would be alienated and disoriented without it, while with it she controls her body image and related identity. Today, an individual is a physical entity plus the sum of all her most recent selfies in the sense of image-based status updates. This is not – only – about narcissism, but the control of her daily moods and emotions, which leads to a series of feedback loops between the individual and her instant screen displays. According to them, she changes and fixes things about herself and immediately checks the fixes with a new snapshot shared on social networks. Selfies are made at known locations as well as in actual non-places (Augé, 2011); i.e., in the areas lacking any historical basis or identity, such as airports, terminals, and shopping malls. Selfies can also be interpreted as a medium utilizing the characteristics of a play in which everything revolves around the person taking the picture.

This chapter is mainly interested in text, hence we would like to point to another medium using the attributes of social media; i.e., Twitter, the volume of which also implies the modification of the Cartesian cogito in the sense *I tweet, therefore I am.* Tweets (Twitter is a social networking micro-blogging platform) are usually first person 'verbal bullets', intense messages, comments whose authors – as if they were first person shooter video games players – aim at a rapid response from the followers. Tweets come with the modified language of today's verbal communication which expands the alphabet of natural languages with special symbols. These are # (hashtag) and @ (at) which are fundamental for the constitution of the twitter sphere. Hashtag is used to group posts together by topic, keywords or type, while the @ brackets names for mentioning or replying to other users. Moreover, Twitter enables

The Word-Image-Virtual Body

new forms of searching for what other people are saying online, a kind of discourse-search that discerns from searching for content enabled by Google (Zappavigna, 2011).

Hashtag belongs to expanded concept of punctuation deployed in the Internet textuality; rather than facilitating the reading and meaning decoding, this sign contributes to the tweetosphere and has a role in its organisation. Unlike the question mark and exclamation mark, the hashtag doesn't interrupt and divide but links, stimulates, and triggers a very specific way of thinking and directs one's relationship to information.

Tweets are also included in literary creativity, more precisely in novels in tweets (e.g., #140novel). Their beginner was Nicholas Belardes with the project. *Small Places*, based on a series of tweets that the author started posting in 25 April 2008 and finished on 8 March 2010 when the text numbered about 30,000 words. In addition to Egan's novel *A Visit from the Goon Squad* we should mention her short story *Black Box* (2012) which was released as a series of tweets on The New Yorker's Twitter account. It is composed of reflective tweets as if it were a poem in prose. One of the tweets indirectly refers to the phenomenon of elevator pitch: »The first thirty seconds in a person's presence are the most important. " (1.2). As it would relate to Wilde's *Dorian Gray*, Egan argues »Posing as a beauty means not reading what you would like to read on a rocky shore in the South of France. (3.1)

Table 1. New forms of digital textuality in the realm of present cultural and social paradigms

Digital Textuality	Corresponding Cultural and Social Paradigms
Tweet	Short attention spam, center framed contents, cinematic culture: textual editing
Blog	Hybrid contents, social media, mixed means media
Story as application	Algorithmic culture, macdonaldization, googlezation, networking
E-mails, sms	Abreviations, atention economy, netspeak, elevator pitch

Contemporary verbal contents are committed to the imperative of attracting as much attention as possible and they are prepared for the (neoliberal) competition with other, rival contents, a competition that is required by the attention economy (Goldhaber, 1997). Only the winners can count on the attention of media (entry to the prime time), politics and economy. A printed

text-as-we-know-it, arranged only in the verbal mode is no longer competitive unless it assumes the attributes of trendy cultural contents (e.g. from social media and the entertainment industry) meaning that it is also formed with the components of a video clip, ride, performance, travel and show. Present readers come across the expanded and ubiquitous concept of the textual service which is visual, hypertextual, conceptual, auditory, multi-medial, adapted to new textual formats aimed at static, or portable screenic devices. "No longer are words so prominent, but graphics and animation are just as likely to communicate story content or be used as part of the interactive inter-face. " (Page & Thomas, 2011, p. 2)

STORIES WITH VERBAL AND NON-VERBAL SIGNIFIERS, STORIES AS APPLICATIONS

The new media textuality and storytelling point to the contemporary visual culture with a characteristic feature which can be explained by the film *Mad Max IV Fury Road* directed by George Miller. Margaret Sixel did the editing and it was executed in center framed mode (Vashi Visuals, 2015). Center framed is the modality which is actually required by the attention economy; the fact that the crucial things have to be played out in front of the viewer's nose and promptly involve her in what's happening is necessary for a cultural content in competition with rival contents. We refer to this example because tweets also tend to be center framed (the point has to be revealed after the third or fourth word in the first line, when everything has to be promptly clear to the tweet reader) in order to come to the fore and make an instant hit. The simplifications, abbreviations and short formats are less demanding on the level of imagination; they normally don't engage the reader's activity in filling spots of indeterminacy (Ingarden, 1973), gaps and blanks (Iser, 2006).

There are many types of narratives and not all of them stimulate imagination nor are they based on the evolution of the main character in the process of the story's conflict and resolution related to the character's actions. This applies to tweets and their minimalist format which prevents sophisticated descriptions articulated in long sentences. Many tweets are created from minute to minute without their author's intention of making a complex narrative. Immersion in fictitious worlds is difficult to convey in distinctively interactive tweets, a rather abstract medium which doesn't really stimulate images and the imagination. Immersive imagination is also interrupted by

The Word-Image-Virtual Body

references related to the use of hashtags and at-s. Therefore, it takes a series of tweets for enough persuasive descriptions necessary for the character's formation of world and her evolution. In addition to Twitter (and e-mail) novels there are also blogs as micro-narratives (for instance diaries) tagged by date and stored in a database. This genre, established in particular in on-line journalism, is also used in writing for digital media, and, as mentioned above, also in literature.

Selfies and tweets stimulate a new generation of stories that are prepared as applications. As an example of such new media shaped narrative can be mentioned Alan Bigelow's *How to Rob a Bank* (2016-2017), a love story in five parts built with HTML5, CSS, and JavaScript and playable on desktop, laptop, and portable devices. This story is embedded in the world of mobile Internet and its applications. *How to rob a bank* as a narrative generated in the tradition of the net.art resembles Olia Lialina's Internet artwork *My Boyfriend Came Back From The War* (1996) that was created specifically to be experienced in a web browser (for example, the use of frames).

The Bigelow's story focuses on the misadventures of a young and inexperienced bank robber and his female accomplice. The project's involvement in the mobile and Internet culture, means that along with human characters, its key protagonists also include hardware and software components; i.e., programs and applications. Moreover, such a multimedia text would be stripped of most of its attributes if transferred to the stationary culture of printed documents. The story of the inexperienced robber couple is set on the mobile phone's display (iphone) as an ordinary device which nowadays practically substitutes for a piece of written or printed paper. In the story, the key protagonists and the readers/users use a lot of iphone applications. Indeed, it's been a while since the weather forecast was deducted by looking up in the sky, at the sun and clouds. Today we look down, on the display and one of many weather channels. No need to describe the itinerary to the fellow traveler (and readers); a Google map application does the job perfectly. Today, the applications provide for an individual a basic orientation to the world; they are a generator of her literacy which is profiled on the basis of "findabiliy." Application-mediated searching hence functions as one of the devices which contribute to storytelling as well as a plot.

How to Rob a Bank opens up the world of a constant search. When you dwell on death, you use the application to find the instructions regarding how to write a testament. When you plan a bank robbery, you just enter the string in the search engine, and find the right weapon in a web store. You make your decisions based on hits provided by a search engine. There is

always a multitude of hits; this is not an unambiguous or bipolar world (the Shakespearian to be or not to be). And Google map doesn't give you one single route, but alternative routes with alternative times according to the shortest route. Competition on Amazon and eBay also exists. You think, act and get oriented according to the hits of your searches and, when you tweet, on the additional information provided by @ and # put in front of selected words. To a hybrid reader-viewer-listener-rider, this story is both a verbal and visual event which can be repeated several times.

In the world of application-mediated searches, you are never alone, but in the company of the artificial intelligence which is behind these applications. It is about cooperation which simultaneously points to the fact that you can no longer decide without the support of search results. You are an individual with a multitude of applications in a multitude of applications. You perceive the world through animations, Instagram videos, snaps and tweets. The quantity of contents generated by social media and applications far exceeds the 'natural world'. In this case, the comparison between real wealth and that generated by financial markets derivatives needs no comment.

A mobile display and its imagery are with you every step you take. Bigelow's project is an example of new intertextuality rendered possible by the use of key social media and principal devices of today's media culture. It is a story and at the same time its interpretation because it's not only fiction constructed of tweets, Google maps, FBI data, Instagram snapshots, animations, film inserts and searches in online stores (Amazon, eBay), but also includes explanations through Wikipedia, the online MW dictionary, Google and film footage (the sequence of the final shooting from *Bonnie and Clyde*) which make strange naive searches. Its reference is nothing less than the robber couple, online life itself, and the life taking place on mobile screenic devices. The author doesn't clarify ambiguities within a verbal fashion but suggests explanations through various search engines and portals.

In addition to a modified text in the age of new media and social networks, we also witness a new organization and format of a story and its narration. Today, oral and verbal communication are complemented by visual, auditory, kinetic and tactile forms of narrative and many hybrids thereof, as illustrated in application *How To Rob a Bank*. Visual and animation elements are no less important for the story than words, because each of them contributes something specific in the construction of the narrative which exceeds only verbal storytelling. Here we draw attention to the concept of a zoom narrative deriving from Karpinska's iphone story *Shadows Never Sleep* (2008) where

The Word-Image-Virtual Body

a technical characteristic of the device (iphone) even works as one of the building blocks of this literary application.

In the age of new media, not everything revolves around sequential and the conflict-and-resolution based narratives. Verbal medium is strong in the description of the protagonist's philosophy, in particular extreme mental states, causal relationships and the construction of the conflict so that the reader of the stories constructed in this medium is relatively safe and successful on her way through the textscape. However, such a way is more difficult with regard to a story in static or animated images (non-verbal communication), which, on the other hand, facilitates the presentation of the developments in space demonstrated by the story-application.

ELECTRONIC LITERATURE AND THE DANGER OF TECHNODETERMINIZEM

The textuality of new media also finds its expression in the electronic literature as a textual practice, termed with a misleading name because it is by no means a continuation of the literature as we know it; i.e., printed, tied to the institution of codex. In addition to the unsuitable name, e-literature (a number of this practice's examples can be found in on-line Rhizome Artbase and three Electronic Literature Collections) is subject to misunderstandings related especially to its elite, academic institutionalization and the reference in the textual work of art as if were a real and stable textwork formed by the author-brand. Literature with its principal devices, such as make-believe, plot, suspense, character, estrangement, minus device (Juri Lotman's concept) and spots of indeterminacy (Roman Ingarden's concept), is not fully exploited the way it is presented – i.e., with digitality and networking. The misunderstandings are also related to most of its authors emphasizing the institution of the author, ignoring the specificity of networking media successfully established by new media culture, (digital, electronic, cybernetic) art, club cultures, and creative industries. And above all, e-literature is constantly threatened by technodeterminism and the ideologies of the posthuman. Rather than foregrounding the media shaped text in terms of sophisticated network of relations and fold (Deleuzian concept), the ELO theoreticians and critics foreground the role of the smart machine as the co-author of e-literary textuality.

Technodeterminism (Wyatt, 2008; Servaes & Rolien, 2015) is based on the premise of technology's autonomy, meaning that e-literature's technical

advances determine the changes in the literature itself or that literariness (the term introduced by Russian formalism) is the function of technological innovations. And the authors of e-literature actually seem to immediately react to technological changes and start writing e-literature (especially poetry) in, for instance Pearl, JavaScript, Shockwave, and Flash, which also extends to the naming of their practice (popular Flash art and poetry). These programs and plug-ins are not neutral tools; they actually affect the organization of textscape and add energy to the word by animation – stimulation of its movement – which is illustrated by electronic kinetic poetry. These changes also affect the construction of the meaning, although today's text is also realized on the basis of non-technological influences and contents; born digital (which was considered as the key feature of e-literature according to Electronic Literature Organisation) co-exists along no the less important born political, born social, born corporeal (e.g. Husárová & Panák,2012), born fictional and born debunking (e-literature has to reveal something, demystify, take from the ideology of faith in progress).

The mainstream e-literature is also affected with the ideology of the posthuman (encountered first in literary cyberpunk, Stelarc's techno performances, and the cyborg theory), based on the expectations that the concepts regarding the entry of algorithms in our everyday life has a surplus that will allow the understanding of the nature of today's individual surrounded by smart devices. Posthuman is manifested in the algorithmic culture (Seyfert & Roberge, 2016) that claims algorithms co-create cultural contents, measure our needs and desires and even determine our identity (Cheney-Lippold, 2011). However, contemporary humanities accept the fact that in the posthuman world of algorithms "being-as-such" gives way to "being-instrument" (Marcuse, 1964) too affirmative, positivist and descriptive. They lack a negative reflection that doubts, provides counter-proposals and resists this one-dimensional world. The motto "too big to fail" and the notion of the absence of any alternatives seem to extend to a number of areas, and a dialectical tension of counterparts disappears from the instrumentalized (and McDonaldized) postpolitical world.

Although the present is populated with many posthuman creatures, like cyborgs (Harraway, 1985), these are evermore humanly vulnerable and exposed; instead of posthuman, a human of a new generation threatened by techno-fascism comes to the fore. Techno-fascism is about substituting the principal concepts of traditional fascism (blood and soil, the race, the leader, following the leader, the enemy through which you identify yourself, the scapegoat Other) with the technological concepts and devices which often

The Word-Image-Virtual Body

relate to the tools generated by clearly identifiable neoliberal corporations. In addition to techno-fascism we should also draw attention to micro-fascism which is not identical to established notions of the left and right but rather based on the individual's intolerance and even hatred of everything which doesn't suit her egoistic desires; such individual's inclination is supported and facilitated by dating apps and other digital apps of the social media which are anything but neutral tools. "Micro-fascisms are shaped by our emotions towards things we see, especially online. Our hatred of other worldviews, our preference for white faces or our love of cats can cause us to dislike, block or like content; to craft and shape an environment around us that is familiar and acceptable." (Penney, 2016, n.p.)

New media are interactive and immersive, they provide a lot of competences to their users; however, these media are not only efficient in learning, participation and communication, but also in negative, dark projects, for instance those related to techno- and micro-fascism which is not alien to electronic literature community. The popular applications not only facilitate communication and sharing but they are also efficient when you want to block, delete, select, reject, abolish, push aside or pay attention to only certain contents.

Another issue is the nature of machine-generated language (e.g. in e-literature genre the poetry generator) which abandons ambiguity, the richness of metaphors, a sophisticated style full of risk for both the author and the reader due to its spots of indeterminacy. Instead, we face McDonaldized language structured as the invitations, smart contracts or commands (McDonald's famous "Eat here or take away") and language which is close to the clarity and unambiguity required by commands and instructions in using a computer or a mobile phone. Web language has long been a subject of interest because "language use in the new media is not considered as an exceptional or deviant form of communication. Rather, it is seen as yet another platform where human beings use language in order to produce meaning and explore forms in order to exploit and create new symbolic resources" (Locher & Mondada, 2014, n.p.). It should be noted, though, that despite its aspiration for economical and fast messaging, the language of web portals, on-line communication, tweets, blogs, (PowerPoint, Keynote, Prezi) presentations may be understood as a creative area where new forms of textuality, communication and production of meaning emerge. We deal with an extended concept of the text which relates to the materiality of languages and their inscriptions.

Despite boundaries created by technodeterminism and the ideology of posthuman, electronic literature demonstrates many significant features related

to the materiality of medium. These features function as commonalities that mediate between the e-literature and social media. The point of intersection and similarity between both fields is found in their use of spatial grammar as an organizing principle of screen based textuality that directs toward the concept of word-image-(virtual) body. At this intersection we encounter the digital, software-controlled word, structured neither as an ideogram nor as a verbal image (Mitchell, 1966). Because of its placement within the windowed environment we can touch it by mouse, stylus and touchscreen, as well as lift and transport it due to its virtual embodiment.

A special mode of digital word-image-body is generated by movement, which connects verbal, visual, and kinesthetic features. The word-image-body in movement (e.g. in kinetic, animated pieces of electronic literature, in Jenny Holzer's LED displays, moving text accompanying breaking news and stock exchange information, and broadcast TV and Internet commercials) behaves in a space like a moving video or film image, meaning that editing (montage) is an organisational principle of the moving textuality. Deploying a montage in the text organisation presupposes that the author used enriching procedures when writing for digital media, such as cinematic methods and devices (e. g. stain, taken from Pascal Bonitzer's cinema theory). The textual material is deployed, like footage in cinema and serves as raw material for textual compositing. The movement brings dynamics to the screenic window, temporal grammar is important in forming text, features of before and after, not-yet and forevermore, forming unstable textual organisation. Rather than following a line, the movement illustrates ornaments and labyrinths. From the readers' point of view, the moving text does not demand the reading of movement, but just the scanning of it. The issue of moving words opens up the remediation problem (Bolter & Grusin, 1999) due to the fact that the new media remediate the old ones, meaning that the moving words (in visual arts, information industry, advertising) refashion the moving images of film and video and vice versa. Along with such classical examples of media refashioning the contemporary art deploys also the counter-remediation in terms that the old medium refashion the new one (e.g. the book remediates the video). Such is Robert Ochshorn's video *Chewing* related to John Smith's short film *The Girl Chewing Gum*, which transforms a video from time into space. Each row of the video represents one minute of time which is mapped from left-to-right and top-to-bottom as it were a line of the book. The entirety of Smith's film is played from top left to bottom right, This piece challenges the reader/user to jumpy reading in terms that she is urged to smoothly moves from the entire spatialized film to its short played components placed in the rows.

The Word-Image-Virtual Body

WORD-IMAGE-BODY IN THE REALM OF POWER

The common denominator of new textuality (from social media and text-based popular culture to e-literature and text based installations) is the word-image-body, which allows the entry of verbal content into the trendy culture of concise, striking, visualized, and short formats that can also compete for the leading position among (spectacular) images. Simply put, even the word-image-body is an image in a very particular mode and belongs to today's visual paradigm.

The collective author Retort argues that the terrorist action on September 11 was based on "belief (learned from the culture it tried to annihilate) that a picture is worth a thousand words—that a picture, in the present condition of politics, is itself, if sufficiently well-executed, a specific and effective piece of statecraft." (2004, n.p.) This view refers to the very particular interpretation of September 11 attack in the sense that it was a spectacular event and was, therefore, even more painful for the attacked country, as it had to face the 'image death' or 'image defeat'. The USA is able to neutralize a variety of attacks (economic, military, hacking, etc.), however, despite being the homeland of Hollywood and MTV music videos, the terrorists defeated them in the area where they are most at home - in the very realm of images themselves. September 11 was a striking attack that deployed images, the cameras were turned on, and there was no Dresden, Hiroshima, Rwanda and Srebrenica, where there were no cameras and the massacres took place without live documentation. The relevant emphasis of this Retort's view, in the background of which Debord's theory of spectacle can be found, is that the picture is worth a thousand words, which directs toward the excess weight of the image such as it is in the current, highly visualized mainstream culture. Images are those that count today, the struggle for their authority is constantly on-going, and Retort juxtaposes the images with thousands of less valuable words.

Such a view of the word vs. image problem is not self-evident and challenges the diametrically opposite thesis, which is one of the generators of this chapter, and states that in the present culture, the words are not less valuable than images, but equivalent. However, words being equivalent to images in the present, defined by visual culture, is again not self-evident, but rather the result of the effort of the words themselves to transform into visual words which can compete with pure images and thereby participate in the struggle for mastery in the realm of the images.

How do words approximate images? What demands must they meet? The criterion of the visualized word-image-body is fulfilled by the word in the moment it is designed in a way that its user (hybrid reader-viewer-listener) not only reads it, but also looks at it or touches it (moves it with a navigation device if the word is placed into a screen). Such a word deploys spatial grammar meaning that its position in the windowed environment is of crucial importance.

Despite the current cultural turn from the literary culture to the culture of performance (Fischer-Lichte, 2004) and trendy battles for the authority among images, the Internet textuality and the verbal have also adapted to the imperative of digital morph, real time, and virtual reality, and entered the paradigm of expanded concept of text. At this point it is important that today's textual culture demonstrates a number of innovative features that are challenging for its users (readers, listeners, viewers) as well as for the theory.

BEYOND THE MAINSTREAM: CYCLING TO THE *DRONE POEM*

Today's popular culture, which is by no means equal to art and literature, is formed on social media. Although this culture (similar to other areas, e.g. economics and politics) borrows a lot from the procedures of artistic avant-gardes, it contributes to conformism – i.e., to the one-dimensional world which lacks more convincing alternatives. The author of this chapter is also faced with these issues and his response to the challenge of new media hybrid texts (which are 'more expressive than the expressible' and establish a global communication) was an esoteric 'counter-text', 180 degrees opposite to the mainstream.

One of his texts that encouraged him to write about a special, already addressed subject, is *Cycling as reading a cityscape* (hereafter *Cycling 1.0*) which is available in a journal and in a book (Strehovec, 2016). From the cyclist in the city-textspace searching for construction sites and sites of fire, he navigates where cars can't and pedestrians won't go because they couldn't get away fast enough (basic situation of *Cycling 1.0*), he moves in the new, conceptual text about drone poem (it could be marked as *Cycling 2.0*) to 2016 when the city which presents him a challenge for cycling-riding-reading is becoming populated with new contents. These include mobile networks, the Internet of things, drones, social networking, Big Data, recording with

The Word-Image-Virtual Body

action, sports cameras (e.g. GoPro). The cyclist rides to the city, crosses it, and writes a story about it in real time; with each cyclist and his ride there is, put simply, more of the city. He usually rides fitted with a camera, a mobile phone, a music player, with devices that constitute his mobile cockpit. During the ride he often records, thereby documenting his way. The bicycle he rides doesn't fall into the posthuman, but the human paradigm; it is very here and allows the view which is neither too high (up) and nothing happens too fast (it is not a car or an airplane).

Cityscape described in his cycling texts is not a container with static contents but rather a relational space formed live by the cyclists and their actions (as well as the pedestrians in the sense of de Certeau's text *The practice of everyday Life* and the video games' players). It is a space articulated in the event, explicitly existential and consequently project-like and interactive. The cyclists and pedestrians are invited to interfere in it, to participate in its stories.

This is what his counter-writing of poems looks like: He visits an abandoned construction site at night before the forecasted rain and either on a flat surface, a landfill or the combination of both, writes a poem. He writes it with a short pointed stick found on the site. He usually writes poems composed of 64 lines meaning they are neither too long nor too short but actually big enough to constitute a textual event which can be read in different ways and listened to from different positions.

On 13 May 2016 at 11.08 pm he found in the western suburbia of Ljubljana a high fenced construction site with shabby doors which had above an abandoned pit a flat landfill of soil and fine sand. A genuine gift for him and the poem he started to write on the flat surface. He titled it *Drone Poem* because at first he wanted to record it with a quadrocopter but he didn't write its title. However, he clearly inscribed in the sand:

Written----without a shade _ _ _in the sand _ _ _sandbank _ _ _hour, day.
Reading it _ _ _circles - - -forgets- - - crosses out,
blue, he wrote_ _ _pronounced- - - takes,
Didn't read, - - - icy.

These words are merely fragments taken from various lines of the actual, fully written poem. He wrote it all, a long poem, and left it in the night before the rain. After writing it, he illuminated it with a torch and took several pictures with a compact camera from a fixed point; he used the camera in photography mode. He also made a video while cycling around and through it. He returned with the first drops of rain the following day at 9.20 am. Nobody was there.

87

The Word-Image-Virtual Body

The poem was alone, slightly faded compared to the original inscription... First a few drops of rain, then that lingering in the sense whether it will pour down or not, a gust of wind followed by cold and then heavy rain. The poem in the sand starts to dissolve, it is also destroyed by the wind, what was written disappears in the streams of rain. He takes his camera and repeats the previous night's procedure. First some photographs of the disappearing text, followed by a three-minute video on the poem drowning in the heavy fall of rain. After completing the task he returns home and prepares the documentation of the poem which is at that point the only material trace of it. He takes the memory card out and writes some technical data on it (title of the footage, its duration, the brand and model of the camera).

He concludes the projects two days later when at 11 pm he takes the memory card with *Drone Poem* and together with the hard disc that he only used that day, physically destroys it. He pounds it with a heavy hammer a couple of times – both the card and the hard disc – so that they shatter into tiny pieces. He sweeps up the remains with a dustpan and dumps them in a black container for plastic. This was the last act in the life of that poem and the words that were granted only a three-day existence in the form of photo and video documentation. And that was it.

First it was and then it disappeared. The counter-poem. Its strength and message lay in the fact that it's gone. That nobody will ever read it. That it came about with a poet who didn't share it with anybody. It is a poem that communicates through its absence. Only sometimes an echo can be heard in the blast of wind, the cold of the night and the falling curtains of rain. However, what is heard is not articulated in letters and words.

Drone Poem is about the author, the text, the reference to the literary criticism and its readers, but it lacks a reader of the (poetry) project who is for the author of that text irrelevant. Such a decision is related to the author's views of the electronic literature which is in his mind a field that brings greater pleasure to a theoretician than a reader. By implying theory, the author of this text doesn't completely disregard communication with the public; however, he significantly restricts it to those with a specific knowledge, the theoreticians. Still, they also don't have the entire text of the poem but only the author's concept of its disappearing and the (cycling) story of this disappearing, meaning that they are deprived of a close reading of the entire text. This project enables dialogue but only at the conceptual level, for example on the disappearing text and its conceptual traces.

The Word-Image-Virtual Body

SPACE POETRY

Drone Poem challenges the boundaries of the poetry text, which is in this case explicitly esoteric and conceptual. Projects that pushing the boundaries of text and poetry have for decades been the objective of the artist Eduardo Kac who examines various modalities of poetry situated beyond a printed page and structured in a line. In addition to biopoetry and holopoetry, he also explores Space Poetry, in regard to which he published a manifesto in 2007. "Space Poetry is poetry conceived for, realized with, and experienced in conditions of micro or zero gravity. In other words, Space Poetry is poetry that requires and explores weightlessness ("micro or zero gravity") as a writing medium." (Kac, 2007) On February 18th, 2017 French astronaut Thomas Pesquet according to Kac's instruction, created at the International Space Station (ISS) the project *Inner Telescope*, which allows a new experience of a poetry object composed of environment-friendly materials available at the space station. It consists of a form that has neither top nor bottom, neither front nor back – because these attributes apply to the definition of an object in the physical, gravity-defined space whilst they are not required in the outer space. Viewed from a certain angle, it reveals the French word "MOI" meaning "me", or "myself", which stands for the collective self, evoking humanity. It is a symbolic, ecological and minimalist project in which "moi" can be explained with hundreds of words which, together with "moi," and similar to *Drone Poem*, write a story.

Such a transposition of poetry in the condition of zero gravity means that gravity exerts a significant influence on our perception of given reality, the creation of art (e.g. ballet) and literature and the reading of literary contents. (Here we can mention the Slovenian artists within the 50-year theatre "projectile Noordung 1995-2045" who have been engaged in postgravity art for more than two decades.) In the state of weightlessness, the cards in all these fields are shuffled anew, space poetry becomes temporal and performative, close to visual arts, abandoning the medium of the book and printed page, substituting it with weightlessness; space poems produce new "antigravimorphic" syntaxes which provoke a special perception/reading. With special choreographies of floating, pushing forward, jumping and swimming, it can move around the poem as a fluid entity composed of one or several words in motion. The metaphor of a text as a ride definitely refers to the experience of text in weightlessness.

The Word-Image-Virtual Body

At this point we would like to draw attention to Kac's pioneering work in holopoetry, facing the reader with the tasks similar to those in the conditions of zero gravity. Since the holographic poems are written by means of light manipulation, they are freed from material and gravitational constraints. Reading such poems is a sophisticated endeavor including moving "around the text and find meanings and connections the words establish with each other in empty space. Thus a holopoem must be read in a broken fashion, in an irregular and discontinuous movement and it will change as it is viewed from different perspectives." (2007, p. 131)

Space Poetry is time-based in the sense that there is an internal temporal logic to each poem. It is performative, since the body of the reader is weightless and thus engaged in a particular kinesthetic readerly experience. Space poems are naturally close to the visual arts and other disciplines since they are not meant to exist in a book, but in weightlessness. They use few words (potentialized semantically through the exploration of the behavior of materials in weightlessness) and often involve the direct participation of the reader. Just as importantly, space poems produce new antigravimorphic syntaxes and the challenge of a new weightless choreography.

CONCLUSION

Nowadays people are faced with the hybrid textuality of short formats used by social media, digital (electronic) literature, traditional media (especially television), and new forms of literary storytelling, based on Twitter, Google, and Facebook textuality. New modalities of texts (e.g. text as ride, text as market) are a challenge for reading and wider perception of textual entities; the sophisticated organisation of digital text frequently put the readers into an impossible position without visible spatial and temporal coordinates that usually accompany traditional, print-based texts. The readers face the challenge of perception, which is similar to that of postmodern architecture, for which Jameson argues

that we are here in the presence of something like a mutation in built space itself. My implication is that we ourselves, the human subjects who happen into this new space, have not kept pace with that evolution; there has been a mutation in the object unaccompanied as yet by any equivalent mutation in the subject. We do not yet possess the perceptual equipment to match this new hyperspace, as I will call it, in part because our perceptual habits were

The Word-Image-Virtual Body

formed in that older kind of space I have called the space of high modernism. The newer architecture therefore – like many of the other cultural products I have evoked in the preceding remarks -- stands as something like an imperative to grow new organs, to expand our sensorium and our body to some new, yet unimaginable, perhaps ultimately impossible, dimensions. (p. 38-39)

The growth of new organs is in current expanded and ubiquitous textuality not necessary, however, new generations of texts from the reader/user definitely demand new approaches (for example, not-just-reading, which involves circling around a textual installation). The new textuality can also be understood in terms of ubiquity due to its presence in various media and integration with various objects. It can be found on sites, screens, walls, streets, sandbanks, in the outer space, on the TV picture, and in art installations, which means that there by no means exists less texts than in the Guttenberg paradigm of the press, however, these texts are often modified, hybrid and (because based on words-images-bodies) seamlessly integrated into the multimedia cultural and information content. Also essential for such striking visual and temporal texts is conceptuality, which today accompanies all the main social areas that have passed the phase of dematerialization, from art to post-political politics and finances. The mention of finances in relation to the conceptual sounds unusual, however, precisely the criptocurrencies demonstrate the proximity of this dematerialized and decentralized money to the conceptual art (Catlow et al, 2017).

The expanded concept of textuality includes numbers and their manifestations in algebraic processes. Equally as about the word-image-body, can we today talk about the number-image-body, as the number also attracts the sight, is (often 3D) visualized and kinetic (number-image-movement). It is included in a film of numbers, which are either growing or falling, participate in spectacles related to market indices and different count downs (till the new year or the beginning of the Olympic Games). The flood of falling signs in Matrix film code and on LED displays in installation art also includes numbers.

REFERENCES

Augé, M. (1995). *Non-Places: Introduction to an Anthropology of Supermodernity*. London: Verso.

Bazzichelli, T. (2013). *Networked Disruptions. Rethinking Oppositions in Art, Hacktivism and the Business of Social Networking*. Aarhus: Digital Aesthetics Research Centre Press.

Belardes, N. (2008). *Small Places*. Retrieved May 18, 2019 from http://www.nicholasbelardes.com/twitter-novel-small-places/

Bell, A., Ensllin, A., & Rustad, H. K. (2014). Analyzing digital fiction. New York: Routledge.

Berardi, F. B. (2012). The uprising. On poetry and finance. Los Angeles: Semiotext(e).

Bigelow, A. (2016/17). *How to Rob a Bank?* Retrieved May 18, 2019 from Part 1: http://webyarns.com/howto/howto.html

Bolter, J. D., & Grusin, R. (1999). *Remediation. Understanding New Media*. Cambridge, MA: The MIT Press.

Catlow, R. (2017). *Artists Re:thinking the Blockchain*. Retrieved May 18, 2019 from http://torquetorque.net

Cheney-Lippold, J. (2011). A New Algorithmic Identity: Soft Biopolitics and the Modulation of Control. *Theory, Culture & Society*, *28*(6), 164–181. doi:10.1177/0263276411424420

Crystal, D. (2001). *Language and the Internet*. Cambridge: Cambridge University Press. doi:10.1017/CBO9781139164771

Crystal, D. (2011). *Internet Linguistics*. London: Routledge. doi:10.4324/9780203830901

De Certeau, M. (1984). *The practice of Everyday Life*. Berkeley: University of California Press.

Egan, J. (2010). *A Visit From the Goon Squad*. New York: Alfred A. Knopf.

Egan, J. (2012). *Black Box. Twitter novel*. Retrieved May 18, 2019 from https://www.newyorker.com/magazine/2012/06/04/black-box-2

Ekman, U. (2013). *Throughout. Art and Culture Emerging with Ubiquitous Computing*. The MIT Press.

Electronic literature Collection 3. (2016). Retrieved May 18, 2019 from http://collection.eliterature.org/3/

Fischer-Lichte, E. (2004). Ästhetik des Performativen. Frankfurt: Suhrkamp.

Galloway, A. R. (2006). *Gaming: Essays on algorithmic culture*. Minneapolis: University of Minnesota Press.

Gibson, W. (1992). *Agrippa*. Retrieved May 18, 2019 from http://agrippa.english.ucsb.edu/

Goldhaber, M. H. (1997). The Attention Economy and the Net. *First Monday*, *2*(4). https://firstmonday.org/ojs/index.php/fm/article/view/519/440

Grant, M. (2010). *Feed*. London: Orbit.

Haraway, D. J. (1991). A Cyborg Manifesto: Science, Technology, and Socialist-Feminism in the Late Twentieth Century. In *Simians, Cyborgs, and Women: The Reinvention of Nature* (pp. 149–181). New York: Routledge.

Husárová, Z., & Panák, L. (2012). *Enter:in' Wodies*. Retrieved May 18, 2019, from https://vimeo.com/73711422

Ingarden, R. (1973). *The Cognition of Literary Work of Art*. Evanston: Northwestern University Press.

Iser, W. (2006). *How to Do Theory*. Malden, MA: Blackwell Publishing.

Jameson, F. (1993). Postmodernism, or The Cultural Logic of Late Capitalism. In T. Docherty (Ed.), *Postmodernism, A Reader*. New York: Columbia University Press.

Kac, E. (Ed.). (2007). *Media Poetry: An International Anthology*. Bristol: Intellect Books.

Kac, E. (2007). *Space Poetry*. Retrieved February 18, 2019 from http://www.ekac.org/spacepoetry.html

Karpinska, A. (2008). *Shadows Never Sleep*. Retrieved May 18, 2019 from http://www.technekai.com/shadow/shadow.html

Lazzarato, M. (2007). Machines to Crystallize Time. *Theory, Culture & Society*, *24*(6), 93–122. doi:10.1177/0263276407078714

Marcuse, H. (1964). *One-dimensional Man: Studies in the Ideology of Advanced Industrial Society*. Boston: Beacon.

Matrix raining code. (n.d.). Retrieved May 18, 2019, from https://www.youtube.com/watch?v=kqUR3KtWbTk

Mitchell, W. J. (1996). What Do Pictures "Really" Want? *October*, *77*, 71-82.

Mondada, L., & Locher, M. A. (2014). Linguistics and the New Media. *Dichtung-digital*, *44*. Retrieved May 18, 2019 from http://www.dichtung-digital.de/journal/englische-artikel/?postID=2538

Ochshorn, R. M. (2013). *Chewing*. Retrieved May 18, 2019, from https://flatness.eu/chewing_time/index.html

Page, R., & Thomas, B. (2011). *New Narratives. Stories and Storytelling in the Digital Age*. Lincoln: University of Nebraska Press.

Pavalanathan, U., & Eisenstein, J. (2016, November). More emojis, less:). The competition for paralinguistic function in microblog writing. *First Monday*, *21*(11), 7. doi:10.5210/fm.v21i11.6879

Penney, T. (2016). Digital Face-ism and Micro-Fascism. *The Official. International Journal of Contemporary Humanities*, *1*(1). Retrieved October 6, 2019, from https://www.researchgate.net/publication/331033518_Digital_Face-ism_and_Micro-Fascism

Retort. (2004). Afflicted Powers. *New Left Review*. Retrieved May 18, 2019 from https://newleftreview.org/II/27/retort-afflicted-powers

Servaes, J., & Hoyng, R. (2017). The tools of social change: A critique of techno-centric development and activism. *New Media & Society*, *19*(2), 255–27. doi:10.1177/1461444815604419

Seyfert, R., & Roberge, J. (2016). *Algorithmic Cultures: Essays on Meaning, Performance and New Technologies*. New York, London: Routledge. doi:10.4324/9781315658698

Smith, J. (1976). *The Girl Chewing Gum*. Retrieved May 18, 2019 from https://www.youtube.com/watch?v=57hJn-nkKSA

Ståhl, O. (2016). Kafka and Deleuze/Guattari: Towards a Creative CriticalWriting Practice. *Theory, Culture & Society*, *33*(7–8), 221–235. doi:10.1177/0263276415625313

Strehovec, J. (2016). Text as Ride. Morgantown: Literary Computing, VW University Press.

Teller, A. (1997). *Exegesis*. New York: Vintage.

Vashi Visuals. (2015). *The editing of MAD MAX Fury Road*. Retrieved May 19, 2019 from https://vashivisuals.com/the-editing-of-mad-max-fury-road

Vrilio, P. (1991). The Aesthetics of Disappearance. New York: Semiotext(e).

Wagner, C., Aguirre, E., & Sumner, E. M. (2016). The relationship between Instagram selfies and body image in young adult women. *First Monday*, *21*(9), 2016. doi:10.5210/fm.v21i9.6390

Weinstein, M. (2006). *Short and Sweet: Storytelling in 300 Words*. Retrieved May 31, 2019 from https://www.poynter.org/2006/short-and-sweet-storytelling-in-300-words/74791/

Wyatt, S. (2008). Technological determinism is dead, long live technological determinism. In E. J. Hackett, O. Amsterdamska, M. Lynch, & J. Wajcman (Eds.), *The Handbook of Science and Technology Studies* (pp. 165–180). Cambridge, MA: The MIT Press.

Zappavigna, M. (2011). Ambient affiliation: A linguistic perspective on Twitter. *New Media & Society*, *13*(5), 788–806. doi:10.1177/1461444810385097

96

Chapter 5

The Politics Through Arts and Culture: On Slovenian Literary Nationalism

ABSTRACT

The expanded concept of work of art that challenges the boundaries of aesthetic theory and directs the attention toward the artistic service as a flexible cognitive activity is useful in the field of politics. Today's societies are faced with the expanded concept of the political that is set at the intersection of politics-as-we-know-it (including the national state and the parliament) and the novel modes of the (post)political including the activities of civil society, international organizations, and the cultural. This chapter refers to the Slovenian literary nationalism as one of the key Slovenian ideological state apparatuses that is at play in today's Slovenian politics and is deeply affected by not-just-political agents from economy, religion, lifestyle, and culture. The criticism of literary nationalism is not directed towards the activity of writing and the literary world but towards institutions that form a literary-ideological, interpretative, and propaganda context of national literary production.

DOI: 10.4018/978-1-7998-3835-7.ch005

Copyright © 2020, IGI Global. Copying or distributing in print or electronic forms without written permission of IGI Global is prohibited.

The Politics Through Arts and Culture: On Slovenian Literary Nationalism

INTRODUCTION

Events in contemporary political reality diverge from expectations. In order to explain their complexity, causal chain analysis and the use of traditional methodology are not sufficient; research should include the approaches of the political theory, analyses of institutions of the contemporary civil society, contributions from cultural studies, and the theory of those movements in post-aesthetic contemporary art and literature that perform political functions. Contemporary politics is being pursued at the intersection of various fields, one of the generators of its innovations is the art and literature. In the global world of hybrid content interconnected with software units (Internet of things, ubiquitous computing, Cloud, Big data), interdisciplinary and multidisciplinary approaches are required, including contemporary art and literature conceived as research and service activity. The challenge is the today's individual with her lifestyle, views and decisions that are more affected by multinational marketing, civil society organizations, and social media than by decisions of political parties in national parliaments. A look at the pedestrian below in the crowd (De Certeau, 1984) and her tactics provides more exactly an explanation of today's public space and the distribution of power in it than the analysis of strategies of large systems (nation states, multinationals, the military complex).

To understand the political in totalitarian (national-socialist, communist) and post-communist European countries, it is essential to take into account the social position of culture that played (and still plays) numerous important roles in these countries. In German national-socialism, culture (based especially on the arts) was used for propaganda purposes, as a means to spread the Aryan ideology (e.g. the blood and soil principle), and played a role in education and self-promotion of the German question (Hinz, 1979; Petropoulos, 1996). In the Soviet Union, where the approved artistic style was socialist realism, culture had, first and foremost, a propagandistic and educational function, whilst in the countries of the Warsaw Pact (e.g. Poland, Czechoslovakia) and in former Yugoslavia, it also functioned as an area which formed an important part of the opposition articulated as the so-called cultural dissidence.

The fall of the Berlin wall allowed the emergence of new post-socialist countries in Central and Eastern Europe and accelerated the transition to democracy in some of them. When these countries were established, numerous individuals who were for decades unprivileged under the Communist

government (e.g. religious individuals, nonconformist artists, and social scientists) considered themselves as winners and started to act accordingly. Rather than developing non-authoritative behaviour and helping to establish new democratic institutions, they established themselves as the new aristocracy and started to enjoy the privileges of winners. Since the declaration of independence in 1991, such individuals in Slovenia have included the so-called liberators (individuals who participated in the establishment of the new country) and especially intellectuals (predominantly writers, philosophers, and sociologists) of the journal Nova revija. Shortly afterwards, this spirit, tied to symbolic capital (Bourdieu, 1984) of the national independence endeavor, also spread to writers from other circles that are not explicitly nationalist, e.g. circles around the literary journal Literatura and Beletrina publishing house. Instead of literary nationalism in the strict sense they relate much more to the yuppie and hipster culture in the sense of the authoritative attitude based on new marketing and promotional devices.

Established, media and cultural politics supported Slovenian writers consider themselves as the core of the nationalist elite, demand more rights for themselves in comparison to other groups of citizens, while in parallel, their intellectual core is mostly weak and shallow. Today, we are contemporaries of a series of cultural turns, such as performative (Fischer-Lichte, 2004), and new paradigms (internet of things, cloud computing, blockchain technology, discoveries in the field of molecular biology, particle physics) that affect contemporary art (e.g. bio art, performance art, and new media art installations), whilst many of the Slovenian writers remain caught in the paradigm of Reading-room ideology (expressed by the popular Tone Pavček's claim "If we won't read, the bucket we will hit"). Their debates are 60 or more years behind what is currently being discussed by the intellectuals dealing with new media art, Visual art, and Performing art. Similar lagging of US writers was already addressed in 1959 by Brion Gysin who complained that writing was lagging *50* years behind painting (p. 135). In the Introduction to *The New Media Reader*, Lev Manovich argued that:

this book is not just an anthology of new media but also the first example of a radically new history of modern culture – a view from the future when more people will recognize that the true cultural innovators of the last decades of the twentieth century were interface designers, computer game designers, music video directors and DJs -- rather than painters, filmmakers or fiction writers whose fields remained relatively stable during this historical period. (p. 16)

The Politics Through Arts and Culture: On Slovenian Literary Nationalism

Intellectual weakness of the Slovenian literary community is demonstrated by a section of articles on the topic of *Literature and politics* published in the journal *Literatura* which mainly ignores the very nature of politics in 2018. Politics had significantly changed due to the new post-political actors, while in parallel, the artistic activism and hacktivism opened up new ways to articulate the political. This section of articles also disregards the possibility for the artistic (also literary) activists to use their interventions to extend the area of political or try to reinvent it in the recent post-political age (Mouffe, 2007). More politics through arts and culture is today an imperative and is being used by art activism with approaches that deploy subversive affirmation, prank, and over-identification (e.g. projects by Anonymous, EDT, The Yes Men, and Janez Janša group).

Slovenia is also a host of international meetings focused on glorification of literature and literary intellectuals' views on politics (e.g. PEN Conference in resort Bled). At these meetings, a collective ecstasy is established by means of literary fascination, all characterized by something "more", i.e. the effects arising mainly from the rituals of social gathering and writers' debates about current topics. The PEN community in the present often includes writers with modest literary opus which is why in their numerous discussions about political topics they often come up with moralizing conclusions. The Slovenian state, where literary nationalism represents one of the dominant ideological features, dedicates significant financial support to such representative social gathering with allegedly strong propaganda effects – presentation of Slovenia in front of the international public.

In term of methodology this chapter refers to approaches of media studies, cultural studies, theory of ideology, philosophy, sociology of culture, and Marxian criticism. Rather than deploying traditional concepts of artwork and literary work, in the next, art activism chapter is introduced the concepts art service and literary service that more correctly address the role of art and literature in the world of cognitive labor, knowledge society, and service economy.

LITERARY NATIONALISM AS AN IDEOLOGICAL STATE APPARATUS

The ideology that accompanies the context, where the Slovenian literary production and the related representative rituals are being realised, is literary

The Politics Through Arts and Culture: On Slovenian Literary Nationalism

nationalism as one of the key Slovenian ideological state apparatuses (Louis Althusser's concept). Rather than being a simple derivative of European nationalism of 1848 (the nationalism of the Spring of nation), the present Slovenian literary nationalism is more subtle ideology of power which deploy a number of state-of-the-art devices and procedures applied for propaganda purposes. Instead of classical nationalism of the Spring of nations we are facing today the second order literary nationalism which deploys several subtle strategies. As an EU and NATO member state and on the basis of the Constitution, the Republic of Slovenia is a democratic post-communist country established on the foundations of the Socialist Republic of Slovenia which was the most developed republic of the former Yugoslavia. In fact, it is a country where the transition to democracy has failed and where a set of so-called left-wing parties defend the privileges of old national-communist elites. Slovenia is characterized by intellectually weak right-wing opposition which includes right-wing media and right-wing civil society. From one year to another, it is also possible to detect intellectually weaker and weaker left-wing parties tied to state authorities which pointed out the national interest (closure of the national economy in order to strengthen the internal market which is considered as essential for the country, scepticism towards foreign investments, opposition to NATO and EU, only marginal opposition to the construction of the fence on the border with Croatia intended to stop the migration flow) even before Donald Trump was elected as the president of the USA. The concept of national interest which Luka Mesec, the leader of the Levica party, expressed in the demand for strengthening of the internal market in order to become less dependent on the import, which is allegedly the 'Achilles heel' of the Slovenian economy (magazine Reporter, 2018), recalls the blood and soil national-socialist concept in German Third Reich. It looks like that in today's Slovenia the far right-wing populism and nationalism goes hand in hand with the far left-wing populism and nationalism.

Such situation generates cultural and especially literary nationalism (in the second order mode) which exploits the Slovenian obsession with national identity, national interests, national character, hostile other (e.g. hostile neighbour nations, emigrants, artists dealing with the excessive bio art) and borders (national communism directed against the universal Roman Catholic Church and praising national interest hidden in front of the hatred emigrants is the main ideological paradigm of the post-transitional Slovenia). In this chapter, the Slovenian culture with its second order literary nationalism is considered as a phenomenon which should challenge critical theory of society in order to analyse how is it possible, in this day and age, for a country with

The Politics Through Arts and Culture: On Slovenian Literary Nationalism

two million people to develop practices and rituals of the extremely regressive ideology.

THE EXAGGERATIONS WITH THE LITERARY METAPHYSICS

In Slovenia, the literary institutions and especially writers foster and promote expanded literary reproduction. These efforts resulted in a nation with extremely expanded national culture and aggressively imposed literature which can be compared with the Amish culture due to its extremity and ahistorical behaviour. Slovenians actually don't share any contents with the Amish, have nothing in common with Amish rejection of (modern) technologies, their simple way of life, clothing, or their religion. The only thing connecting them is the extremism in the sense of noticeable exaggeration in the special cultural field. In the case of Slovenians, this is the field of literature considered in the metaphysical sense, where thousands of Slovenians would like to work especially as writers. Most of them are not devoted book readers, they relatively seldom read books by their contemporaries, and are predominantly interested in writing that should, because it is an activity that preserves and promotes national identity (literary nationalism is based on this idea), guarantee a solid income, fame, and entry into the literary canon (especially into primary and secondary school textbooks).

These authors demand from the state to use the taxpayers' money to translate their works into English and other European languages and to support the publishing of their works by foreign publishing houses cooperating in such projects. The result is simply absurd: In European countries and in the US, where poetry is extremely marginalised and is of interest only to rare academic communities, the Slovenian poetry should be printed and distributed with the purpose to promote Slovenian culture and statehood. Copyright protected work in the fields of literature and art should be a profession of a noticeable part of Slovenians. This demand is accompanied by authoritative discourse which immediately eliminates and overrides individuals who show any doubt in the meaning of such panliterary and panartistic Slovenia.

In the text above we used the term 'imposed literature' because institutions of recent literary nationalism exploit numerous mechanisms of power in order to impose the citizens with their own interests and demands that are of little importance in comparison to the international literary culture. This

is mainly done with the use of the educational apparatus since students in schools also have to gain thorough knowledge about modern national authors and their works.

Apart from being focused on the educational apparatus, second order literary nationalism also focuses on numerous festivals, celebrations, rituals (e.g. celebration of the national cultural day which is an official non-working day in Slovenia), party politics and media. It is directed to national identity which is subjected to language whose guardians are the writers themselves; by reading their works the Slovenians constitute themselves and reproduce as a nation. The already mentioned Tone Pavček's claim "If we won't read, the bucket we will hit" favours reading of literature-based literacy (which is in practice favoured at the account of several other functional literacies, e.g. the digital).

The care of native language preservation is an important task of Slovenian authorities, the participation of national writers in fostering and developing language is crucial (this chapter does not disregard this endeavour), what is at issue here is just a metaphysics or a belief which is demonstrated in a way how Slovenian writers exploit their role in promoting native language.

ARTISTIC AUTONOMY AS AN ALIBI

Dissident writers (e. g. internationally renowned Czech author Havel and Russian writer Solzhenitsyn) characteristic for the socialism were often the subject of political persecution and punishment. It is also possible to find such cases in Slovenia as a part of former Yugoslavia (e.g. multiannual or multidecadal blocking of the publication of certain literary works, Balantič's poems for example), although in smaller numbers than elsewhere. In their defence (during institutionalised persecution and blockage) writers generally appealed to artistic autonomy in the sense that the reality of literary characters appearing in these works is so specific that there is not a point to consider them as real individuals. They actually act as the as-if real characters with a similar ontological status as the fictitious characters (e.g. centaurs) discussed in phenomenological aesthetics (Moritz Geiger, Eugen Fink, and Roman Ingarden). Dissident writers therefore used artistic and literary autonomy as an alibi for articulation of political disagreement with the ruling class and political elites.

In Western democracies, it is difficult to imagine opposition articulated through the arts and culture. In Slovenia, such opposition (using the artistic

autonomy devices) was widely reproduced and involved in the establishment of the journal Nova revija (1982-2010) which played an important role in the Slovene independence process and also in the formation of the transitional and post-transitional Slovenia. In post-socialist Slovenia, Nova revija functioned as one of the building blocks of literary nationalism, especially its 57th issue where the Slovenian national programme was published. The authors (the key was philosopher Tine Hribar) and editors of this journal are regarded as the so-called liberators and benefited from numerous privileges provided by the transitional Slovenia. Some of them became ministers (e.g. Minister of Foreign Affairs and Minister of Culture), whilst others occupied the leading positions in the publishing industry, media, and universities.

SOCIAL AND INTELLECTUAL CONTEXT OF LITERARY NATIONALISM

In the 21st century, sciences, technology, media, civil society, politics, art, design, and creative industries are the bearers of innovations. They take a part in the formation of new scientific and cultural paradigms that affect the present intellectual and creative landscape. Art is only one of the important factors here. Especially art associated with the science which applies new technological advances (such an art explores rather than represents). Slovenia is not deficient in the field of research art. The practice and theory of new media art with the striking function in research have been forming for two decades now. Amongst the practitioners we have to mention Vuk Čosić (one of the pioneers of net.art), Maja Smrekar, and Marko Peljhan (both the winners of Golden Nica, the 'Oscar' of electronic art awarded by Ars electronica, Linz). Artists (and theoreticians) of new media art are integrated in international cooperation, they take a part in the creation of new cultural paradigms.

Literature occupies a special place in the Slovenian art and is recognized as the drive of national identity and preservation of the language. This particular position of national literature can be explained with the syllogism:

Writers constitute the Slovenian nation.
I am a writer.
I constitute the Slovenian nation.

It is on the basis of this conclusion that the writer starts making demands against the state. She establishes partner relations with the state and demands a big increase of budgetary funds for culture, which would, apart from the fees, also include more resources for working grants. Writers do not stand shoulder to shoulder with other citizens who were often put in an impossible economic position by globalization, neoliberalism, and precarious labour. They keep to themselves as if they were something more and have an added value due to their participation on symbolic capital. They have no understanding for modern social tendencies (e.g. in the already mentioned section of articles on the topic of literature and politics in the journal Literatura), show no solidarity, and only demand advantages from taxpayers' resources. With their demands they don't expand the political area but develop extremely partial and narrow policy of their own interest group which demands privileges for itself.

MANIFESTATIONS OF THE SLOVENIAN SECOND ORDER LITERARY NATIONALISM

In Slovenia, a writer acts as an individual with the added value and as one who is as such also perceived by her reviewer. Let us quote the opening words from the review by Ana Schnabl.

"I have the honour to write the review of a top-class Slovenian novel which, in my humble opinion, must become a public asset for all the reading Europeans. And, of course, it must receive the Kresnik award. I am writing about the last literary work by Mojca Kumerdej poetically entitled The Harvest of Chronos" (p. 228). These aren't opening words of a political speech at a certain celebration spoken by someone in power but the beginning of the text which the author considers to be a review. Ana Schnabl does not give a superlative review after the conclusion of the analysis and the reviewing process, which also includes comparison with Slovenian and foreign novels on the same topic, but immediately opens up the review with superlatives. She does not only express her review, but in a political manner also proposes the future destiny of the reviewed text, in the sense that it must become a public asset for all reading Europeans, and also that it must receive an award. In this Slovenian example, the reviewer does not only review the work itself, but also tries to put it into a context of dissemination and public recognition (i. e. award for the best novel of the year). The novel must become a public asset – this opinion is not a neutral suggestion, but a genuine demand. Such

The Politics Through Arts and Culture: On Slovenian Literary Nationalism

opening words of the review redefine the reviewer practice. The reviewer acts as an individual who is also a politician, someone who controls the context of the placement of the literary work.

The next example of the Slovenian second order literary nationalism is the reception of Boris A. Novak's epic poem *Vrata nepovrata* (The Doors of No Return; 2017), a project written in three books, Zemljevidi domotožja (T*he Mapping of the Forsaken Home*), Čas očetov (The Time of Fathers) and Bivališča duš (Residences of Souls), with more than 40,000 verses on 2.302 pages. Epic poem is a literary form associated with a special material, spiritual, and communication culture. It functioned as a historical chronicle, myth, "color television", collective experience, religion, politics and documentation of a certain historical period far before the modernist differentiation of the fields of science, media, politics, art, and literature (Lash, 1990). The author has every right to write epic poems also in present times and to continue and intensify this conduct (for example, he can produce an epic poem with several hundred thousand verses and recite it with his like-minded supporters for months and months), but the horrible fact is that in the present times the literary theoreticians, reviewers and the public declare writing of an epic poem as an epochal achievement (Košir, 2017) and underline that this made Slovenes equal to the great nations with their own epic poetry.

As extremely ridiculous appears the next case of Slovenian exaggeration with the literature, which demonstrates the Slovenian smallness. The national television (Televizija Slovenije) invited in its Culture show (Kultura, 3. March 2015) the young French author named Clément Bénech, because he mentioned Slovenia in the name of his first novel, specifically *L'été Slovene* (2013), and in the novel content refers to Slovenian tourist destination Bled. Bénech took a part as a special guest also at Fabula festival of world literatures in Ljubljana, 2015. Rather than the quality of his novel or the writer's international reputation, the criterion of his invitation based on the very fact of mentioning Slovenia in his novel.

These cases are accompanied with faith in strong literary propaganda effects. The nation glorifies the function of literature designed as a time-transcending machine, whose forms and genres can be used by writers in various time periods for their own needs and for the sake of the nation. In doing so, these writers-ideologists-politicians abstract individual literary forms and genres, their material cultures and their spiritual world from the very historical context. They consider the epic poem as an available, forever relevant textual depository (de Vries, 1961), into which they can reach at any time and start to continue its show.

IDEOLOGICAL STATE APPARATUSES

The theoretical foundation for understanding the new generation of literary nationalism as the ideological state apparatus can be found in Louis Althusser's social theory. He argues that ideological state apparatuses, which are strictly separated from the repressive state apparatuses, also include the cultural apparatus (literature, the arts, sports, etc.). "The Repressive State Apparatus functions 'by violence', whereas the Ideological State Apparatuses *function 'by ideology'.*" (1971) In the following sections he emphasizes that "the Ideological State Apparatuses may be not only the *stake*, but also the *site* of class struggle, and often of bitter forms of class struggle", which means that it is mandatory to take them into account in order to understand the struggle for power in a certain social formation. If they are neglected, as this is done by Slovenian right-wing parties, it is possible to lose a lot of voters.

Ideological state apparatuses function through ideology which is in modern times realized through spectacle and the mastery of images. (Retort, 2004) Literary nationalism uses functions of the spectacle, and sustains itself with rituals, myths and religious-like ceremonies. Reading of literary works is not enough. It is also mandatory to experience as much as possible, which is why the Slovenian literature requires a scene shaped by rituals of spectacle (e.g. Kresnik award presentation ceremony which takes place every year on the hill Rožnik above the Ljubljana).

As the ideological state apparatus, the Slovenian second order literary nationalism is driven by the ideology of spectacle and is not just a random "Amish" peculiarity but in the interest of the post-socialist Slovenian state. Cooperation of national literati in such a project would be insufficient. The project also requires state's contribution which promotes literary nationalism in present mode, not only through the cultural apparatus, but also through the educational apparatus and media, in order to internalize and include it in its main national ideology. The key idea of this chapter is that second order literary nationalism represents an essential part of the Slovenian ideology whose fundamental feature can be understood by means of literary nationalism itself. By drawing upon Said's Orientalism concept in terms that it "has less to do with the Orient than it does with 'our' world" (p.12), we can say that Slovenian literary metaphysics tells more on the Slovenian state and their cultural ideologists than it tells on the national literati.

In order to understand the Slovenian ideology it is useful to take into account the "Californian ideology" model presented in the article with the same title

The Politics Through Arts and Culture: On Slovenian Literary Nationalism

written by Richard Barbrook and Andy Cameron (1995). The authors address the expansion of new industry based on smart machinery which produced the marketing, technological and ideological hype connected with the American West coast and which included the cooperation of writers, artists, hackers and capitalists, meaning that an alliance between the entrepreneurs and counter-cultural professionals was formed.

Barbrook and Cameron write on heterogeneous orthodoxy, bizarre fusion of the cultural bohemianism of San Francisco with the hi-tech industries of Silicon Valley, on connecting of the free-wheeling spirit of the hippies and the entrepreneurial zeal of the yuppies, the principles of tehnology and the freedom, the disciplines of market economics and the freedoms of hippie artisanship, tehnological determinism and libertarian individualism (Barbrook & Cameron, 1996).

Such contradictory mixture is not coincidental, but contributes to the stability: it gives something to everyone, Technology legitimises the principle of freedom and the latter legitimises technology. It seems that yuppies need bohemians and hippies who provide them with stability. Likewise, counter-cultural hippies, who are regarded as a synonym for non-conformist individuals and also artists, have nothing against relationship with the rich. Each part of this at first glance non self-evident relationship aims to legitimize itself through its counterpart.

The current Slovenian ideology is similar to the Californian ideology. It is also based on the sophisticated balance of incompatible components, i.e. neoliberal economy, politics, and technology on one hand and modified literary nationalism on the other. In this regard we should emphasize that such, at first glance, instable relationship, based on the ideology of connecting weakly compatible components is certainly not just an invention of the West coast in the last decade of the 20th century. If we look at Germany in the period between 1933 and 1945, it is possible to detect the coexistence of technological, architectural, cinematic, communicational, media, and military modernism with extreme archaism represented by the native ideology based on literary and art blood and soil (Ger. Blut und Boden). The Third Reich was not only tied to the ideology of glorification of the Aryan race and lamentations about the German disadvantage in the imperialist division of the world, but also included a series of technological innovations that came into individual's day-to-day life: VW cars, motorways, radio, film industry boom, construction of buildings with large amounts of reinforced concrete and glass.

107

CONCLUSION

Literary nationalism (in present second order mode) has nothing to do with literariness, poetics, aesthetics, or creativity. It is only interested in the ideology which it constructs from the literature intended for political-propaganda purposes. Rather than exploring in literary studies and comparative literature, the literary nationalism challenges the research in cultural studies, critical theory of the society, political theory, and post-communism theory. If literary nationalism is not concerned with the aesthetics and literariness this does not mean that it does not include writers and their attitude towards literary production. They have the possibility to resist the ideological-propaganda-political appropriation of their works by the ruling class, social groups or elites, or can be quiet and agree with the story into which ideologists place their works.

In Slovenia, one can see that most of the authors like to cooperate in such national-revivalist and Reading-room story which allows them to participate in something "larger", something that accompanies this story and surrounds their literature. When writing their works, numerous authors themselves develop such pathetic discourse that accompanies the placement and evaluation of their works. This applies to the authors belonging to the journal Nova revija circle, as well as those belonging to the Beletrina publishing house and Literatura journal.

Why are we emphasizing the role of modified literary nationalism in Slovenia? Because we are talking about a conservative and irrational ideology, modest intellectual basis of the participants of literary rituals, formation of a social group that claims privileges, anachronistic behaviour based on the abstraction from the actual challenges of the social and intellectual reality in the second decade of the 21st century. We are also talking about the play of the national politics which strives to reach a national consensus that would be as stable as possible: The national politics tries to neutralize the set of neoliberal and globalization projects and practices (political and economic modernisation) by allowing the archaic national literary ideology and its institutions. In this respect, the writers can also be regarded as profiteers who occupied a privileged position required by a modern society in order to manipulate with the voters and taxpayers. The national politics provides them with the Slovenian version of the Californian ideology and consequently privileges (participation on symbolic capital) which, this has to be emphasized,

are no greater than those enjoyed by artists employed in Slovenian national institutions (drama, opera, ballet, philharmonic society).

Criticism of literary nationalism is not directed to the writers' concern for the Slovene language and its enrichment, but points out that writers are not immune to irrationalism which accompanies euphoric exaggerations and pathetic rituals in their field. As a rule, writers are found among the critics of totalitarianism and of human rights abuses, but some of them also contribute to fascist ideologies and even call for ethnic cleansing. In the former Yugoslavia, certain poems and novels also called for violence (e.g. works by Vuk Drašković and Radovan Karađić).

REFERENCES

Althusser, L. (1971). Ideology and Ideological State Apparatuses. In *Lenin and Philosophy and Other Essays*. New York: Monthly Review Press. Retrieved March 17, 2019, from https://www.marxists.org/reference/archive/althusser/1970/ideology.htm

Benech, C. (2013). *L'été Slovene*. Paris: Flammarion.

Benjamin, W. (1969). The Work of Art in the Age of Mechanical Reproduction. In *Illuminations* (H. Zohn, Trans.). New York: Schocken Books.

Bourdieu, P. (1984). *Distinction: A social critique of the judgement of taste*. Cambridge, MA: Harvard University Press.

De Certeau. (1984). *The Practice of everyday Life*. Berkeley: University of California Press.

De Vries, J. (1961). *Heldenlied und Heldensage*. Bern, München: Francke.

Drucker, J. (2018). *The General Theory of Social Relativity*. The Elephants Ltd.

Gysin, B. (2003). *Tuning in to the Multimedia Age* (J. F. Kuri, Ed.). London: Thames & Hudson.

Košir, M. (2017). Bivališča duš. *Bukla,* 132-133. Retrieved May 12, 2019, from https://issuu.com/revijabukla/docs/bukla-132-133

Manovich, L. (2003). In N. Wardrip-Fruin & N. Montfort (Eds.), *New Media from Borges to HTML. Introduction to The New Media Reader* (pp. 13–25). Cambridge, MA: The MIT Press.

Novak B. A. (2018). *Vrata nepovrata: epos. Knj. 1, Zemljevidi domotožja 2*. Novo mesto: Goga.

Retort. (2004). Afflicted Powers. *New Left Review*. Retrieved July 18, 2018, from https://newleftreview.org/II/27/retort-afflicted-powers

Said, E. (1978). *Orientalism*. New York: Pantheon.

Schnabl, A. (2017). Pred žetvijo smo vsi enaki. *Literatura, 29*, 307-308.

Stallabrass, J. (2004). *Art incorporated: the story of contemporary art*. Oxford, UK: Oxford University Press.

Strehovec, J. (2016). *Text as Ride*. Morgantown: West Virginia University Press.

Virno, P. (2004). *A Grammar of the Multitude. For an Analysis of Contemporary Forms of Life* (I. Bertoletti, Trans.). New York: Semiotext(e).

Chapter 6

The Subversive Affirmation as a New Device of Art Activism Deployed in Post–Political Reality

ABSTRACT

The transition of activist art from the utopian projects of the society as a work of art into its present activistic phase based on artists' serious political engagement implies significant aftermath in extra-artistic reality. Whereas the projects such as social sculpture (Joseph Beuys notion), temporary autonomous zones (Hakim Bey's concept), and total work of art (expression used by K. F. E. Trahndorff and R. Wagner) were accompanied by explicit confidence of artists in the liberating power of artistic creativity, today's activists enter pure political "direct action," which often fits well to daily engagements of political parties. This chapter addresses the Slovenian case of Janez Janša activists' group deeply involved in daily politics, precisely in the struggle against the politician Janez Janša. In doing so, these activists deploy subversive affirmation as a new subtle political device that enables them an alibi due to their background in elitist institution of art.

DOI: 10.4018/978-1-7998-3835-7.ch006

Copyright © 2020, IGI Global. Copying or distributing in print or electronic forms without written permission of IGI Global is prohibited.

INTRODUCTION

Although the (social) subsystem of art (especially in its autonomous development in the nineteenth and twentieth century) is explicitly auto-poetic and self-referential (contemporary art seems to be a self-feeding machine which needs to reinvent itself with each movement and new genre), such noticeable turns in contemporary art are possible in the presence of profound and essential shifts arising in other fields as well. Reality itself has mutated too, it has passed over noticeable turns and shifts of paradigm; nowadays we can find out that traditional concepts and devices for its understanding have become useless, even obsolete. All its important components have become included in a new constellation defined by bio-politics, post-political politics, technosciences, globalization, multiculturalism, new empire, new – to the exclusion – even more fatal social segregations and new lifestyles. The solo play of the contemporary art would not be possible today, if the 'prime' (given) reality components and forces would not undergo such transformations; in the fields of science, technology, and politics processes occurred which lead towards their art-like nature in terms of destabilization and relativization of traditional forms, one could say as parallels between destabilization of artifact in today's art and destabilizations of national state in the globalized (trans) politics, material wealth in (new) economy and the project of discovering natural laws in technosciences.

The contemporary science has mutated too, it has abandoned the project of revealing natural laws in terms of scientific decoding of nature's open book. By this we mean nature as representing the objectivity of natural world as a stable given reality based on inherent order, and nature that can be exactly observed, measured and interpreted by means of information based on empirical observations. Here is significant Paul Feyerabend's claim from his essay *The Nature as Work of Art (Ger. Die Natur als ein Kunstwerk)*, where he argues "nature is a work of art designed by generations of artists, who are considered as scientists today" (Feyerabend, 1993, p. 278). This notion makes a certain concept of objective nature, sustained in the traditional natural science, as relative and historic one, for "what we find when researching nature (…) is not nature alone, but the way how nature responds to our efforts" (ibid, p. 286). The world of scientific research is on the move either. In place of the profound specialization so prevalent within the modern science of twentieth century, there is a novel emphasis on the need to have creative work across the boundaries, disciplines and the *two cultures* divide (Snow, 1959).

The Subversive Affirmation as a New Device of Art Activism Deployed in Post-Political Reality

Present (social) reality is also defined by the new economy based on e-business globalization, networking, flexible production, services, algorithmic trading, and information technologies. In the USA approximately four fifths of employees no longer produce things. They are employed in professions requiring moving of things, handling or producing of information and other intellectual services. Due to the new economy based on intangible capital, global smooth space transactions and closely connected to the stock exchange, and e-business (e-enterprises as Cisco Systems, Yahoo, Google, Amazon, etc.), based on 'networked business model' (Castells, 2002, p. 68) the stress is shifting from material wealth towards intangible, immaterial wealth (the latter grows faster within stock exchange processes than the material one) and towards intellectual services, among which also art can be found. Abandoning the value of material production in the new economy and even its devaluation and shift towards (intellectual) labor and services coincide with the frequently mentioned tendency accompanying contemporary art, namely the shift from a complete artifact to an art service. Various parallels can be drawn between the two fields today; the art (sub)system too frequently works as a stock exchange, it is faced with rapid evaluations of certain works and steep slumps of their value, meaning that it is no longer possible to explain anything in both fields by means of common sense. The shift from artwork as artifact to art service, which is as customized and oriented towards knowledge production as possible, reasonably connects both fields. Just as an example we can mention that the stock exchange, e-business, trademarks, multinational corporations, etc. are also becoming a motif and topic of various artistic projects. Many contemporary artists have used various e-commerce strategies in order to form projects that are in their core critical to capitalistic way of production and consumption. One among them is Michael Goldberg's *Catching a Falling Knife*, which took place in Artspace, Sydney, between 17 October and 9 November 2002, and this field was pioneering with the net artists, too (e.g. Etoy and RTMark).

It is essential for today's reality, undoubtedly defined by the emptiness existing since the September 11, 2001 on the ground zero in Manhattan, New York that within this reality also a profoundly changed politics articulates. The globalization processes, based on new information technologies, multiculturalism, postcolonialism, and new colonialism, have significantly shaken up the basic concepts of politics and influence (the power of so-called parliamentary democracies) bound to the national state. In the world of different temporalities, meaning temporalities in plural, coexist the liberal forms of democracy, tied to capitalism, and the most extreme forms of nationalism,

tribalism, populism, and fundamentalism, which, even at the beginning of the twenty-first century, re-actualize forms of ethnic cleansing and ritual killings of their political opponents. Destabilization of national state in contemporary politics means that many decisions of international organizations (with no democratic mechanisms of control), multinational corporations, and the recent social media have much more far-reaching consequences for the everyday life of the citizens (and for shaping of their needs and opinions) than resolutions and decisions of parliaments and other democratic institutions. Facing the issue of multitude and the new political subjects in the present world of post-Fordist labor, Paolo Virno (2004) has introduced the term of post-political politics, which refers to various political activities beyond the state and its decision-making mechanism.

That is why in the milieu of such social turns new political subjects come to the fore, which can even take over positions of traditional institutions of civilian disobedience. One of them is certainly activism, also carried out by some artistic groups (*Radical Software Group* for example), especially those cooperating with technical experts in the field of new media, among which hackers are most important. Hacktivism, the term combining activities of hackers and political activists is based on electronic civilian disobedience and believe that traditional society institutions are more vulnerable in their cyberspace forms than in their traditional representations bound to the physical world. The way, how hacktivists work is that hackers deliver weapons, while activists locate the targets against which the weapons are to be used. At this point let us mention actions directed towards blocking the servers of the opponent institutions, one could say, a unique cast – so-called virtual sit-ins (e.g. SWARM action on behalf of the Zapatistas by means of Java script program Floodnet, produced by the Electronic Disturbance Theatre, 1998).

SLOVENIAN ART ACTIVISM

An example of radical art activism which mainly abandons the artistic way of acting and focuses on the world of pure political goals is The Janez Janša project, focused primarily on the film entitled "I am Janez Janša" (2013). In 2007, three Slovene artists and art managers (two of them are directors of private cultural institutions, namely Maska and Aksioma, while one is professor at the Academy of Fine Arts of the University of Ljubljana) who are active in the Slovene cultural space renamed themselves Janez Janša, which in fact is the name of a concrete person, namely according to (old)

The Subversive Affirmation as a New Device of Art Activism Deployed in Post-Political Reality

ideological representations a right-wing politician who was the Prime Minister of the Republic of Slovenia (from 2004 to 2008), while before and after that term he was the leader of the Slovenian opposition and leader of the SDS (Social Democrats of Slovenia) party (he was the prime minister again for a very short period in 2012-2013). Up to March 2020, the SDS party was the strongest opposition party in Slovenia, as an EU member state, which is usually dominated by left-centre parties while the opposition is extremely intellectually undernourished, weak, and almost completely incompetent in terms of social theory. In March 2020 Janez Janša was back as the Prime Minister of the Republic of Slovenia. The renaming of these artists was definitive for two of them (only the teacher Žiga Kariž abandoned the common name Janša in 2012) and not an occasional assuming of identities in confrontation with corporations and transnational organizations (e.g. WTO), which is what The Yes Men does.

The Janez Janša project was conceptually based on subversive affirmation as the original device of art activism:

Subversive affirmation and over-identification are tactics — if we are to follow Michel de Certeau's definition — that allow artists to take part in certain social, ideological, political, or economic discourses, and affirm, appropriate, or consume them while simultaneously undermining them. On the Western art scene, these phenomena appeared here and there among the Lettrists and the Situationist International. (Arns & Sasse, 2005)

The authors of this notion mention the application of this method to numerous artists and collectives, among them also the Slovene group Neue slowenische Kunst. In practice, the The Janez Janša project appears as follows: artists are identified with the name of Janez Janša and are obsessed with it, they pronounce it on various occasions and also refer to it in their other projects, and they try to interest other individuals for the ritual repetition of this name. The artistic Janez Janšas want to be more Janša than the politician Janša himself and with this constantly rotating "Janša machine" they try to demonstrate that there is something wrong with this politician. By exaggerating with Janša, by being demonstratively obsessed with him, they direct the public opinion toward the critique of Janša. What is more, the intention of this machine is that when all become Janez Janša, Janez Janša becomes a nobody in his exclusive visibility, then the politician Janša will lose his recognisability, he will have to rename himself or even leave the territory in which he established himself with this name. These artists therefore strive for a purely political

The Subversive Affirmation as a New Device of Art Activism Deployed in Post-Political Reality

goal – the weakening of the right-wing politician and its symbolic erasure (with severe and real consequences). Whereas American activists' collective The Yes Men deploy some artistic features and devices that enable the cynic, satiric, ironic, humorous, and to a certain extent ambivalence effects, The Janez Janša group behaves 100 percent seriously and politically persuasive.

The Janez Janša project demonstrates that traditional left-wing and right-wing features and values do not function well in the present. They are too abstract and void to exactly address the today's play on political stage. Rather than naming the right-wing political parties, it is more precisely to address the key recent right-wing politicians engaged in populism and nationalism like Berlusconi, Salvini, Orban, Le Penn, and Wilders.

ACTION DIRECTED TOWARD THE POLITICAL OPPONENT

We are therefore faced with a project aimed at daily politics, which tries to disable the right-wing politician by using the tools of art activism, and with him also the party that he leads.

Today the politician Janša did not disappear, nevertheless the Janša project activists succeeded in mobilising a large part of Slovene civil society and the cultural public against him, which means that today the politician coexists together with the critique of him generated by subversive affirmation. Art activists therefore highlighted a certain antagonism and opened up the space of the political. The Occupy Wall Street slogan *We are 99%[1]* is in the today's Republic of Slovenia converted into the finding that Civilian society and the cultural public are 99% left-wing and the artists from The Janez Janša project have contributed to this state. On the other hand, it is a special story about what is considered to be left-wing in Slovenia. Because it is a small country with only two million inhabitants, left-wing politics functions predominantly as right-wing in the sense of preserving the national identity, culture, and privileges of the old communist elites. When political science and history will discuss the politician Janez Janša in the future, they will have to take into account – in the sense of credibility – the art activist The Janez Janša project as part of the historic 'Janez Janša package' which is deeply rooted in the social reality of Slovenia and the ideologically favouring of its national culture (a case of Slovenian literary nationalism). Let us therefore draw attention to one aspect of this project which refers to the social position of the three renamed artists:

The Subversive Affirmation as a New Device of Art Activism Deployed in Post-Political Reality

The Russian avant-garde artists of the 1920s believed in their ability to change the world, because at the time their artistic practice was supported by Soviet authorities. They knew that power was on their side. And they hoped that this support would not decrease with time. Contemporary art activism has, on the contrary, no reason to believe in external political support. Art activism acts on its own relying only on its own networks and on weak and uncertain financial support from progressively minded art institutions. (Groys, 2014)

Anyone familiar with the political and cultural reality in Slovenia cannot agree with this Groys' finding. In Slovenia, there have always been pro-regime artists, and also exist today (e.g. poet and professor Boris A. Novak), who received great support from the state for those projects that are in the interest of the ruling politics. This also applies to activist artists who are privileged at the expense of those through the works of whom the ruling elites cannot self-represent themselves. The activities of the activists of The Janez Janša project are supported by the national state through the Ministry of Culture; the film "I am Janez Janša" was even made in co-production with Television Slovenia, i.e. the national television, such as RAI in Italy and the BBC in the UK, while crowdfunding was only included in the completion and distribution of the project.

In this case, the context of the action is actually changed, even when compared with the situation that The Yes Men encounter: "Art as a category is not important to what we do. If we actually talk about what we do to a larger public we never refer to ourselves as artists. There's no political utility to that. People in America, especially, dismiss art." (Smith, 2014) The emphasis is on the view that people in America, especially, dismiss art, whereas in the Republic of Slovenia art pedagogy (educational system), politics, and the media support art that is produced by verified artists and proclaim it as an essential factor of national identity. A role similar to that played by Serbian academics in the preparation of the terrain for radical Serbian nationalism during the Yugoslav wars in 1990s, related to ethnic cleansing (the Srebrenica massacre case), was played in Slovenia by the national writers (in cooperation with philosophers and sociologists, e.g. Tine Hribar) from the journal Nova revija, who contributed the intellectual foundations to the forming of today's Slovenia.

In chapter of Slovenian Literary Nationalism we have seen that Slovenian literary culture acts in the nationalistic Slovenia crowded with both the left- and right-wing populism manifestations as an extremely regressive and corruptive force which would also deserve proper treatment from art

activists. An important aspect of the entrance of Slovenian intellectuals to the left-wing position would require of them to present a radical critique of the national, especially literary, ethno-culture and art.

CONCLUSION

The Janez Janša art activism project demonstrates that contemporary art, in its interactions with the extra-artistic reality, writes a story that deserves the attention of contemporary social sciences and humanities. What is happening in such art is worthy of the attention of political sciences, cultural and media studies, which could also base developments in their primary spheres on examples from the contemporary art and its avant-garde and neo-avantgarde predecessors. Contemporary art, as an extremely flexible area, has developed a series of procedures and devices for disrupting, which are at work in the modern economy, and it is also innovative in interventions in the political sphere, where we paid attention to the functioning of subversive affirmation within art activism. This tool is convincing in media manipulation with a (political) opponent and is certainly also useful in parliamentary politics which can engage artists to pummel their opponents.

In such cases, however, we can witness the abuse of art for the goals of daily politics, which means that only a small step divides the *art incorporated* (Stallabrass's term) from the *art corrupted*. After all, large corporations can also hire art activists to, for example, attack and weaken a competitive corporation, or a politician, or a public person through hacktivist[2] procedures. If such a corporation would then try to sue and persecute art activists, the latter could hide behind the art and civil society institutions, they would internationalise their case and encourage global solidarity among sympathisers. The situation of the attacked person or organization would deteriorate further, as many would be sympathetic with the artists due to conformist automation. It would appear that artists (especially in small, often mafia-affiliated countries) are allowed to do anything and are privileged at the expense of non-artists.

The new roles of art and literature also challenged art theory and literary criticism to redefine the basic notions of their fields. Arts and literature deployed in literary nationalism and art activism are post-aesthetic, belong to expanded concept of art (Joseph Beuys's term), with the emphasis on their use value. In fact, pieces deployed in such artistic and literary endeavours gave up the very nature of work of art or literary work (with privileged literary features), and begin to behave as pure art and literary service.

REFERENCES

Arns, I., & Sasse, S. (2005). 'Subversive Affirmation': On Mimesis as a Strategy of Resistance. In Art East Map. Irwin.

Janša, J. (2013). *My Name is Janez Janša*. Retrieved March 12, 2019 from http://www.mynameisjanezjansa.com/

Retort. (2004). Afflicted Powers. *New Left Review*. Retrieved July 18, 2018 from<https://newleftreview.org/II/27/retort-afflicted-powers>

Smith, W. S. (2014). Corporate Aesthetics: The Yes Men Revolt. *Art in America. InterViews: An Interdisciplinary Journal in Social Sciences*. https://www.artinamericamagazine.com/news-features/interviews/corporate-aesthetics-the-yes-men-revolt/

Stallabrass, J. (2004). *Art incorporated: the story of contemporary art*. Oxford, UK: Oxford University Press.

Strehovec, J. (2016). *Text as Ride*. Morgantown: West Virginia University Press.

Virno, P. (2004). *A Grammar of the Multitude. For an Analysis of Contemporary Forms of Life* (I. Bertoletti, Trans.). New York: Semiotext(e).

ENDNOTES

[1] Known from the Occupy Wall Street movement, 2011.

[2] Hactivism (word-compound consisted of hacking and activism) relates to hacking digital networks for politically motivated aims.

Chapter 7

Remediating the New Media:
Refashioning Film Through New Media Textuality as a Model of Forming New Media Cultural Contents

ABSTRACT

By applying the researching devices of media studies, art theory, film theory, philosophy, and cultural studies as a theoretical background, this chapter aims to explore the role of remediation in new media production, where the digital procedures enable smooth interaction, remixes, mashups, and hybridization. Remediation brings the dynamics into the institution of contemporary art and electronic literature by stimulating traditional and new media to refashion each other and generate novel hybrids at the intersection of several media (e.g. animated digital textuality which refashions film and video) as well as media contexts. Although the key reference of this chapter is Bolter and Grusin's theory of immediacy, hypermediacy, and remediation, the issues of post-remediation theory are addressed as well.

INTRODUCTION

The 20th century was in every way a cinematic one; a number of parallels can be drawn even between the industrial organization of labor on the assembly line (Taylorist rationalization in the sense of training the worker's movement, which is adjusted to the pace of the machine) and the cinematic way of organizing

DOI: 10.4018/978-1-7998-3835-7.ch007

Copyright © 2020, IGI Global. Copying or distributing in print or electronic forms without written permission of IGI Global is prohibited.

Remediating the New Media

moving images. Jonathan Beller (2006) argued that "early cinematic montage extended the logic of the assembly line (…) to the sensorium and brought the industrial revolution to the eye" (p. 9), which means that even the Fordist assembly line presupposes cuts, a montage and a sequencing of movements as though it were a film whose moving images had become an example for a number of basic cultural contents (from avantgardist procedures on stage to the introduction of the copy and paste command in a number of computer tasks) and even for a way of thinking (e.g. Burnett's questions raised in *How Images Think*, 2004).

According to Beller (2006), cinema is not only the art form that fundamentally defined the century in the sense of Jameson's cultural dominant, but also the dominant mode of production; it concerns the industrial revolution and the industrial organisation of labor on the assembly line as well as capitalism itself, which is increasingly structured like cinema, so we can even observe a continuation of the industrial mode of production in film production:

Not all production passes through cinema in the institutional sense, but global production is organized as cinema is. Consciousness is dominated by the organization of movement – the organization of materials produces affect (…). Cinema provides the architectonics of the logistics of perception for capital. Indeed, it represents their fusion. Hence, the cinematic has been machining the postmodern for nearly a century. In this sense, we can say that during the twentieth century, much of the world is literally in cinema, much in the way that the futurists intended to put the spectator inside the painting. (p. 109)

The world shaped by the cinematic mode includes the literature as well. When we are talking about montage as a key filmic procedure one should mention the "literary montage" in terms of Tristan Tzara's suggestion on how to make a Dadaist poem:

Take a newspaper.
Take some scissors.
Choose from this paper an article the length you want to make your poem.
Cut out the article.
Next carefully cut out each of the words that make up this article and put them all in a bag.

Shake gently.
Next take out each cutting one after the other.
Copy conscientiously in the order in which they left the bag.
The poem will resemble you.

And there you are—an infinitely original author of charming sensibility, even though unappreciated by the vulgar herd. (Tzara 1920)

When we draw upon the film, we need to emphasize that the significant achievements of the humanities in the 20th century were also defined by seeing films and reading about cinematic procedures, from Benjamin to Deleuze, Kracauer, and Manovich. Rather than relating just to a very particular art form, the cinematic paradigm is crucial for understanding various cultural fields and cultural contents. In his article on Döblin's *Berlin Alexanderplatz* Walter Benjamin addressed the montage procedure in the modern novel by arguing that "the stylistic principle of this book is montage. Petit bourgeois leaflets, scandalous stories, misfortune, sensation from 28, popular songs, and advertisements sprinkle this text. The principle of montage explodes the *novel* its form and its style, and it opens up new, very epic possibilities, mostly with regard to form." (Benjamin, 1972 p. 232)

This short excursion to film and the cinematic principle (e.g. montage) introduces us to the basic topic of this chapter, which focuses on issues regarding electronic literature and its relationship to (new) media art and the film. In doing so we will deploy Bolter's and Grusin's (1999) concept of remediation in order to demonstrate that e-literary text, first and foremost in the genre of animated electronic poetry refashions some features taken from film, and that the electronic literary kinetic pieces could be understood by applying cinema theory. E-literary text shaped by the (new) media belongs to algorithmic and software culture (Strehovec, 2016); however, the mention of film is not such a great departure from e-literature. Electronic textual practice is by no means placed in an area alien to film and the cinematic mode of organization of textual units.

Where we can find e-literature projects? Because these are electronic pieces, the Internet is an excellent place for saving and distributing this type of practice. In this regard, one should mention electronic literature online databases published by the ELO — the *E-Literature Collection 1* (2006), *2* (2011), *3* (2016) — and the Elmcip Anthology of European Electronic Literature. A series of basic information on electronic literature is also available in the Elmcip Knowledge Base. Along with the ELO's collections

that privileged the American authors we can mention that many significant works in this field are created in Brasil, Central, and Eastern Europe as well.

The author of this text spent some time following hypertext fiction, i.e. the genre that was the most distinct and media-covered part of literary writing in an e-media, at least in the USA in the late 1980s and 1990s; however, in the effects of hyperlink and maze, which are at play in a hypertext with literary features, he discovered merely one of the possibilities of writing using the new media tools. He found a bigger challenge for the recent reader/user in those new media textual practices that focus on movement, which results in a film of words. The latter is composed of units, which over a decade ago the author of this chapter had already named word-image-movement, i.e. the verbal and visual signifier-in-motion. What is crucial here is that in the very moment when text starts moving it begins to behave like a film, i.e. a film of verbal contents, presenting a challenge to theory which in turn abandons the field of literary specificity (literariness as we know it) and begins to direct itself towards effects concerning the cinematic organization of textual contents. Using the concepts like the form, value, atmosphere, style, lyrical, poetics, the author gives way to the theoretical devices deployed in the cinema theory (e.g. stain) and the new media theory (remixes, mash-ups).

When observing the text-film one soon discovers that it appears as content-in-motion, which is based on the play of fast or slow cuts, close-ups, speed-ups, dissolves and montages; other procedures that are also relevant to it extend from the field of film to digital video, digital music, computer games, digital architecture, forming in locative media, i.e. in addition to montage and (fast) cuts also sampling, mixing, remixing, and mash-ups. This situation concerns both the creativity of authors in this field, who apply procedures that are typical of the DJ and VJ culture, and the feedback and behavior of the audience, which is recruited for the field of e-literature also among fans of club culture, software culture, new media art, and artistic activism.

This chapter explores the e-literary text in terms of a textual film, however the issues connected with this are by no means the only constituent. We consider such a text as part of the expanded concept of textuality, which includes both verbal and non-verbal signifiers accompanied by new media paratexts (e. g. metadata, statements, reviews, instructions, menus, documentation). E-literary text challenges readers to complex experiencing, which is by no means exhausted in the reading-as-we-know-it in the sense of decoding meaning and comprehending language (Hoover & Gouch, 1990), but rather in integral corporeal experiencing, which also deploys kinesthetic and motor arrangements in one's navigation of such a textscape.

TOWARD THE IMMEDIACY OF AN E-LITERARY TEXT-EVENT

New media, including e-literature are about the experience and the perceptual hypermediacy (Bolter & Grusin, 1999), they relate to Baudrillard's "being more real than real" (Kellner, 1989, p. 83) in terms that they generate artificial worlds that enable striking and persuasive multi-sensory experiences. Just take a look at the advances of virtual reality with its promises of full immersion in virtual worlds and navigation inside them. It is all about the efforts to convince the user about as much as persuasive immediacy, and making the cultural content stimulate all the senses in a way which diminishes the presence of the interface. The electronic text does not relate to something remote, to long distance things, it aims to strike the reader-user with its very closeness and immediacy.

In the present augmented reality, the remote world of imagination and would-be-reality of artificial worlds is brought nearer and nearer; the user is allowed to enter this world in a very persuasive fashion by deploying the mouse, scrollbar, data glove, webcam and other interfaces. The e-literature authors/ programmers seek to put the user-reader in the same place with letters and words. "If immediacy is promoted by removing the programmer/creator from the image, it can also be promoted by involving the viewer more intimately in the image." (Bolter & Grusin, 1999, p. 31) In his *Language of new media*: Manovich writes in a very similar fashion "The new media image is something the user actively goes into, zooming in or clicking on individual parts with the assumption that they contain hyperlinks (for instance, image-maps in Web sites). Moreover, new media turn most images into image-interfaces and image-instruments. The image becomes interactive, that is, it now functions as an interface between a user and a computer or other devices." (p. 183)

Such a situation is not alien to digital text, on the contrary it is extremely familiar with it; in fact, in the digital textscape the user/reader is identified with the cursor as a kind of nervous, flickering, and distant presentation of herself. One of the key efforts in e-literature is directed towards as much as persuasive immediacy, presupposing the textual event, which addresses all the senses and accelerates the text to the performative mode. Not just writes down a text, but organizes it as a textual event (as a kind of *Gesamttextwerk*, which stimulates various senses, including such as proprioceptive sense and touch) – that is the proper task of e-literature authors. One of the historical examples of such an endeavor is Jeffrey Shaw's *The Legible City* (1988-1991).

Remediating the New Media

This piece is shaped as a responsive environment, which put the user in the role of cyclist/reader. She rides a stationary bicycle through a simulated representation of a city (plans of actual cities – New Yorks's Manhattan, Amsterdam and Karlsruhe) that is constituted by computer-generated three-dimensional letters, forming words and sentences along the sides of the streets. The existing architecture of real cities is completely replaced by textual formations written and compiled by Dirk Groeneveld. Daring and curious (even nervous) cycling/riding along the streets of words represents a journey (or even a ride) of reading. The choice of the path one takes is a choice of texts as well as the spontaneous juxtapositions and conjunctions of meaning that are constituted by computer-generated three-dimensional letters, forming words and sentences (as artificial buildings) along the sides of the streets. The handlebar and pedals of the interface bicycle provide the cyclist with interactive control over the direction and speed of the ride. The physical effort of cycling in the real world is transposed into the virtual environment, affirming the cyclist's activity within the mixed reality (composed of the given reality and the world of virtual architecture).

The immediacy effect works first and foremost at pieces that are interactive and algorithmic, e.g. the e-literary derivatives (mods, patches) of video and computer games. We can mention here Jason Nelson's *Game, Game, Game and again Game* (2007). This piece addresses its users in a striking way, refashions various other media (literature, film, architecture, video games), and places it in the state of immediacy. Within the new media condition this state is also enabled by high-tech stimulation of various senses, including the lower ones (e. g. touch). Kinesthetic activity deploying touch is crucial for immediacy simulation, which brings tactile arrangements to the foreground. Touch as a proximal sense is to a significant extent addressed in the process of reading and experiencing the e-literary text, which is embedded in a very specific technological platform that (over)determines its accessibility, manipulability, and ways of reading. The crossing over from the text's physical presence to its digital expanse on the screen challenges theorists of reading to discuss this issue:

The reading process and experience of a digital text are greatly affected by the fact that we click and scroll, in contrast to tactilely richer experience when flipping through the pages of a print book. When reading digital texts, our haptic interaction with the text is experienced as taking place at an indeterminate distance from the actual text, whereas when reading print text

we are physically and phenomenologically (and literally) in touch with the material substrate of the text itself. (Mangen, 2008: 405)

It is certainly true that in the process of reading we are not in direct physical relation with the e-literary text (we neither touch the pages of printed text, nor turn them), yet this is by no means a drawback; on the contrary, e-text is there in a very subtle interface-shaped *dispositif*, so that we are in a certain sense closer to it than we are on the printed textual platform, which presupposes merely a sort of rudimentary turning of the pages. Let us note here that turning the pages, touching the paper, and even sensing its scent undoubtedly signals the presence of a text in the reader's physical proximity; however these activities are accompanied by the reader's powerlessness to simply reach into the text and manipulate it. Within an e-text, however, we encounter the subtle, interface-based presence of the reader/user in the text itself in terms of her identification with the cursor as a flickering avatar, which marks the reader's position in the textscape. Such a constellation addresses the user/reader's hand as a key organ deployed in bridging the individual with the world she enters:

Certain parts of the body are particularly important in acting as bridges to the world and here I concentrate on one of the most important of these / the hand. The sensory system of the hand is complex and capable of exquisite fine-tuning. It is not just an 'external' organ: it is so vital to human evolution that it seems quite likely that parts of the brain have developed in order to cope with its complexities rather than vice versa. (Thrift, 2004, p. 597)

In the text shaped by new media, the reader is in fact where the cursor is, while the latter is in close proximity to the word itself and to its atomic units – letters. Furthermore, the cursor is not there as a coincidental ornament tool but is an active factor that can erase a letter, add a new one, or insert a punctuation mark, that is to say, alter the text from the inside in such a way that its operations can be concealed (it is impossible to do this with a printed text). Rather than being a simple opposition, the digital and the tangible are linked by new media technologies that enable subtle forms of, let us say, the digital tangible. Such a tangible is not something concrete and profane: we are not dealing with visible operations, but with very subtle ones; the touch (sense) at work with the digital tangible is a "sense theoretician", since it is a sense that does not grab in a rough physical relation but functions precisely

Remediating the New Media

through its avatar in the textscape. The term "sense theoretician" was coined by Karl Marx in the following context:

The forming of the five senses is a labour of the entire history of the world down to the present. The sense caught up in crude practical need has only a restricted sense. For the starving man, it is not the human form of food that exists, but only its abstract existence as food.(…) The care-burdened, poverty-stricken man has no sense for the finest play; the dealer in minerals sees only the commercial value but not the beauty and the specific character of the mineral: he has no mineralogical sense. (…) The eye has become a human eye, just as its object has become a social, human object – an object made by man for man. The senses have therefore become directly in their practice theoreticians. They relate themselves to the thing for the sake of the thing, but the thing itself is an objective human relation to itself and to man. (Marx, 1844)

What is crucial in this Marx's notion of human senses is the very historical (e.g. changeable) attitude to them. They are mutated across history, and this point is of significance also in a moment, when we draw upon the senses engaged within the present interface culture, and their deployment in the experiencing and reading of electronic literature.

The touch theoretician as discussed in the afore-mentioned Marxist theory of senses is the self-learning touch, which is deployed in the electronic literature as well. One of the significant works in this field, which stages the material/immaterial problem as well as the subtle issue of touching within the interface culture is Serge Bouchardon's *Toucher* (2009). Touching means exploring, there is a certain curiosity, which generates the touch as a sense of proximity and movement (the touching hand gets more information, when it moves around the object). The *Toucher* thoroughly demonstrates the shift from immediate touching to the interface mediated; the touching requires in this piece interface mediation by the mouse, microphone and webcam. Such a subtle touching experience including the interface reading (e. g. the mouse reading) reveals a lot about the way we access a multimedia content on screen.

This piece demonstrates that the reading of e-literary texts presuppose the interface shaped sophisticated experience, which stimulates various senses and put the reader-user into the riding adventure as an event that stimulates several senses and provokes a corporeal and kinesthetic participation. New generations of digital devices most assuredly provoke new forms of perception and action. With a stylus or a touch pad we enter into very direct, although

Remediating the New Media

virtual contact with the word, contact that is much more immediate than in using a typewriter, which means that these devices once again establish an immediate relation between the body (in fact, the hand) and the word.

TEXT ON THE MOVE

When addressing one of the key topics of this chapter, we need to draw upon one significant example of the text-film, which challenges theory to redefine its concepts and find novel ones. As such an example we can mention Claire Dinzmore's *The Dazzle as Question* based both on the author's very intimate, lyrical account of interpersonal communication and on technical solutions, which disrupt our expectations about the way the poetic text behaves. *The Dazzle* is a lyrical one, one which heeds the romance and history echoing throughout poetic creation, yet plumbing this new media for the singular sonority which the encounter affords. Its locutional marks and varied rhythmic emphases are indicative of the particular tones and dialectical nature of the question and confusion underlying this untoward relationship. The noted tendencies of the digital, of both pleasure and menace, are then marked by the distinct use of text within the piece - it is not easily read, being rather ghostlike and obscured, thereby signifying the effect of the media in erasing/ displacing the narrator's words/identity, undermining his/her marks, his/ her history - the history of poetic form itself with obliquity. The effect is thus abstracted, culminating in an aura, shall we say, which is more "... impressionistic/textural than textual." Digital media seek to inscribe within and around the text layers of sub and supratext which work upon myriads unexpected levels beyond the page, hence underscoring the [desired!] incision implied by the surface meaning of 'mere words.' Semantics battling within fertile, yet deliciously foreign, terrain - and accordingly tantalized. Such a rich play of unstable meanings and their controversy is accompanied by the dynamic unmappability of textual articulation, which places the reader in a very unsafe position. She is faced with the dynamic textbar which disrupts the normal way of reading and perceiving the textual units.

Dazzle's text is a nervous one consisting of several tapes of moving letters and words shaped in various fonts and formats. The temporal and spatial grammar of this textscape and timescape impact the very plot of this piece, which is very short as if it were a textual music video. The turning point in this piece occurs at a moment when after the line with "His identity uncertainly shifting", running from the left to the right, another line suddenly appears

128

Remediating the New Media

with "About [Yes of course] Yes of course The Dazzle-Touch-In-Space-Border-less-Larger than Sometimes…", which runs in the opposite direction, from right to left. Such a turning point strikes the reader, and gives her an intensive experience of the textual film (as a play of nervous signifiers) and the film of thoughts.

How can we explain that turning point? Instead of traditional literary theory we will apply Pascal Bonitzer's cinema theory and one of its theoretical devices the "stain". The concept of stain is described in Bonitzer's essay on Hitchockian suspense in passage referring to the movie *Foreign Correspondent* (1940), in which the highlights include an assassination on a rainy day with the killer escaping into a sea of umbrellas and a group of spies signaling to their Dutch contacts by turning a windmill against the wind. The stain as "an object which goes against nature," is found in such visual effects as the field of windmills in which the sails of one windmill are mysteriously turning the wrong way. Such a special effect strikes the gaze and the viewer's expectations about the ordinary way things behave, therefore she is getting more and more curious about that uncanny condition. Can we find an equivalent of the windmill turning against the wind in *The Dazzle* piece?

Just as the sails of one windmill turn in the opposite direction, we are facing the *Dazzle*'s moving textbar, which at a certain moment begins to enter the visible/readable field from the right (after the line with "His identity uncertainly shifting"). The ordinary stream of textbar running from left to right is interrupted and the reader asks, what the meaning of such a disruption of the way the text ordinary runs might be. Her stable reading point has been made strange, she finds herself unsafe within the textscape, and her normal way of perception is changed in a kind of high-adrenaline adventure. The disrupted order of running text fits well to the very nature of *Dazzle*; the stain relates to the semiotic and semantic level, it disrupts the way of reading as well as the way of imagining the distant artificial worlds.

Electronic animated (kinetic) poetry refashions moving images of film, video and other media. Here the question arises, what is the common denominator of moving images and moving text, based on moving words-images-virtual bodies. The answer is not very difficult. This is the movement and acceleration associated therewith. "We declare that the splendor of the world has been enriched by a new beauty: the beauty of speed. A racing automobile with its bonnet adorned with great tubes like serpents with explosive breath ... a roaring motor car which seems to run on machine-gun fire, is more beautiful than the Victory of Samothrace." (The Futurist Manifesto, 1909)

Remediating the New Media

When we are talking about the speed we refer to a special constellation, defined by a greater or smaller speed, acceleration, riding, and racing. Without being familiar with the hardware and software that generates digital textuality, William S. Burroughs (2000) wrote in *The Invisible Generation.*

Take any text speed it up slow it down run it backwards inch it and you will hear words that were not in the original recording new words made by the machine different people will scan out different words of course but some of the words are quite clearly there and anyone can hear them words which were not in the original tape but which are in many cases relevant to the original text as if the words themselves had been interrogated and forced to reveal their hidden meanings. (218)

Burroughs was fascinated with the capabilities of the tape recorder, whose functions he applied to textual material. His essay, from which this quote was taken, dates from 1962 (when he made experiments with type recorder) and everything in it focuses on the technical manipulability of text, which experienced an actual bloom only with the new generation of technologies, namely those that are based on computers and digitization. In any case Burroughs's reference to speed and acceleration as the generators of a new mode in which modern textuality operates, is important even with regard to animated e-literature.

Speed is what brings things to clarity, to an experimental and accelerated state which brings them in motion in the sense of riding as intensively as possible, (in the popular culture, e. g. in theme park attractions) by loop-shaped experience. Such mobility implies the condition of being endangered, which the German expression *Erfahrung* used by Walter Benjamin alludes to etymologically; the expression contains both *Fahrt* (ride) and *Gefahr* (danger). In a certain way, both of these components are also involved in the English term 'experience', since, when one experiences something, one moves around it and if one goes (too) far, one gets in danger. Speed is also experienced in e-literary texts (for example in electronic animated poetry and poetry generators), when one "rides" the tapes of words-images-in-motion (e. g. in *Dazzle*), yet at the same time with regard to text/film one tries to capture and perceive that which has not yet been included in the ride. Although these components are outside the field of vision, they are important for the understanding the text displayed on the screen.

Remediating the New Media

ON EXPERIENCING AND READING
THE E-LITERARY TEXT

New media art and e-literature challenge the present researchers with the complexity of their projects-processes-performances-events that demand the multi-disciplinary approach and the deployment of various methods. In the previous section we have explored Claire Dinzmore piece *The Dazzle as question* based on the moving textbars and their dialectic in entering the visual/reading field from various directions. Rather than refashioning only the cinematic moving images, the tapes of words in this e-poem relate also to Marinetti's concept of words in liberty (*It. parole in liberta*), which is deployed in "structuring specific poetic texts according to visual conventions for the representation of space" (Drucker, 1994, p. 107).

The reader, faced with this piece, is expected to execute various steps in order to experience it in terms of the textual event. At the very beginning of her cognition, perception and reading of this piece, the reader needs to:

- Collect the basic sources and paratexts relating to this piece, including author's statement, various references, metadata, reviews and information related to software applied and to other projects this piece relates to;
- Bracket the traditional way of approaching the text (horizon of expectations) in terms that her attitude should also address non-verbal signifiers and the software specificity;
- Write down the introductory observations of this piece relating to a) the number of moving textual tapes, b) the spatial structure of words that often enter the moving tapes, and c) other similar pieces of e-literature that need to be compared with *Dazzle* in order to clarify its basic particularities shaped by the new media;
- Read and view all the moving tapes of text at once in their radical difference, and take into account also the speed of the textual tapes entering from the right. It is significant that she must insist in reading-viewing the textual 'sculpture' at once, because only such an attitude to the entire textscape in the discontinuous variety of its moving tapes enables the reader's rich experience and her participation in the textual event;
- Restart and reread this piece several times to come closer to the meaning as well as the decoding of visual and temporal grammar,

Remediating the New Media

- Turn away for a while, push the reading behind, and think about the ideas that a text provokes.

Such a multi-phase process begins at the moment, when the reader is struck by a very unfamiliar quality in the visual appearance of the text that focuses her attention span and transports her in a state of excitement. Such a quality of this piece occurs in the process of the reader/user's encounters with the stain, caused by the conflict between directions in which the textbars run.

What is crucial here is also the spatialization of text in terms of a sophisticated multi-layered structure, which presupposes the insertion of novel spaces (opened up with the lines entering from the right) that might be considered as an interval, or a gap. And such an insertion is also about the meaning and the very particular intellectual atmosphere, generated by *Dazzle* which is spread around the text. As an arrival of the unfamiliar, strange and unsafe, the spatialization implies also the possibility of conceptualization in terms of arranging the meaning as an enigma, and in non-identical and non-mediated (e.g., uncanny) form. "More" can be read from this text also by those familiar with programming, who can read what is above or below (in terms of the code) and which programming operations generate precisely this textual output.

Perception of e-literature do not include just reading (and not-just reading in terms of user's more intensive bodily activity based on textual arrangements that tactually strike her), but also the basic cognition of the software applied and the procedures that enable such a textual practice. The significance of software for e-literary writing demonstrates the use of programming languages for naming the genres of electronic poetry such as Perl poetry, Java poetry and Flash poetry. Understanding of the new media-shaped e-literary text, therefore, demands new media literacy in terms of one's ability to navigate and control the new media contents.

One of the key features of novel generation of e-literature (after the hypertext fiction of 1980s and 1990s in 20th century) is that the reader-user's interest becomes focused on a new series of (rich multi-sensory) experiences by which she expects to be addressed as directly as possible. The reader-user demands from the e-literary text that it strikes her with visual and tactile effects, and that it arouses her motor stimuli. The reader-user, who is more and more the rider (Strehovec, 2016), expects even literary and artistic content to be organized in the form that she encounters in attractive products of the entertainment industry, that is to say, she expects that they also strike and intoxicate her as if they were a roller-coaster ride or a SF movies.

Remediating the New Media

ERASING AND VANISHING TEXT IN
NEW MEDIA INSTALLATIONS

Movement with its intervals and acceleration is significant companion of erasing and vanishing text, which might be considered as one of the most compelling fields of e-literature.

In discussing the issue of the vanishing text, let us first give some examples of modern poetry whose authors did research into the very nature of language, they called into question its common use, they approached the word as broken down into letters, and even depicted linguistic failures. They saw the "wordness" of the word as though the word would suddenly happen anew in front of their eyes. Modern poets like Stéphane Mallarmé, E. E. Cummings, Paul Celan, and Edmond Jabès were important innovators in the realm of language by broadening its material presence with blanks, voids, silence, intervals, interruptions, lower case replacing capitals, unstable margins. They called into question the entire field of poetry and destabilize the meaning, the power of the sayable, and the link between things and words. One can say that they had struggled with language and the outcome of this struggle was quite uncertain. Underneath, their writing raised the question: why letter, word, line, lyric and not just silence, void, whiteness and blanks? Sometimes it appears as nonverbal signifiers as in the case of blanks and isolated, dead, crossed-out letters that are in their poetry allotted the same relevance as words. The unsayable as the hidden part of all literary words (and their metaphysics) is in modern poetry deployed in a poetical textuality which brings the silence and the desert of meaning to the fore. The blanks and intervals of modern poems also convey meaning.

A very similar questioning of the very nature of language and textuality is being conducted in e-literature which refashions its predecessors in Concrete and Visual poetry and in the above-mentioned (experimental) modern poetry as well. E-authors break all languages down into their elements, including the html (and other programming and scripting) characters. They try to move fluently between the code and its screenic, to human reading devoted output. In fact, it sometimes appears as if e-writers place themselves in the non-space between the code and the displayed word. They make sense not just of a material (visual and temporal) appearance of the word, but also the punctuation, brackets (e.g., in Mez's poetry), striken-out letters, interruptions, blanks, erased words, and voids. Some procedures in Mez's poetry (the use of punctuation, brackets and interruptions as well as the innovative approach to

Remediating the New Media

typography) resemble the poetics of E. E. Cummings (e.g., in the poem *I Will Be*). However, the use of software advances enables e-authors to approach anew the issue of the textual void, the unsayable, absence, erasure, vanishing – so we can see in the erased, unreadable, and vanishing text some of the most particular features of e-literature. Here the use of the software as well as the materiality of the screen and the use of controlling/navigating devices bring some advantage to the fore with regard to the print where some obstacles appear: "In print literature, actual erasure is difficult to attain. Print writers can allude to a segment of text that might not be present, they can make a part of the text less readable (type size, strike-out, etc.) – or they can leave a space to indicate what has been omitted. Sometimes this faux-obscure text is part of deconstruction practice. Usually translated as 'under erasure', it involves the crossing out of a word within a text, but allowing it to remain legible and in place." (Marjorie Coverley Luesebrink) By taking a look at projects of Concrete and Visual Poetry one can determine the very limitations in forming the text by the typewriter, which remains bound to designing text just with regard to the space grammar (distribution of letters and punctuations in various directions on the page, crossing out of characters, etc.). By contrast, the software advances enable more sophisticated design, including animated text and poetry generator produced text, which might be accelerated to the limits of illegibility or to the mode of vanishing text.

As the predecessor of recent accounts with the erased and vanishing text in e-literature we can mention *Agrippa* (1992), formed by cyberpunk writer William Gibson, artist Dennis Ashbaugh, and publisher Kevin Begos Jr. The project consists of Gibson's electronic poem, embedded in an artist's book by Ashbaugh. This poem was stored on a 3.5" floppy disk, and was programmed to encrypt itself after use. An artist's book was prepared with photosensitive chemicals, causing a fading of the words and images as the pages of the book were exposed to light. In recent, posthypertext e-literature there are several projects dealing with the erasing, vanishing, and self-destructing text, as well as the text on the limits of legibility (see Marjorie Luesebrink).

There are also many examples of new media art and e-literature projects associated with the procedure of destroying the text. Along with Tisselli's *Degenerative* project, 2005 (a web site that slowly becomes corrupted each time it is visited, one of its characters is either destroyed or replaced), we should also mention Thomson and Craighead's video game mode *Trigger Happy* (1998), in which the users are challenged to shoot the moving target consisting of sentences taken from Foucault's essay *What is an author. Trigger Happy* is the first person shooter mode of the seminal video game *Space*

134

Remediating the New Media

Invaders; its point is in the gamer's effort to destroy the letters and words of Foucault's text; however this procedure does not leave the gamers cold; they must critically consider their activity as not directed to the hostile objects but to the institution of the word and the text, which lies in the core of Western cultural tradition. On the other hand, we can explain such gamer activity as the metaphor for the fate of the word and the text in the present instant, copy/paste culture of googlization, in which the institution of author, text and word loses its authority and autonomy and are endangered by visual popular culture. The next explanation of this project is that the point of gaming is here in the will to kill Foucault's "death of the author" text before it gets you.

With the afore-mentioned *Agrippa* the possibility of temporary textual projects being brought into life within a very short temporal interval was initiated. Temporary text is that with existence restricted by a very limited time. It demonstrates the author's struggle not just with the text but also with its communicative possibilities. The question is raised whether the text needs to be a durable entity. In 2003, the author of this essay published the essay *Verses for Seven Weeks*, which had related to his project of writing poems for a very short temporal interval (seven weeks or less). After this period, he burned the poems, and what remained beside the ash just an essay (in the role of documentation about this endeavor) in which rare cues inform the readers forever in the flames of vanishing poems. In this experimental event the issue of the communicative function of poetry was addressed: Does a poem exist solely under the condition that it is presented for human readings?

Verses for Seven Weeks was a project based on print literature deploying the materiality of paper, which burns in fire. Quite different in terms of its technological basis and the (non)reading procedures is Stephanie Strickland's, Cynthia Lawson Jaramillo's and Paul Ryan's visual and textual project *Slippingglimpse* (<http://collection.eliterature.org/2/works/strickland_slippingglimpse.html>), arranged in regenerate, scroll text, and full text mode. This 10-part regenerative Flash project from 2008 based on algorithmically generated text according to the movement of chaotic water patterns (creods) challenges the established concept of reading as meaning decoding by considering reading as a broader cognitive activity in which even the machines take place (water reads text, text reads technology, technology reads water); during the life of this project several events of reading enter, including the machinic, which is not fulfilled in the human readable output. In fact, the human reading is enabled just in the *scroll text mode* where one window appears in which the stable text in a moving pattern suddenly appears. This piece demonstrates that reading is not a self-evident issue; text

appears or not, very particular conditions must be fulfilled for the word to enter the human readable mode, and also in such a mode it is sometimes just conditionally legible; great efforts on the side of the user are necessary to identify the word interacting with the water creods. Lines of this project are sometimes presented within an inhuman outcome: not evident enough to be read. Legibility goes hand in hand with the illegibility – such is demonstrated in digital poetry.

The new media and smart technologies shape the writing space of the internet authors who are addressed to question the very condition of poetic word in the realm of software. Ana Božičević and Sophia Le Fraga placed in the internet some poems of print poetry (from Ana Božičević's second full-length collection *Rise in the Fall*, 2013) and at the same time invited the reader to face also the erased version of these poems (http://media.rhizome.org/fall/childrens-lit.html). Just reading of them is not enough, one needs to navigate their digital double by cursor scroll-overs and text-image overlays. Poems of the cicle »not_I's *The Fall* » (2015) are read and perceived within their erased/visual counterparts in which just some isolated words refer to underlaying print poem. The life of such poetry is in-between, in the very act of jumping between the both modes of poetic textuality.

What is behind this will to erase textual signifiers, to strike them out, to stage the absence and the void, and make the text unreadable? What is the philosophical point of such procedures that link e-authors with those modern poets who are engaged in the struggle with language? Whereas some authors as well as critics try to explain such textual projects with one's mental states, the author of this chapter sees in them an attempt to answer the question relating to the desert of the meaning, the weakness of language, the triviality of the current mcdonaldized language. Today, with too many words mediated and distributed by Google, there is a lack of words that stage their uncertainty on purpose, are crossed-out, erased, accelerated toward illegibility. The words entering the silence, magic and abyss of the void and their relationship with the absent God.

Through exploring the vanishing text, e-literature actually demonstrates its power because it questions its field. The text (temporary) exists, it may vanish or transform into a conditionally legible entity. This is similar to the manipulation of the financial market economy with the value of derivatives. At a certain point, their growth becomes a crash, the bubble crashes, bull trend in the world stock exchanges is followed by a downward bear trend. Destabilization is also a constant in global politics driven by wars, terrorism, economic instability and multiculturalism. As contemporaries of a conceptual

Remediating the New Media

phase in a particular field (e.g. finance, art, politics that "deal with themselves"), we encounter speculations, experimentation and risks. Being a function of various factors, the language of e-literature is also subject to a great uncertainty which is demonstrated by Biggs' VR installation *The Tower*, 2013, generated as a mash-up of Joyce's *Ulysses* and Homer's *Odyssey* where the text doesn't vanish but rather appears in a completely unpredictable modality. The central role in this installation is given to the user wearing a VR head-display whose spoken words appear to float from their mouth and join the spiraling history of previously spoken words. As the uttered word emerges, other words, predicted on the basis of statistical frequency within a textual corpus, spring from the spoken word. We encounter the spoken words as well as those suggested by the algorithms; the number of spiral word structures constantly increases. Their authority is destabilized, everything could be different and consequently the Tower of Babel triumphs in the end. One version of the Tower's logic can be observed in the core of e-text culture which is today particularly illustrated by the googlezation of natural languages.

CONCLUSION

Electronic literature as an emerging practice of writing in new media is not about the depicted objects, events, and people, its very nature is not in the mimesis, but rather in the poiesis, e. g. in constructing artificial textual worlds that address our experiencing of digital words-images-virtual bodies and even the letters in the new media condition. Rather than telling stories or depicting events, e-literature arranges the experience of the words and letters by making them behave in a way which shifts from the mode in which they are deployed in storytelling-as-we-know-it. Moving images and moving words deployed in the new media relate to the movement and its basic features like speed and acceleration. They are technical images (Flusser) and their reference is conceptual.

In this chapter, we have addressed the concepts like immediacy and refashioning that originate from Bolter and Grusin's book on remediation, which has thoroughly addressed the fact that the new media refashion the old ones and vice versa, which means that at present the autonomy of (single) medium is being endangered. Talking about a pure medium is getting more and more obsolete, it even contrasts with the very nature of digital code. However, at present the theoretical devices[1] taken from Bolter and Grusin's book (hypermediacy, refashioning, remediation…) are just the ones that are

137

useful in exploring the specificity of new media contents. It makes sense to deploy them along with other concepts generated within other theoretical accounts of new media (e. g. in contemporary technoculture studies, new media studies, communication theory, software studies, philosophy of technology, or cinema theory).

Therefore, the following theoretical concepts and devices need to be taken into account along with the basic "remediation concepts": database, algorithm, protocol, remix, mash-up, hacktivism, lived abstraction, cognitive mapping, media specific analysis, metadata, art platforms, art service, and the new media paratexts. It seems that the remediation in its historical form has given way, on the one hand, to the investigations of the media specificity, which increasingly deploy the concepts originated from software studies, and on the other hand, to the investigations of what specific behavior of the user is elicited by the particular medium. The user, a hybrid viewer-listener-reader becomes the key agent in the new media that behave in response to her actions, which means that stress is shifting towards one's experience of new media contents. "Experience always invents. Every perception is a creative activity culminating in the production of an event of change." (Massumi 2011: 27)

Another significant movement in, let us say, "post-remediation theory" is directed toward the materiality of new media and their (social) contextualisation. New media (and e-literary) contents are becoming increasingly contextualised, performative, and embodied. This suggests that matters of significant importance are taking place in a field that is abandoning the classic cyberpunk and post-human perspective, founded on Cartesianism and Cyberplatonism that can be found (in the case of literary cyberpunk) in novels such as Gibson's *Neuromancer*, and (in the case of several theories of the posthuman) in the view that the posthuman condition blurs the border between embodiment and the cybernetic, between the biological and simulation. Such notions of aficionados of artificial life that are beyond the findings of contemporary humanities and social sciences as well as the practice of today's performance art have been based on classical information theory (Shannon and Weaver, 1948) in that the specificity of information is determined by message length, complexity, and signal integrity. By contrast, issues concerning the material and bodily contexts in which the information is embedded have been pushed aside as unimportant.

Today the most significant movements in contemporary philosophy and cultural studies are about the cultural shift in which the linguistic, discursive and textual give way to the material, biological, life, event-driven and biopolitical (Negri, 2011; Agamben, 1998; Virno, 2004; Thacker, 2011). By shifting

Remediating the New Media

the focus on life, biopolitics, the issues of Antropocene, and the body, the political issues that concern movement, feelings, affects, and perception are also highlighted, particularly with regard to art and (new) media (Hansen, 2003; Massumi, 2011). Rather than foregrounding smooth hypermediacy in terms of seamless transitions between different media, new media art deals with glitches, noises, and general malfunctioning of new media technologies. Here we can mention the Jodi couple who were among the first net artists to investigate and subvert the conventions of Internet, computer programs, and video and computer games. By disrupting the language of these systems, including interfaces and code, these artists destabilize the relationship between computer technology and its users as well as the ideology of progress, which accompanies the development of new media and their promises.

Bolter's and Grusin's concept of remediation is deeply embedded in the world of technical advances and mainly pushes aside the basic links of new media and the social. In doing so the remediation authors remain tied to the positivistic approach to new media and the fascination with the digital. However, the media are not the neutral tools, their social implications need to be critically addressed.

REFERENCES

Agamben, G. (1998). *Homo Sacer: Sovereign Power and Bare Life* (D. Heller-Roazen, Trans.). Stanford, CA: Stanford University Press.

Beller, J. (2006). *The Cinematic Mode of Production*. Hanover, MA: Dartmouth College Press, University Press of New England.

Benjamin, W. (1972). Krisis des Romans: Zu Döblin's 'Berlin Alexanderplatz'. In Gesammelte Schriften. Frankfurt: Suhrkamp.

Biggs, S. (2013). *The Tower*. Retrieved September 9, 2019 from http://littlepig.org.uk/tower/

Bolter, J. D., & Grusin, R. (1999). *Remediation: Understanding New Media*. Cambridge, MA: MIT Press.

Bonitzer, P. (1992). Hitchcockian Suspense. In S. Žižek (Ed.), *Everything You Always Wanted to Know About Lacan (But Were Afraid to Ask Hitchcock)* (pp. 15–30). London: Verso.

Bourchardon, Serge: Touch, Toucher. (n.d.). Retrieved May 21, 2019 from http://collection.eliterature.org/2/works/bouchardon_toucher.html

Božičević, A. (2015). not_I's *The Fall. Poetry as Practice.* Retrieved July 22, 2019 from http://media.rhizome.org/fall/childrens-lit.html

Burroughs, W. S. (2000). *Word Virus: The William S. Burroughs Reader* (J. Grauerholz & I. Silverberg, Eds.). New York: Grove Press.

Drucker, J. (1994). *The Visible Word.* Chicago: University of Chicago Press.

Galloway, A. R. (2006). Gaming: Essays on algorithmic culture. Minneapolis: University of Minnesota Press.

Gibson, W. (1992). *Agrippa.* Retrieved May 21, 2019 from http://agrippa.english.ucsb.edu/

Hoover, W. A., & Gouch, P. B. (1990). The Simple View of Reading. *Reading and Writing, 2*(2), 127–160. doi:10.1007/BF00401799

Korsten, S. (2010). Reversed Remediation: Evelien Lochbeck's Noteboek. *Rhizome.org.* Retrieved May 23, 2019 from https://rhizome.org/editorial/2010/nov/10/reversed-remediation-evelien-lohbeckas-noteboek/

Luisenbink, M. (2014). One + One = Zero – Vanishing Text in Electronic Literature. *Electronic Book Review.* Retrieved May 24, 2019 from http://www.electronicbookreview.com/thread/electropoetics/disappearing

Mangen, A. (2008). Hypertext fiction reading: Haptics and immersion. *Journal of Research in Reading, 31*(4), 404–419. doi:10.1111/j.1467-9817.2008.00380.x

Manovich, L. (2002). *The Language of New Media.* Cambridge, MA: The MIT Press.

Marinetti, F. T. (1909). *The Futurist Manifesto.* Retrieved May 26, 2019 from http://vserver1.cscs.lsa.umich.edu/~crshalizi/T4PM/futurist-manifesto.html

Marx, K. (1844). *Economic and Philosophic Manuscripts of 1844, Private Property and Communism.* Retrieved May 26, 2019 from https://www.marxists.org/archive/marx/works/1844/manuscripts/comm.htm

Massumi, B. (2011). *Semblance and Event.* Cambridge, MA: The MIT Press. doi:10.7551/mitpress/7681.001.0001

Negri, A. (2011). *Art and Multitude.* Cambridge, MA: Polity.

Remediating the New Media

Strehovec, J. (2003). Stihovi za sedam tjedana [The Verses for seven weeks]. *Quorum: časopis za književnost, 19*(5-6), 109-128.

Strehovec, J. (2012). *Derivative Writing: E-Literature in the world of new social and economic paradigms. In Remediating the Social.* Bergen: ELMCIP, University of Bergen.

Strehovec, J. (2014). In M. Cornis-Pope (Ed.), *The E-Literary Text as an Instrument and a Ride. In New Literary Hybrids in the Age of Multimedia Expression. Crossing borders, crossing genres* (pp. 340–356). Amsterdam: John Benjamins Publishing Company.

Strehovec, J. (2014). E-Literature, New Media Art, and E-Literary Criticism. *CLCWeb: Comparative Literature and Culture, 16*(5). doi:10.7771/1481-4374.2486

Strickland, S. (2007). Slipingglimpse. *Electronic Literature Collection. Vol. 2.* Retrieved July 18, 2019 from http://collection.eliterature.org/2/works/strickland_slippingglimpse.html

Thrift, N. (2004, November). Movement-space: The changing domain of thinking resulting from the development of new kinds of spatial awareness. *Economy and Society, 33*(4), 582–604. doi:10.1080/0308514042000285305

Tzara, T. (1920). *To make a Dadaist Poem.* Retrieved July 18, 2019 from https://modernistcommons.ca/islandora/object/yale%3A352

ENDNOTE

[1] Key concepts of the Remediation book are also the subject of thoroughly executed critique. Saskia Korsten discussed reversed remediation as a counter-mechanism of remediation as explained by Bolter and Grusin serving a historical desire for immediacy. Following McLuhan's fear of the narcotic state, which the user of a medium can enter when becoming a closed system with the medium; reversed remediation offers a chance to wake up the viewer. It creates a state of critical awareness about how the media shape one's perception of the world. Reversed remediation works counter to remediation mechanisms in the sense that it makes the media visible instead of transparent. It makes critical awareness possible because it lays bare the workings of media instead of obfuscating them.

Chapter 8
Remediating the Social: Impacts of Historical Fascism on Academic Fascism

ABSTRACT

Remediation is the process whereby the new media (animation, virtual reality, video games, and the internet) define themselves by borrowing from and refashioning traditional media (print, film, video, and photography). This chapter explores how the remediation that is successfully deployed in forming new media contents and adds dynamics to media production can be applied to the understanding of academic fascism as a new field of research in contemporary social theory. Traditional fascism as the movement based on historic fascism (i.e., German, Italian, and Spanish) refashions academic fascism as a new manifestation of contemporary fascism; likewise, the academic fascism impacts the fascism as-we-know-it and contributes to many new devices and procedures that demand the attention of critical theory of society. The researcher as scapegoat Other, academic cleansing, privatization of knowledge, and smart technology (on the place of blood and soil) are the key concepts addressed and analyzed in this chapter.

DOI: 10.4018/978-1-7998-3835-7.ch008

Copyright © 2020, IGI Global. Copying or distributing in print or electronic forms without written permission of IGI Global is prohibited.

Remediating the Social: Impacts of Historical Fascism on Academic Fascism

INTRODUCTION

Fascism evokes unease in people. Hearing the word reminds people of concentration camps, ethnic cleansing, the Nurenberg trials, international court in the Hague, and dealing with those who were justly but also unjustly stigmatized as fascists. When thinking about fascism, people also think about special historical events in Europe between both world wars, and the use of this word in the present, which often is not sufficiently thought out or said quickly, perhaps in attempt to politically disqualify an opponent. As early as World War II, George Orwell warned of the dangers of the inconsistent use of the term fascism, as it was applied to denote phenomena that have very little in common (1944). When thinking of fascism (the term originally denotes Italian corporatism), people also think of the German National Socialism and the segregations it introduced and spread (Hitler 1925; Rosenberg 1935). Similarly, when it comes to violence, segregation, and stigmatization of certain social groups, the practice of fascism can be partially linked to Orientalism defined by Said (1978) in terms of a particular modality of the political unconscious, and the emergence of authoritarianism in the psychology of masses (Reich, 1933). The topic of homo sacer, discussed in Agamben's (1998) book with this title, refers to the banned person being excluded from society and deprived of all rights, can be included in present discussions on fascism as well. Fascism denotes irrational and violent social phenomena (Woodley, 2009), which are not only outdated (i.e., German National Socialism or ethnic cleansing during the war in the former Yugoslavia and Rwanda), but are still present. Like many other phenomena, fascism can be said to have mutated, found new subjects, and manifested itself through new carriers of irrationality, new iconography, and new vocabulary. In one of the modalities of today's fascism, the emphasis from the macro scale shifts to the individual and their desires, fears, and hatreds.

"Rural fascism and city or neighborhood fascism, youth fascism and war veteran's fascism, fascism of the Left and fascism of the Right, fascism of the couple, family, school, and office: every fascism is defined by a micro-black hole that stands on its own and communicates with the others, before resonating in a great, generalized central black hole. What makes fascism dangerous is its molecular or micropolitical power..." (Deleuze & Guattari, 1987, pp. 214-215) With regard to the spread of fascism-like phenomena in the third world, mention should also be made of nano-fascism, considered in

the sense that fascism has travelled across the borders between the West and the East, and has been transformed into nano-fascism in Turkey (Aracagök, 2018).

In the second form of fascism-like phenomena today, people face the implicit principle of blood and soil in terms of forcefully emphasizing Asian people as those who will rule in the 21st century (emergence of the Asian century ideology), while in the third, people are dealing with discrimination and group violence against individuals who stand out. This is an example of the academic fascism that is discussed in this chapter. Some peculiarities of academic fascism include features of fascism-as-we-know-it, such as:

- Cult of the leader and submission of oneself to the leader;
- Masses of people, devoted to leaders, whose anger is based on their dissatisfaction with their lives (they tend to and obey the leader simply to convey their desires and expectations to the leader);
- Applying an irrational criterion (German National Socialism was based on the concept of blood and soil) on the community ready for sacrifice, on the criterion of race, and its secondary attributes (e.g. appearance);
- Hatred of others or of different groups (in anti-Semitism it is a Jew, in the Central-European nations and in the countries of the Visegrad Group in Europe, it is an Islamic emigrant);
- Violence against an independent and creative individual, her stigmatization as a black sheep, or the scapegoat;
- Extremely violence against others that culminated in historical fascism in concentration camps;
- "Endlösung" (German expression for a definitive solution of the problem) in terms of ethnic cleansing, which in its extreme mode took place during the war in Yugoslavia in the 1990s;
- Awareness of national or ethnic disadvantages, for example in the imperialist dividing of the world (in German National Socialism) or in territorial and ethnic integrity (e.g. Serbia in the former Yugoslavia);
- Dissatisfaction from the middle class or a very special social group;
- Segregation of those who think differently (and who think at all);
- The enforcement of the one-dimensional mind;
- Contempt for the weak, associated with chauvinist elitism.

The author addresses academic fascism with the aim of demonstrating a new form of aggressive segregation and exclusion that is characteristic of modern, highly developed societies and of communities where cognitive work

Remediating the Social: Impacts of Historical Fascism on Academic Fascism

comes to the fore. It is crucial for academic fascism to refashion the fascism-as-we-know-it, based on various historical fascisms (German, Italian, and Spanish), and to include manifestations of irrational forces and manipulation of the collective unconscious.

ACADEMICS AND FASCISM

The link between fascism and academics sounds strange. Are academics (scholars, researchers, cultural workers, and cognitive workers) not the ones who critique fascism? Is a democratic and tolerant position that resists all extremism, segregation, and exercise of violent power, not an integral part of the academic stance? Do we not find academics among those who stand in solidarity with vulnerable and marginalized social groups and, as public intellectuals, point to discrimination, and segregation? The answers to these questions can be also in the negative. The academic sphere is, on the one hand, a domain of the exercise of democratic principles and the pursuit of liberties, and, on the other, a sphere of the will to exercise power and its violent enforcement. Foucault's concept of power-knowledge (Fr. pouvoir-savoir) is also at play here. Important names in the history of science are often thieves of ideas, copyists of scientific articles of others (plagiarism), ideologists, supporters of undemocratic politicians, and those who have built their careers on disabling (controlling or disciplining) others; academics were also ideologists of ethnic cleansing (in the Third Reich and Bosnia).

According to established ideas, academics are the bearers of democratic values; this is merely an impression that conceals the dark and dangerous side of academia, which the author refers to as academic fascism in this chapter. Academics, as a social group of cognitive workers, are often frustrated by their social and economic position as defined by the public, politics, and the media. They believe that they are victims of great injustice because the attention economy (Goldhaber, 1997) places greater emphasis on other social groups. They operate with a super-ego that is constantly hurt and frustrated. They do not accept contempt and because they are extraverted by nature, they begin to look for the culprits for their painful deprivation (for scapegoat other as an intruder in their academic community). A key role in the academic community is played by a leader who disciplines the community, unifies it, and transforms it into a tool of her struggle for power. Community members, therefore, suck up to her, elevate her, and transfer a number of competencies to her.

Not only does the academic social group create great cohesion through interactions with the members involved, but it is the leader who contributes significantly to the cohesion of the group and the interactions between its members. Even if the academic group is not organized explicitly or hierarchically, a (non)formal leader appears in it sooner or later, who makes most of the essential decisions. Shared interests and values are the socially connecting factors, but they are not enough for academics; thus, the energy that is introduced into the life of a social group by a leader who also performs decision-making tasks is essential.

Academic communities are numerous and include innovative individuals, as are many who have missed their profession. They are not suitable to become university teachers or researchers, and the constant acquisition of new knowledge and the creation of knowledge is too difficult for them. To be a part of this community is a mistake; they would work more effectively and be more relaxed elsewhere. In other words, they would be happier in other professions and adequately challenged with other tasks. An interesting example of this is Central European intellectuals from countries such as Slovenia (EU member and NATO member state). After the fall of the Berlin Wall, when many literati and intellectuals (university professors, researchers, and journalists) were given the opportunity for political action (first in the fight for the rule of law and the protection of human rights, then for national independence as so-called liberators, later in established politics), they abandoned their previous professions without restraint and became politicians. This example demonstrates a leap from scholar to politician and provides evidence that many researchers and university professors are embarrassed by their profession and that they take another profession as a real relief, only to bring them adequate social attention and financial compensation. In other words, academics can be equally—if not more—satisfied with positions outside of academia.

As creatively unsuccessful individuals are also a part of the academic community, they compensate for their weak innovation potential with great loyalty to the leader. This is expressed by doing the leader's dirty work regarding the disabling of intruders in this community. Those who are equally creative as the leader or perhaps are more creative than leader may bother and endanger the leader who, for that reason, tries to take them out of the picture. The leader knows the creatively weak members of the community well, so she assigns them the role of purifier (i.e., someone who uses different, even vile ways to disable successful, but less-docile, academics). In addition, those who disagree with the leader and may jeopardize her prestigious position. Thus,

Remediating the Social: Impacts of Historical Fascism on Academic Fascism

weakly creative members perform academic cleansing for the benefit of the leader, which does not present them any moral dilemma, because when an individual intensely connects with a group, there is an equation between her personal and social identity. In turn, this leads to an individual's willingness to perform extreme actions in favor of social groups (Swann et al., 2009). Performing dirty tasks (such as academic cleansing) is not difficult for them because fascism "seems to come from the outside, but finds its energy right at the heart of everyone's desire" (Guattari 1995: 245).

Thus, the key features of academic fascism include:

- Privatization of a specific academic field by an international organization and its leader;
- Stigmatizing and disabling members of the community who disrupt the almighty leader and their appropriation and distribution of knowledge;
- Disabling the publication of the views of an eliminated researcher as a scapegoat other (and "homo sacer") so that the professional public does not encounter views that differ from the star academics, especially the almighty leader;
- Academic cleansing of the disruptive individuals who destabilize the cohesion of the group, especially if they are from small countries, with little importance in global politics and economics;
- Belief in new technologies or the irrational glorification of a smart machine that replaces the criterion of blood and soil in historical fascism;
- Academic *Drang nach Osten* in terms of finding new territories to disseminate her industry, namely, knowledge controlled by the leader (e.g., a march into a globalized world with theories verified by the leader and organizations under her influence);
- Efforts to fully control knowledge transfer in a specific field;
- Privatization of knowledge by an almighty leader and politicians who support them.

Academic fascism is devoid of concentration camps (known from German National Socialism in the Third Reich), but it invents new forms of segregation and disenfranchisement (academic cleansing, for example). In doing so, it uses a variety of distraction devices, including a trick to divert attention based on the continued emphasis of clichés and archetypes that threaten academic freedom (totalitarianism, anti-Semitism, privatization, the abolition of public space, and post-political decision-makers) to distract the attention from

Remediating the Social: Impacts of Historical Fascism on Academic Fascism

devices that they themselves use to achieve their goals. In doing so, their devices are often just as totalitarian and exclusionary as those attributed to their opponents. With these devices, they construct fictional islands designed for the perfect purpose of diverting attention.

Theme parks are fiction islands that redirect attention from reality, which is itself speculative and intertwined with fictional effects. "Disneyland is presented as imaginary in order to make us believe that the rest is real, when in fact all of Los Angeles and America surrounding it are no longer real, but of the order of the hyperreal and of simulation" (Baudrillard, 1983, p. 25). Here, the author mentions the case of Slovenian academics, who are active in the humanities and social sciences, and are often trapped in far-left nationalism. They deal extensively with the Roman Catholic Church to conceal that there are many other, more influential, but skilfully obscured churches in Slovenia that are 100 times more adept at manipulating citizens than weak organized Catholics due to the corrupted leadership under the former, now retired bishop Anton Stres. Politics in the Republic of Slovenia constantly establish Disneylands in several modes (from literary journals, confessional departments at faculties, and cultural institutions to festivals, spectacles, and ritual gatherings of like-minded people). Further, they often employ state pleasure-seekers who are usually only slightly creative individuals who understand their work as a gift because the one who gave them praise must be their master.

The goal of academics is to single out and destroy the theoretician as *homo sacer* who thinks differently than they do, looks differently, and does not adapt. And above all, the goal is to discipline and eliminate the one who knows more than they do and who is more innovative than them, thus jeopardizing their hard-won knowledge and a related social place. They are not interested if such prohibitions prevent the creation of new knowledge and its flow. They defend the interests of their community and they sacrifice themselves for it because stable relationships in such a community could be destroyed by others, and therefore erased. They are not seeking knowledge, but rather are seeking knowledge-power that disciplines those who have access to an episteme other than that controlled by the leader. Such efforts are particularly characteristic of the labor of academics in the social sciences and humanities (i.e., in fields that are significantly exposed to daily politics, and researchers are often engaged in projects designed to serve the needs of party politics). Here, the author turns to Slovenia, where, as a rule, national policy only finances research carried out by loyal researchers in these fields (who thankfully publicly support a parliamentary party whose success is in

their interest). Philosopher and activist Mladen Dolar said of the Levica Party (included in Slovenian Parliament), "Levica seems to me to be the only one who does not blow into the same horn and brings a different discourse ... And so it has my voice" (Rak, 2018).

TROUBLES WITH ACADEMIC FASCISM

The academic sphere is, on the one hand, a domain of the exercise of democratic principles and the striving for liberties. On the other hand, it is a sphere of the will to exercise power and its violent discrimination and segregation of researchers as scapegoat others, along with the obstruction of knowledge that is incompatible with the model of knowledge that is promoted by the leader. The academic sphere has also played an important role in historical fascisms by preparing the conceptual foundation for fascist ideology and its operational goals. This is certainly the most relevant example of German National Socialism, whose ideology was drawn up by many theorists of racism and anti-Semitism, including Paul de Lagarde, Houston Stewart Chamberlain, and Adolf Josef Lanz (Merker, 1983). The key place among the ideologues of the National Socialism state certainly belongs to Alfred Rosenberg, whose best-seller *The Myth of the Twentieth Century* (1930), along with Hitler's *Mein Kampf* (1925), is a basic texts for understanding German Nazism, racism, and fascist arts and culture.

Threats to the German people have been thought and written down by German intellectuals and confronted with Germany's poor yield of the imperialist division of the world before World War I due to the Treaty of Versailles. In fact, these intellectuals acted as spiritual fathers of German National Socialism, calling on the Drang nach Osten (to march East) and glorify the German race. A similar role was played in the rise of Greater Serbia and Serbian Nationalism by SANU (The Serbian Academy of Sciences and Arts) academics and, in Slovenian literary nationalism, by ideologists of Nova revija journal (the central role was played by the philosopher of the Heideggerian orientation, Tine Hribar). Even in what was a catastrophic defeat for Europe, the ethnic cleansing during the war in former Yugoslavia (Srebrenica), theorists and even poets played an important part, as pointed out by Žižek:

True, Slobodan Milošević "manipulated" nationalist passions—but it was the poets who delivered him the stuff that lent itself to manipulation. They—the

sincere poets, not the corrupted politicians—were at the origin of it all, when, back in the seventies and early eighties, they started to sow the seeds of aggressive nationalism not only in Serbia, but also in other ex-Yugoslav republics. Instead of the industrial-military complex, we in post-Yugoslavia had the poetic-military complex, personified in the twin figures of Radovan Karadžić and Ratko Mladić. Karadžić was not only a ruthless political and military leader, but also a poet. His poetry should not be dismissed as ridiculous—it deserves a close reading, since it provides a key to how ethnic cleansing functions. (2014, n.p.)

Such a complex also existed in Slovenian partisan poetry (1941-1945), which promoted militant stance (for example, the famous verse "Stretch the gallows over the whole world/our God are: robbery, arson, murder!" from the poetry collection *Previharimo viharje*, written by Matej Bor.

Academic fascism is close to the concept of fascism that Foucault approached in his preface to *Anti-Oedipus* with the words "not only historical fascism, the fascism of Hitler and Mussolini... but also the fascism in us all, in our heads and in our everyday behavior, the fascism that causes us to love power, to desire the very thing that dominates and exploits us" (Foucault, 1983, p. xiii). Academic fascism is a hybrid that consists of a conglomerate of traits ranging from molecular and micro fascism to transformed and updated forms of historical fascisms. Appeal to the frustrated middle class in historical fascism has been replaced in academic fascism by an appeal to mostly frustrated researchers who are below average or at most average capable of precarious, high-risk research work. They pass their hidden desires and traumas on to the leader and they should then get rid of the danger, posed to their position by the intruders. Because they do not know strangers well, they are expected to have a conspiracy to act.

A CASE STUDY: MARIA FROM NOWHERE

Specific to academic fascism is the fate of a researcher who, with goodwill, full of optimism and expectation, began research in one area of the social sciences, but soon had to face violent disabling, humiliation, and ousting. The researcher's story (the e-mail and video correspondence documentation needed to reconstruct her story is kept by the author of this chapter on his computer and in the cloud) is a document of what can be imagined as academic fascism. In order to protect a colleague from a small EU Member State,

Remediating the Social: Impacts of Historical Fascism on Academic Fascism

the author will use Romania instead of her real homeland, which is a small European country created after the fall of the Berlin Wall, and will portray her using a pseudonym, Maria. Although Maria is from the EU, it does not mean that she is safe there or that she enjoys basic human rights because the image of Europe, the protector of such rights, is a social construct that European politicians create. For many of its citizens, Europe is a stepmother who does not protect human rights but violates them and in doing so makes pacts with the offending countries.

One of the offending European countries is Maria's homeland, created through deception (several years before the fall of the Berlin Wall) while a secret communist intelligence service began to prepare an agenda of independence that was generally democratic. This was, with their own people, imposed on the so-called liberators as those who were underprivileged in communism and truly fought for change. To illustrate the American political reality looked as if the American Democrats had written the electoral program to the Republicans and conspiratorially plant it to them. After winning the election, however, the Trojan horses would begin their own Democratic (instead of the Republican) doctrine. In the wake of these developments, astounded authentic Republicans would then just be helpless because they would no longer be able to change anything, things would go their way, and be pursued by the prodigal politicians of another political option.

A number of deprived individuals in the communist period of Maria's country followed the events of the fall of the Berlin Wall, leading to the formation of a democratic state. In turn, this demanded the exercise of human rights and redresses the injustice with great anticipation. However, this did not happen there, and individuals who bet on joining the democratic community were cheated. This deception influenced Maria and, in her research, she began to deal with the topic of the defeat of democracy in post-socialist countries, in which she has interwoven political theory, sociology, philosophy, and cultural studies. With support from her colleagues from a large university in a neighboring city, she was able to raise funds for research on the transition in post-socialist countries. As her work was only scarcely noticed in her home country, she soon began to publish the results of her research in foreign academic journals and present them at international conferences. Her articles fall into the field of basic research and developing new knowledge; she did not publish her texts abroad because they were based on already established knowledge applied to the social specificity in her home country, but because she was creating a new scientific field together with key, established experts in the scientific world.

Remediating the Social: Impacts of Historical Fascism on Academic Fascism

At some point in her international activities, however, her scientific path began to stall; until recently, colleagues began to place insurmountable obstacles on her, make problems, and ignore her achievements. The first such milestone was her participation in an international conference in her scientific field that took place in Florence. The organizer of the event sent her a schedule of the conference, as well as the address of a smaller hotel where she was supposed to be staying. She arrived at the Florence airport on time, and because she had to finance this scientific trip on her own, she chose the bus as the cheapest option for transfer to the city center. However, she unexpectedly encountered a problem when looking for the hotel. There was no hotel of that name, and no one had heard of it, not even in smaller guesthouses. Should she just go to the conference with her luggage and ask the organizer why they did it to her, why they sent her to a non-existent location?

No. Maria is too proud, so she decided to ignore the conference with such a corrupt organizer, and for the next two days, she would rather take the bus to the coast, to a resort near Florence. After a fun stroll down the coast, she returned to the airport on time and flew home. Because of her experience with this organizer, she complained to the EU Commissioner for Culture but has never received any response. Although she continued with her research after returning home, her thoughts often kept straying to her colleagues from a broader group of theorists in her field of expertise and their relationship to her. She found that she was too naive and kind, and she generously explained her original ideas and concepts to them, though she never received proper feedback from them. She began to remember how, once, at a bar after the end of a conference, three participants made fun of her, at the expense of her appearance, her boyish face, which, due to her elongated head, taunts with the stereotype of a sexually attractive woman (Penney, 2016).

Within weeks of that discriminatory event, she had another disappointment. A journal, which publishes monthly professional and scientific texts in her field, published a paper that included an excursion to the history of dealing with the field in which Maria was a pioneer. Although she introduced the distinction between two different modalities of the transition to post-socialism at the conference of autumn 1998, and introduced a specific term for the modality inherent in Romania, the paper cited only the first and authoritative distinction between the two modalities that was introduced by the head of the academic field in which Maria operates. Not 1998, but 2003 was the first time that science began to apply this distinction based on a text written by the leader. She found it humiliating to protest and cite her original contribution

Remediating the Social: Impacts of Historical Fascism on Academic Fascism

(published online and in a scientific journal), which was ignored by that paper, so she decided not to go down to the level of contention with manipulators.

Having enough texts and a full head of ideas from post-socialist studies, she wrote a new scientific paper in spite of the isolation and abandonment of contacts with the community in which she presented her ideas and contextualized her concepts. She sent it to the academic journal Post-socialism Studies Web (we deliberately somewhat changed the title). The editorial staff first informed her that the review process would take four to five months, but three days after that, she received a new notice, saying that her review of the paper would take eighteen to twenty months. This notice was accompanied by a form requesting her written consent to such an unusually lengthy evaluation process. Why all of a sudden this change and discrimination (i.e. four times longer reviewing period in her case)? She took a closer look at the affiliate of the editor-in-chief of that journal and immediately found out that she was employed by a university where the almighty leader of her field was a dean years ago. Things became clear to her instantly; the editor-in-chief of the journal asked her former dean and colleague, who is the leader of Maria's field, what opinion he had of Maria, before submitting her paper to the reviewer, and, because he had given a negative view, she discouraged Maria from publishing in that journal through a gesture of an unreasonably lengthy evaluation process.

The question that even an independent observer asks herself in the story of Maria's discrimination is why did they get so hostile toward her and why did they not have any restraint on her exclusion from the community and micro-fascist shame? The answer to this question also comes by considering the facts of her homeland. In the field of humanities and social sciences, there is an internationally renowned researcher who belongs to the premier league in the world of renowned researchers. Maria's colleagues kept asking the popular researcher what Maria is really like, what her political beliefs and preferences were, what party she votes for in her home country, and what her personal life was like. In addition, they asked whether the internationally renowned researcher answer to them? Recognizing a competitor in Maria, who could jeopardize her excellent status and the privileges associated with it, she practically defrauded Maria abroad and blamed her as an anti-Semitist. Being an anti-Semitist is the most swearing word in very strong, democratically-defined, academic circles; this is why members of the academic-fascist community have adopted this definition as pure gold and have justified Maria's stigma as a sacrificial researcher or as a kind of *homo sacer*. It did not even occur

to them to check the accusation of anti-Semitism, though it was definitely false, because of Maria's genuine Jewish roots.

The story of Maria is the story of academic cleansing as a mode of elimination, disability, and discrimination of a researcher as a scapegoat other. Such discrimination has material and financial consequences for the discriminator; the fatwa uttered by the almighty leader above her can send her to the existential margin and solitude, to the state-of-the-art *homo sacer*. The academic fascists did not send Maria to a concentration camp, but they ruined her career. Now she is dealing with other things, but sometimes she still looks on the web to see if anyone else cites something from her papers. She easily finds that her knowledge is deliberately ignored by colleagues and researchers from Western Europe and the USA (the leader of her field has banned subordinated researchers from quoting her), and her work is scarcely mentioned by Turks, Pakistanis, and Indians, and sometimes researchers from Slovakia, Czech Republic, and Poland.

CONCEPTUAL FOUNDATIONS OF ACADEMIC FASCISM

There is a chapter in *The Myth of the Twentieth Century*, Racial Aesthetics, in which Alfred Rosenberg, the ideologist of the German National Socialism has argued that those philosophers who have written about the aesthetic condition, or the establishing of values in art, have bypassed the fact of a racial ideal of beauty. This ideal relates to the physical appearance of the racial types and to the race's supreme value. In this respect it is evident that if the nature of art is to be discussed, then the pure physical representation, for example, of a Greek, must have a different effect upon us than, for instance, the portrait of a Chinese emperor (1930, n.p.).

The racial criterion, as an irrational one, entered the ideology (and aesthetics) of the Third Reich and its art, which, as one of the fundamental ideological state apparatus (Althusser, 1971), had important propaganda and educational function. According to Rosenberg, art is an expression of a continuous clash between cultural and creative North Atlantic people, whose antipodes are Jewish-Semitic, in the field of culture non-creative people.

Smart Technology Instead of Soil

The question raised here is whether, in academic fascism, an irrational criterion can also be found, but at the same time a distinctively content one that plays a role similar to that of race (blood) in historical fascism. The authors' affirmative answer refers to the fetishization of smart technology, which appears in some areas of contemporary humanities as a decisive and connecting factor. One such area where some theorists act as aficionados of advanced technology and its ideological surplus is electronic literature as a practice, which intersects with new media art (Strehovec, 2016). Similar to the Germans in the Third Reich, when confronted with the harmony with native soil (Ger. *Heimat*) and with nature, in academic fascism, the harmony with new technologies is at play. Blood and soil are replaced by software and a belief in the power of technology.

Today's individual is transferring a range of competencies to machines (we are in the paradigm of algorithmic culture), she is a fan of artificial intelligence and in a case of digital textuality, by a smart machine shaped by language. Whereas the contemporary, first and foremost (new) media art is critical to new technologies and their role in manipulating individual freedom (phenomena such as Internet of things, big data, and cloud computing), the electronic literature, (i.e. the one promoted by Electronic Literature Organisation with a key theoretician N. Katherine Hayles and John Cayley as the most praised author), is too fond of technological advances deployed in new media shaped writing. ELO appears to be a community of machine aficionados in the field of digital textuality.

Fascination with smart machines and their role in culture goes back to E.T.A. Hoffmann's *Sandman* (1816) and continues through Ballard's *Crash* (1973) with cyberpunk literature and successful blockbusters (from Blade Runner and Terminator 2 to Lawnmower Man and Star Wars). This fascination also affected (new) media art and ideology that accompanied early editions of festivals such as Ars Electronica in Linz. It was only the beginning of tactical media (1996) and socio-critical projects within the framework of net.art from the second half of the 1990s (e.g. Webstalker, 1997; Jodi's OSS, 1998) that shifted the focus of media art searches from an utopian belief in the omnipotence of smart machines to the dystopian belief. This is associated with the manipulation of technology, its subordination to the military complex, and its weak functioning (artistic references are noise and glitch). Parallel to these efforts, contemporary art has also undergone

noticeable changes where the importance of artistic activism is growing. The spirit of Joseph Beuys from the 6th Documenta art show in Kassel (1977) extends to activist art, which already has a prominent place in contemporary, highly post-aesthetic art, to which performance art projects also contribute. Contemporary performance art tends to emphasize corporeality, especially among female performers (from Carolee Schneemann, Valerie Export, and Marina Abramović to Ann Liv Young, Maja Smrekar, and Milo Moiré). By putting the vulnerable body at the center of attention it can be rediscovered, and we can encounter an emphasized human beyond the ethereal posthuman.

In 2019, the authors can conclude that electronic literature, which is promoted, conceived, and controlled by Electronic Literature Organisation, is being created beyond the critical potential developed by contemporary, (new) media art. The fascination with the omnipotent role of smart technology in e-writing, created by ELO members (as the community of smart machine aficionados), is detrimental to the enforcement of ELO controlled e-literature within new media creativity. In the French Post-structuralism (Allen, 2000), the emphasis has shifted from the author to the text and the pleasure of writing; in modern literary theory, there is increasing attention paid to the reader (e.g. reader-response theory), while in electronic literature, Hayles places the emphasis on co-authorship of the smart machine in the writing process. Thus, people are faced with faith in the technological surplus; metaphysical qualities in Ingarden's phenomenology of literature have given way to the metaphysics of the increasingly independent writing machine.

Computer as Co-Author

In the case of e-literature, its main authors, theorists, and ideologists seem to have overlooked the development of contemporary and new media art of the 1980s, 1990s, and early 21st century, and have become fascinated by things that appear to be very historical and remoted in contemporary art, (i.e. things of the past). Contemporary art is post-aesthetic, abandoning the authority of the completed artwork, while e-literature emphasizes aesthetics (e.g. W. D. Johnston's concept of aesthetic animism) and the role of a completed work of art, and authorship.

In contrast to post-aesthetic contemporary art, within the ELO institutionalized e-literature returns to the author, not to the well-known, corporeal author with passion and imagination, but the one who acts as the co-author together with the smart machine. Suddenly, the most established

Remediating the Social: Impacts of Historical Fascism on Academic Fascism

theorist in this field (Hayles, 2018) is mainly interested in the idea of a computer co-author in e-literature. According to Hayles, what is worth pursuing is, in particular, the surplus contributed by the smart machine (as a poetic rival) to writing supported by new media. The reader of the Hayles's texts even gets the sense that this scholar is constantly fascinated with genetic algorithms in terms of transmitting evolutionary dynamics into an artificial medium. She is excited and enthusiastic about the Heldén & Jonson's Java-based AI application *Evolution* (2014), in which the role of the computer is elevated from a collaborator to the co-creator; in this piece, the genetic algorithm eventually renders the role of the author redundant, the printed text disappears, and only new words are brought up on the screen.

What kind of words are these? They are no longer spoken and written words but computed words processed by computer programs that are losing their individual identity; they are words the raw material has taken from a standing reserve of words that are manipulatively pasted by the algorithm to new places in the matrix of the printed text. Regarding the e-literary criticism, this piece is certainly interesting and stimulating, and it is worth writing about the *Evolution*, but the question is whether more numerous repetitions of the *Evolution* very nature make sense in other e-poetry pieces? What if, for example, 1000 other poems written by other authors were started with such algorithmic upgrades as demonstrated by the *Evolution*? Would it still be interesting or would it be boring and monotonous? This dilemma is reminiscent of the one opened by Christo's land art projects, especially by his wrapped buildings (e.g. Christo's *Wrapped Reichstag* 1995). What would happen if 1000 artists began wrapping other buildings in his manner, albeit with different, more vibrant materials than Christo did? Instead of original art, we would encounter artistic pollution that concerns the basic Anthropocene issues.

Obviously, the power of the *Evolution* lies only in the pioneering of both authors in this field, and the iterations of applied procedures no longer make sense; rather, they are tedious and boring. The reader's perception, experience, and (potential) enjoyment of such an e-literary piece are also at stake. Certainly, at the first (as well as at the second and third) encounter with the *Evolution*, there is a suspense about what comes next, and about what new words will be introduced into the poetic textscape by the smart machine. However, the question is whether such a reader would, after a thorough encounter with such a piece, ever look at similar works without getting bored and being convinced that it's a waste of time?

Remediating the Social: Impacts of Historical Fascism on Academic Fascism

The *Evolution* project actually challenges textual analysis and stimulates special reading requiring the reader's belief that what a genetic algorithm adds to the author's underlying text is something "more" and spreads the meaning using something essential. However, unless you are an aficionado of smart machines, the algorithmic culture and the paradigm of the posthuman, it is by no means necessary for you to consider the text attributes in the underlaying text copyright replaced by the machine as some significant expansion; rather, it is a pleasure in the purely visual design of such text, which can be interpreted as a film that stimulates suspense between what is already shown and what is yet to come. Certainly, the text is interesting as a network of entwined written and computed properties, and the thought of starting to talk about the death of the machine (as the co-author) in the vein of the French post-structuralism is also interesting. However, the ELO-integrated e-literature theorists do not consider this possibility.

We live in the technological age, things and events go technologically, but irrational technology elevation generates a danger that does not necessarily lead to a solution (Heidegger. 1977). Increasingly, the storytelling skill is being lost (Benjamin, 1968), and is being replaced by abstract information that flows into text containers as raw material, further manipulated and purified by algorithms. Poetry generators and algorithms contribute to the technological purification of the word. This completes the cycle at play in this chapter: in fascism, much revolves around purification; academic cleansing goes hand in hand with the technological one; "cleansing" is also performed by smart machines, which are irrationally (euphorically, pathetically) celebrated by e-literature scholars-ideologists-aficionados.

CONCLUSION

Contemporary social theory, challenged by civil society, demands that horizontal and non-hierarchical social processes be foregrounded. Such processes are enabled and fostered by recent smart technology of distributed networks, which are not the same as decentralized networks, for which hubs are obligatory (Galloway, 2004). Theoretician Bauwens writes on peer to peer as "a specific form of network that is based on the assumed equipotency of its participants, organized through the free cooperation of equals in view of the performance of a common task, for the creation of a common good. P2P is a network, not a hierarchy; it is decentralized, not centralized; it a specific form of network using distributive intelligence: intelligence is located not

Remediating the Social: Impacts of Historical Fascism on Academic Fascism

at any center, but everywhere, at the periphery of the system. " (2005, n.p.) In spite of living in a reality where basic things go technologically and IT enables peer to peer social dynamics, today's individuum is faced with the danger of novel forms of social segregation, hierarchy, and repression, as has been demonstrated in this chapter on academic fascism.

Academic fascism is a technical term used to denote discrimination, segregation, violence, and disabling researchers who are not suited to the model of scientific research or are not favored by the leader (including the political underworld standing behind her). Thereby, discriminated researchers are not the only ones who are placed in an impossible position, but knowledge itself. No less than producing knowledge that is verified through her work, the leader is also interested in concealing and even erasing knowledge that does not coincide with her perception of knowledge in that field. The kind of basic research and books that would enrich the various sciences is hushed up and forgotten in the world of science and humanities.

Academic fascism remediates many of the basic concepts of historical fascism, as well as introducing new, specific ones that encourage critical theory to analyze violent segregation in the academic field. The academic fascism discussed in this chapter is close to things that could be termed as academic orientalism because the researcher as a scapegoat other is also an oriental and is treated as such in a theory that is Western (even if it originates from areas that are not considered the West geographically). In academic fascism, the definition of anti-Semitic does not mean much; the scapegoat other is often Jewish, but the Semitic or non-Semitic leader will often try to falsely and unjustly expel them by labeling them as an anti-Semitist.

A special example is the new modalities of the irrational (insanity instead of reasoning) that accompany contemporary arts and humanities, which the author recognized in this book chapter on Slovenian literary nationalism as ideological state apparatus. Another problem is the close connection of academics with the authorities, which leads to the finding of academics and writers even among those who co-create and justify fascist activities, attitudes, and behaviour (e.g. 2019 Nobel prize winner for literature Pater Handke as supporter of Milošević and Karađić, both the mastermind of ethnic cleansing in Bosnia).

This chapter promotes future research that is supported by examples from the academic orient that covers many researchers and scholars from developing and especially small countries, affiliated with little-known universities and institutes, often written in the small nations' languages. It is the responsibility of academics from the Baltic, Central European, Balkan, Middle Eastern,

African, and Asian countries to highlight the cases of segregation, academic cleansing, and displacement they have witnessed in their research work. The very method of how a leader disables the others and the different says a lot about her and her work. Even those who follow her with servitude and accept her views as if made of pure gold are merely erotic slaves of their leader than they are autonomous researches.

Academic orient and academic fascism—in an altered form—are phenomena with which contemporary art is also faced. There are also artists who can do whatever they wish and star-artists who have a similar role as the almighty leaders of the academic sphere. An especially interesting story is also the art market with curators and critics dictating trends in the art industry. With help of fairness in this area, artists from every orient could be recognized, and global art would thus be richer.

REFERENCES

Agamben, G. (1998). *Homo Sacer: Sovereign Power and Bare Life* (D. H. Roazen, Trans.). Stanford: Stanford University Press.

Allen, G. (2000). *Intertextuality*. London: Routledge. doi:10.4324/9780203131039

Althusser, L. (1971). Ideology and Ideological State Apparatuses. In *Lenin and Philosophy and Other Essays*. New York: Monthly Review Press. Retrieved March 17, 2019 from https://www.marxists.org/reference/archive/althusser/1970/ideology.htm

Aracagök, Z. (2018). *A short text about nano-fascism*. Retrieved June 19, 2019 from https://non.copyriot.com/a-short-text-about-nano-fascism/

Baudrillard, J. (1988). Simulacra and simulations. In M. Poster (Ed.), *Selected Writings* (pp. 166–184). Stanford: Stanford University Press.

Bauwens, M. (2005). *Peer to peer and human evolution*. Retrieved April 26, 2017, from the Integral Visioning Website at http://www.integralworld.net/bauwens2.html

Benjamin, W. (1968). *Storyteller. Illuminations*. New York: Harcourt, Brace & World.

Remediating the Social: Impacts of Historical Fascism on Academic Fascism

Bor, M. (1942). *Previharimo viharje*. Ljubljana: Glavno poveljstvo slovenskih partizanskih čet.

Deleuze, G., & Guattari, F. (1987). *A Thousand Plateaus*. Minneapolis: University of Minnesota Press.

Ecco, U. (1995). *Eternal fascism: Fourteen ways of looking at a blackshirt*. Retrieved August 13, 2019, from http://interglacial.com/pub/text/Umberto_ Eco_-_Eternal_Fascism.html

Foucault, M. (1983). *Anti-O edipus*. Minneapolis: Univ of Minnesota Press.

Galloway, A. R. (2004). *Protocol. How Control Exists after Decentralization*. Cambridge, MA: The MIT Press. doi:10.7551/mitpress/5658.001.0001

Goldhaber, M. H. (1997, April). The attention economy and the net. *First Monday*, *2*(4), 7. https://www.firstmonday.org/ojs/index.php/fm/article/ view/519/440

Guattari, F. (1995). Everybody wants to be a fascist. In S. Lotringer (Ed.), *Chaosophy* (pp. 225–250). New York: Semiotexte.

Hayles, N. K. (2018). Literary texts as cognitive assemblages: The case of electronic literature. *Electronic Book Review*. doi:10.7273/8p9a-7854

Heidegger, M. (1977). Question Concerning Technology and Other Essays (W. Lovitt, Trans.). New York: Harper and Row.

Heidegger, M. (1977). Question Concerning Technology and Other Essays (W. Lovitt, Trans.). New York: Harper and Row.

Heldén, J., & Håkan, J. (2013). *Evolution*. Retrieved, 2019 July 13 from https://www.johanneshelden.com/evolution/

Heldén, J., & Håkan, J. (2013). *Evolution*. Retrieved, 2019 July 13 from https://www.johanneshelden.com/evolution/

Hitler, A. (1998). *Mein Kampf* [My Fight]. Boston, MA: Mariner Books. (Original publication 1925)

Johnston, D. J. (2016). *Aesthetic Animism: Digital Poetry's Ontological Implications*. Cambridge, MA: The MIT Press.

Merker, R. (1983). *Die bildenden Künste im Nationalsozialismus*. Köln: DuMont Verlag.

Orwell, G. (1944) *What is Fascism?* Retrieved June 1, 2019, from https://www.orwell.ru/library/articles/As_I_Please/english/efasc

Penney, T. (2016) Digital Face-ism and Micro-Fascism. *The Official International Journal of Contemporary Humanities, 1*(1). Retrieved October 6, 2019 from https://www.researchgate.net/publication/331033518_Digital_Face-ism_and_Micro-Fascism

Rak, P. (2018). Pri nas se politika neoliberalnega konsenza prodaja za sredino. *Delo.* Retrieved October 3, 2019, from https://www.delo.si/novice/slovenija/pri-nas-se-politika-neoliberalnega-konsenza-prodaja-za-sredino-56087.html

Reich, W. (1970). *The mass psychology of fascism* (V. R. Carfagno, Trans.). New York: Farrar, Straus, & Giroux.

Rosenberg, A. (1930). *Der Mythus des 20. Jahrhunderts. Eine Wertung der seelisch-geistigen Gestaltenkämpfe unserer Zeit.* München: Hoheneichen.

Said, E. (1978). *Orientalism.* New York: Pantheon.

Swann, W. B. Jr, Gómez, Á., Seyle, D. C., Morales, J. F., & Huici, C. (2009). Identity fusion: The interplay of personal and social identities in extreme group behavior. *Journal of Personality and Social Psychology, 96*(5), 995–1011. doi:10.1037/a0013668 PMID:19379032

Turner, J. C., & Reynolds, K. H. (2001). The social identity perspective in intergroup relations: Theories, themes, and controversies. Blackwell Handbook of Social Psychology, 3(1).

Woodley, D. (2009). *Fascism and political theory: critical perspectives on fascist ideology.* London: Routledge. doi:10.4324/9780203871577

Žižek, S. (2014). The Poetic Torture-House of Language. How poetry relates to ethnic cleansing. *Poetry Foundation.* Retrieved June 22, 2019, from https://www.poetryfoundation.org/poetrymagazine/articles/70096/the-poetic-torture-house-of-language

Related Readings

To continue IGI Global's long-standing tradition of advancing innovation through emerging research, please find below a compiled list of recommended IGI Global book chapters and journal articles in the areas of media studies, art, and cultural paradigms. These related readings will provide additional information and guidance to further enrich your knowledge and assist you with your own research.

Adikpo, J. A. (2019). The Diffusion of Mobile Telephony in Popular Culture. In O. Ozgen (Ed.), *Handbook of Research on Consumption, Media, and Popular Culture in the Global Age* (pp. 311–327). Hershey, PA: IGI Global. doi:10.4018/978-1-5225-8491-9.ch018

Akar, B. (2019). "The Modern Daily Life" in Turkey in the 1950s in Popular Play Scripts of the State Theater. In O. Ozgen (Ed.), *Handbook of Research on Consumption, Media, and Popular Culture in the Global Age* (pp. 137–161). Hershey, PA: IGI Global. doi:10.4018/978-1-5225-8491-9.ch009

Amoruso, G., & Mironenko, P. (2020). Figuring Out the Interiors Through the Representation of Experiential and Interactive Environments. In L. Crespi (Ed.), *Cultural, Theoretical, and Innovative Approaches to Contemporary Interior Design* (pp. 367–386). Hershey, PA: IGI Global. doi:10.4018/978-1-7998-2823-5.ch017

Anstey, J., & Roussel, R. (2018). Building Sensorium: Perceptual and Affectual Art Processes. *International Journal of Art, Culture and Design Technologies*, 7(2), 26–40. doi:10.4018/IJACDT.2018070103

Related Readings

Anzani, A., & Caramel, C. (2020). Design and Restoration: An Ecological Approach. In L. Crespi (Ed.), *Cultural, Theoretical, and Innovative Approaches to Contemporary Interior Design* (pp. 68–84). Hershey, PA: IGI Global. doi:10.4018/978-1-7998-2823-5.ch003

Arık, E. (2019). Popular Culture and Media Intellectuals: Relationship Between Popular Culture and Capitalism – The Characteristics of the Media Intellectuals. In O. Ozgen (Ed.), *Handbook of Research on Consumption, Media, and Popular Culture in the Global Age* (pp. 1–10). Hershey, PA: IGI Global. doi:10.4018/978-1-5225-8491-9.ch001

Arisoy, E. (2019). Multiculturalism in Cinema in the Context of Popular Culture: Where Exactly Ferzan Özpetek Stands? In O. Ozgen (Ed.), *Handbook of Research on Consumption, Media, and Popular Culture in the Global Age* (pp. 230–245). Hershey, PA: IGI Global. doi:10.4018/978-1-5225-8491-9. ch014

Aslan, P. (2019). Popular Culture and Iconology: Reading Today's Icons as Works of Art. In O. Ozgen (Ed.), *Handbook of Research on Consumption, Media, and Popular Culture in the Global Age* (pp. 174–187). Hershey, PA: IGI Global. doi:10.4018/978-1-5225-8491-9.ch011

Attiwill, S. (2020). Urban Interiors and Interiorities. In L. Crespi (Ed.), *Cultural, Theoretical, and Innovative Approaches to Contemporary Interior Design* (pp. 58–67). Hershey, PA: IGI Global. doi:10.4018/978-1-7998-2823-5.ch002

Ayiter, E. (2018). Playing With Text in Space. In M. Khosrow-Pour, D.B.A. (Ed.), Enhancing Art, Culture, and Design With Technological Integration (pp. 114-130). Hershey, PA: IGI Global. doi:10.4018/978-1-5225-5023-5.ch006

Barneche-Naya, V., & Hernández-Ibáñez, L. A. (2018). A Vitruvian-Inspired Theoretical Framework for Architecture in Virtual Worlds. In M. Khosrow-Pour, D.B.A. (Ed.), Enhancing Art, Culture, and Design With Technological Integration (pp. 152-168). Hershey, PA: IGI Global. doi:10.4018/978-1-5225-5023-5.ch008

Birsa, E. (2019). Creative Realization of Art Tasks in Interdisciplinary Learning Process. In J. Vodopivec, L. Jančec, & T. Štemberger (Eds.), *Implicit Pedagogy for Optimized Learning in Contemporary Education* (pp. 141–165). Hershey, PA: IGI Global. doi:10.4018/978-1-5225-5799-9.ch008

Related Readings

Bittar, A. J., Figueiredo, V. M., & Ferreira, A. D. (2018). Brazil-United Kingdom Dance Medicine and Science Network as a Place for Poetic Preparation Research. *International Journal of Art, Culture and Design Technologies, 7*(1), 1–16. doi:10.4018/IJACDT.2018010101

Bolognesi, C. M., & Aiello, D. A. (2020). Through Achille Castiglioni's Eyes: Two Immersive Virtual Experiences. In G. Guazzaroni & A. Pillai (Eds.), *Virtual and Augmented Reality in Education, Art, and Museums* (pp. 283–310). Hershey, PA: IGI Global. doi:10.4018/978-1-7998-1796-3.ch014

Brusatin, M. (2020). Design Surrenders to Virtual Reality. In L. Crespi (Ed.), *Cultural, Theoretical, and Innovative Approaches to Contemporary Interior Design* (pp. 308–314). Hershey, PA: IGI Global. doi:10.4018/978-1-7998-2823-5.ch014

Caeiro, M., & Folgado, M. (2020). Art Staging the Civic: From Rhetoric to Spaciousness. In L. Crespi (Ed.), *Cultural, Theoretical, and Innovative Approaches to Contemporary Interior Design* (pp. 208–236). Hershey, PA: IGI Global. doi:10.4018/978-1-7998-2823-5.ch010

Campbell, D. M. (2019). Black Lives Matter vs. All Lives Matter in the Generation of "Hashtivism": Constructing the Paradigms of Cyber-Race. In O. Ozgen (Ed.), *Handbook of Research on Consumption, Media, and Popular Culture in the Global Age* (pp. 287–310). Hershey, PA: IGI Global. doi:10.4018/978-1-5225-8491-9.ch017

Cañas-Bajo, J., & Silvennoinen, J. (2018). Experiencing Commercial Videos for Online Shopping: A Cross-Cultural User's Design Approach. In M. Khosrow-Pour, D.B.A. (Ed.), Enhancing Art, Culture, and Design With Technological Integration (pp. 183-214). Hershey, PA: IGI Global. doi:10.4018/978-1-5225-5023-5.ch010

Cavalcanti van Haandel, J. (2019). The AM and FM Radio Changes in the Multimedia Radio Emergence. In E. Simão & C. Soares (Eds.), *Trends, Experiences, and Perspectives in Immersive Multimedia and Augmented Reality* (pp. 171–191). Hershey, PA: IGI Global. doi:10.4018/978-1-5225-5696-1.ch008

Cipolletta, G. (2020). Ubiquitous Self: From Self-Portrait to Selfie. In G. Guazzaroni & A. Pillai (Eds.), *Virtual and Augmented Reality in Education, Art, and Museums* (pp. 93–115). Hershey, PA: IGI Global. doi:10.4018/978-1-7998-1796-3.ch006

Related Readings

Clements, L., & Weber, R. (2018). Making Space for the Psychology of Creativity in Dance Science. *International Journal of Art, Culture and Design Technologies, 7*(1), 30–45. doi:10.4018/IJACDT.2018010103

Clini, P., Quattrini, R., Bonvini, P., Nespeca, R., Angeloni, R., Mammoli, R., ... Mandolesi, S. (2020). Digit(al)isation in Museums: Civitas Project – AR, VR, Multisensorial and Multiuser Experiences at the Urbino's Ducal Palace. In G. Guazzaroni & A. Pillai (Eds.), *Virtual and Augmented Reality in Education, Art, and Museums* (pp. 194–228). Hershey, PA: IGI Global. doi:10.4018/978-1-7998-1796-3.ch011

Cohen, C. (2019). Understanding an Enemy is Like Understanding a Poem: Art and Peace in Theory and Practice. In M. Lutfy & C. Toffolo (Eds.), *Handbook of Research on Promoting Peace Through Practice, Academia, and the Arts* (pp. 278–298). Hershey, PA: IGI Global. doi:10.4018/978-1-5225-3001-5.ch014

Coralli, M. (2020). Public Space "Under Influence": Rewriting in Progress in Africa. In L. Crespi (Ed.), *Cultural, Theoretical, and Innovative Approaches to Contemporary Interior Design* (pp. 104–128). Hershey, PA: IGI Global. doi:10.4018/978-1-7998-2823-5.ch005

Crespi, G. (2020). Art and Space: New Boundaries of Intervention. In L. Crespi (Ed.), *Cultural, Theoretical, and Innovative Approaches to Contemporary Interior Design* (pp. 191–207). Hershey, PA: IGI Global. doi:10.4018/978-1-7998-2823-5.ch009

Crespi, L. (2020). Designing Interiors: A Guide for Contemporary Interior Landscape Design. In L. Crespi (Ed.), *Cultural, Theoretical, and Innovative Approaches to Contemporary Interior Design* (pp. 1–57). Hershey, PA: IGI Global. doi:10.4018/978-1-7998-2823-5.ch001

Crippa, D. (2020). Interactive Spaces: What If Walls Could Talk? In L. Crespi (Ed.), *Cultural, Theoretical, and Innovative Approaches to Contemporary Interior Design* (pp. 237–258). Hershey, PA: IGI Global. doi:10.4018/978-1-7998-2823-5.ch011

Dernie, D. J. (2020). Notes on the Spatiality of Colour. In L. Crespi (Ed.), *Cultural, Theoretical, and Innovative Approaches to Contemporary Interior Design* (pp. 85–103). Hershey, PA: IGI Global. doi:10.4018/978-1-7998-2823-5.ch004

Related Readings

Di Prete, B. (2020). Urban Interior Design: A Relational Approach for Resilient and Experiential Cities. In L. Crespi (Ed.), *Cultural, Theoretical, and Innovative Approaches to Contemporary Interior Design* (pp. 130–153). Hershey, PA: IGI Global. doi:10.4018/978-1-7998-2823-5.ch006

Di Sabatino, P. A. (2020). (more)SoftAssertions: A Progressive Paradigm for Urban Cultural Heritage, Interior Urbanism, and Contemporary Typologies. In L. Crespi (Ed.), *Cultural, Theoretical, and Innovative Approaches to Contemporary Interior Design* (pp. 315–354). Hershey, PA: IGI Global. doi:10.4018/978-1-7998-2823-5.ch015

Domingues, D. M., & Miranda, M. R. (2019). Affective Presence in Enactive Immersive Space: Sensorial and Mobile Technologies Reengineering Life. In E. Simão & C. Soares (Eds.), *Trends, Experiences, and Perspectives in Immersive Multimedia and Augmented Reality* (pp. 23–51). Hershey, PA: IGI Global. doi:10.4018/978-1-5225-5696-1.ch002

Doyle, D. (2018). Imagination and the Phenomenology of Virtual Practice. In M. Khosrow-Pour, D.B.A. (Ed.), Enhancing Art, Culture, and Design With Technological Integration (pp. 131-151). Hershey, PA: IGI Global. doi:10.4018/978-1-5225-5023-5.ch007

Ellington, L. M. (2019). Healing: Use the Power of Your Voice Through Your Stories. In J. Bopp, A. Grebe, & J. Denny (Eds.), *Healing Through the Arts for Non-Clinical Practitioners* (pp. 9–21). Hershey, PA: IGI Global. doi:10.4018/978-1-5225-5981-8.ch002

Endong, F. P., & Essoh, E. G. (2019). The Concept of Power in the Nigerian Religious Discourse: A Study of Advertising Copies by Pentecostal and Charismatic Churches. In O. Ozgen (Ed.), *Handbook of Research on Consumption, Media, and Popular Culture in the Global Age* (pp. 371–396). Hershey, PA: IGI Global. doi:10.4018/978-1-5225-8491-9.ch022

Ersin, N. (2019). The Effect of Popular Culture on TV Program Genres Within Globalization Process. In O. Ozgen (Ed.), *Handbook of Research on Consumption, Media, and Popular Culture in the Global Age* (pp. 76–93). Hershey, PA: IGI Global. doi:10.4018/978-1-5225-8491-9.ch005

Esiyok, E. (2019). How Do Cartoon Movies Construct Children's Consumption Habits for "Special Days"? In O. Ozgen (Ed.), *Handbook of Research on Consumption, Media, and Popular Culture in the Global Age* (pp. 94–104). Hershey, PA: IGI Global. doi:10.4018/978-1-5225-8491-9.ch006

Related Readings

Frogeri, R. F., Pardini, D. J., Cardoso, A. M., Prado, L. Á., Piurcosky, F. P., & Junior, P. D. (2019). IT Governance in SMEs: The State of Art. *International Journal of IT/Business Alignment and Governance*, *10*(1), 55–73. doi:10.4018/IJITBAG.2019010104

Garip, S. B., Saglar Onay, N., & Garip, E. (2020). Re-Coding Homes as a Flexible Design Approach for Living Environments. In L. Crespi (Ed.), *Cultural, Theoretical, and Innovative Approaches to Contemporary Interior Design* (pp. 284–306). Hershey, PA: IGI Global. doi:10.4018/978-1-7998-2823-5.ch013

Geronimo, G., & Giannella, S. (2020). Employing Real-Time Game Technology for Immersive Experience (VR and Videogames) for all at MAIO Museum: Museum of WWII Stolen Artworks. In G. Guazzaroni & A. Pillai (Eds.), *Virtual and Augmented Reality in Education, Art, and Museums* (pp. 263–282). Hershey, PA: IGI Global. doi:10.4018/978-1-7998-1796-3.ch013

Goldfarb, D., & Merkl, D. (2019). Data-Driven Maps of Art History. *International Journal of Art, Culture and Design Technologies*, *8*(1), 1–15. doi:10.4018/IJACDT.2019010101

Gouveia, P. (2019). Transmedia Experiences That Blur the Boundaries Between the Real and the Fictional World. In E. Simão & C. Soares (Eds.), *Trends, Experiences, and Perspectives in Immersive Multimedia and Augmented Reality* (pp. 1–22). Hershey, PA: IGI Global. doi:10.4018/978-1-5225-5696-1.ch001

Grebe, A. M. (2019). Healing Our Heroes: Creating an Arts-Based Intervention. In J. Bopp, A. Grebe, & J. Denny (Eds.), *Healing Through the Arts for Non-Clinical Practitioners* (pp. 22–43). Hershey, PA: IGI Global. doi:10.4018/978-1-5225-5981-8.ch003

Guazzaroni, G. (2020). Role of Emotions in Interactive Museums: How Art and Virtual Reality Affect Emotions. In G. Guazzaroni & A. Pillai (Eds.), *Virtual and Augmented Reality in Education, Art, and Museums* (pp. 174–193). Hershey, PA: IGI Global. doi:10.4018/978-1-7998-1796-3.ch010

Guerra, P. (2019). Ceremonies of Pleasure: An Approach to Immersive Experiences at Summer Festivals. In E. Simão & C. Soares (Eds.), *Trends, Experiences, and Perspectives in Immersive Multimedia and Augmented Reality* (pp. 122–146). Hershey, PA: IGI Global. doi:10.4018/978-1-5225-5696-1.ch006

Related Readings

Hafiz, D. (2020). Improving Occupants Comfort Through Qualitative Indoor Environments: A Case Study. In L. Crespi (Ed.), *Cultural, Theoretical, and Innovative Approaches to Contemporary Interior Design* (pp. 387–404). Hershey, PA: IGI Global. doi:10.4018/978-1-7998-2823-5.ch018

Hitz, T. L. (2019). Collaborative Art and Relationships. In J. Bopp, A. Grebe, & J. Denny (Eds.), *Healing Through the Arts for Non-Clinical Practitioners* (pp. 193–213). Hershey, PA: IGI Global. doi:10.4018/978-1-5225-5981-8. ch012

Invernizzi, F. C. (2020). Dwelling in the Leftovers: Investigation on Design Experience and a Glimpse Into Cyprus Buffer Zone. In L. Crespi (Ed.), *Cultural, Theoretical, and Innovative Approaches to Contemporary Interior Design* (pp. 405–421). Hershey, PA: IGI Global. doi:10.4018/978-1-7998-2823-5.ch019

Johansson, M. (2018). Soundscaping. In M. Khosrow-Pour, D.B.A. (Ed.), Enhancing Art, Culture, and Design With Technological Integration (pp. 169-182). Hershey, PA: IGI Global. doi:10.4018/978-1-5225-5023-5.ch009

Kang, Y., & Yang, K. C. (2020). Employing Digital Reality Technologies in Art Exhibitions and Museums: A Global Survey of Best Practices and Implications. In G. Guazzaroni & A. Pillai (Eds.), *Virtual and Augmented Reality in Education, Art, and Museums* (pp. 139–161). Hershey, PA: IGI Global. doi:10.4018/978-1-7998-1796-3.ch008

Karabacak, Z. İ. (2019). The Reflection of Popular Culture on Calendar Photos. In O. Ozgen (Ed.), *Handbook of Research on Consumption, Media, and Popular Culture in the Global Age* (pp. 162–173). Hershey, PA: IGI Global. doi:10.4018/978-1-5225-8491-9.ch010

Kargas, A., Karitsioti, N., & Loumos, G. (2020). Reinventing Museums in 21st Century: Implementing Augmented Reality and Virtual Reality Technologies Alongside Social Media's Logics. In G. Guazzaroni & A. Pillai (Eds.), *Virtual and Augmented Reality in Education, Art, and Museums* (pp. 117–138). Hershey, PA: IGI Global. doi:10.4018/978-1-7998-1796-3.ch007

Kılıç, Ş. O., & Genel, Z. (2019). Impact of Social Media and Technology Companies on Digital Journalism. In E. Simão & C. Soares (Eds.), *Trends, Experiences, and Perspectives in Immersive Multimedia and Augmented Reality* (pp. 147–170). Hershey, PA: IGI Global. doi:10.4018/978-1-5225-5696-1.ch007

Köroğlu, C. Z., & Köroğlu, M. A. (2018). On the Transformation of Social Movements: An Analysis From the East-West Axis. In M. Khosrow-Pour, D.B.A. (Ed.), Enhancing Art, Culture, and Design With Technological Integration (pp. 50-74). Hershey, PA: IGI Global. doi:10.4018/978-1-5225-5023-5.ch003

Kunjir, A. R., & Patil, K. R. (2020). Challenges of Mobile Augmented Reality in Museums and Art Galleries for Visitors Suffering From Vision, Speech, and Learning Disabilities. In G. Guazzaroni & A. Pillai (Eds.), *Virtual and Augmented Reality in Education, Art, and Museums* (pp. 162–173). Hershey, PA: IGI Global. doi:10.4018/978-1-7998-1796-3.ch009

Kuznetsov, A. V. (2019). Emergence in Interactive Embedded Art. *International Journal of Art, Culture and Design Technologies*, 8(2), 1–19. doi:10.4018/IJACDT.2019070101

Lucchesi, M. (2019). Butterfly, Emerging: How Trauma-Informed Services Help Survivors to Heal. In J. Bopp, A. Grebe, & J. Denny (Eds.), *Healing Through the Arts for Non-Clinical Practitioners* (pp. 44–55). Hershey, PA: IGI Global. doi:10.4018/978-1-5225-5981-8.ch004

Massi, M., Piancatelli, C., & Pancheri, S. (2019). Art and Brand Contamination: How Brands Have Blurred the Distinction Between Low Culture and High Culture. In O. Ozgen (Ed.), *Handbook of Research on Consumption, Media, and Popular Culture in the Global Age* (pp. 339–354). Hershey, PA: IGI Global. doi:10.4018/978-1-5225-8491-9.ch020

Maulana, I. (2019). Big Brothers Are Seducing You: Consumerism, Surveillance, and the Agency of Consumers. In O. Ozgen (Ed.), *Handbook of Research on Consumption, Media, and Popular Culture in the Global Age* (pp. 57–75). Hershey, PA: IGI Global. doi:10.4018/978-1-5225-8491-9.ch004

Mayo, S. (2018). A Collective Consciousness Model in a Post-Media Society. In M. Khosrow-Pour, D.B.A. (Ed.), Enhancing Art, Culture, and Design With Technological Integration (pp. 25-49). Hershey, PA: IGI Global. doi:10.4018/978-1-5225-5023-5.ch002

Megchun, B. I. (2020). Rethinking Retail Design in the Experience Economy. In L. Crespi (Ed.), *Cultural, Theoretical, and Innovative Approaches to Contemporary Interior Design* (pp. 174–190). Hershey, PA: IGI Global. doi:10.4018/978-1-7998-2823-5.ch008

Related Readings

Migliore, I. (2020). New Narrative Spaces. In L. Crespi (Ed.), *Cultural, Theoretical, and Innovative Approaches to Contemporary Interior Design* (pp. 259–283). Hershey, PA: IGI Global. doi:10.4018/978-1-7998-2823-5.ch012

Murialdo, F. (2020). Practice of Consumption and Spaces for Goods/Retail Futures. In L. Crespi (Ed.), *Cultural, Theoretical, and Innovative Approaches to Contemporary Interior Design* (pp. 154–173). Hershey, PA: IGI Global. doi:10.4018/978-1-7998-2823-5.ch007

Novak, J. I., & Bardini, P. (2019). The Popular Culture of 3D Printing: When the Digital Gets Physical. In O. Ozgen (Ed.), *Handbook of Research on Consumption, Media, and Popular Culture in the Global Age* (pp. 188–211). Hershey, PA: IGI Global. doi:10.4018/978-1-5225-8491-9.ch012

Olalere, F. E. (2018). Experience-Centred Design and the Role of Computer-Aided Tools in the Creative Process. In M. Khosrow-Pour, D.B.A. (Ed.), *Enhancing Art, Culture, and Design With Technological Integration* (pp. 99-113). Hershey, PA: IGI Global. doi:10.4018/978-1-5225-5023-5.ch005

Olalere, F. E. (2018). Rapid Product Development and Application in Ceramics Production. In M. Khosrow-Pour, D.B.A. (Ed.), *Enhancing Art, Culture, and Design With Technological Integration* (pp. 215-233). Hershey, PA: IGI Global. doi:10.4018/978-1-5225-5023-5.ch011

Olds, K. F. (2020). Fandom as an Art Form: Artists Who Adopt Fan Behavior as Representational and Political Strategies. In C. Wang (Ed.), *Handbook of Research on the Impact of Fandom in Society and Consumerism* (pp. 234–257). Hershey, PA: IGI Global. doi:10.4018/978-1-7998-1048-3.ch012

Orhan, D. D. (2019). The Redefinition of Arabism Through Satellite Channels. In O. Ozgen (Ed.), *Handbook of Research on Consumption, Media, and Popular Culture in the Global Age* (pp. 123–136). Hershey, PA: IGI Global. doi:10.4018/978-1-5225-8491-9.ch008

Özdemir, B. G. (2019). The Colorful Leak of Postmodernism in the Turkish Cinema Onur Ünlü Narratives: The Reflection of the Concept of Postmodernism in Cinema. In O. Ozgen (Ed.), *Handbook of Research on Consumption, Media, and Popular Culture in the Global Age* (pp. 246–265). Hershey, PA: IGI Global. doi:10.4018/978-1-5225-8491-9.ch015

Ozgen, O., & Elmasoglu, K. (2019). A Film Analysis Related to Globalization and Capitalist Consumer Culture and Its Reflections on Advertising Industry. In O. Ozgen (Ed.), *Handbook of Research on Consumption, Media, and Popular Culture in the Global Age* (pp. 212–229). Hershey, PA: IGI Global. doi:10.4018/978-1-5225-8491-9.ch013

Ozgen, O., & Turkoglu, E. (2019). Popular Culture and Communication Ethics: An Assessment on Umberto Eco's Numero Zero. In O. Ozgen (Ed.), *Handbook of Research on Consumption, Media, and Popular Culture in the Global Age* (pp. 36–56). Hershey, PA: IGI Global. doi:10.4018/978-1-5225-8491-9.ch003

Ozgen, P. (2019). Self-Laundering for Marketing: Maintaining Sustainability. In O. Ozgen (Ed.), *Handbook of Research on Consumption, Media, and Popular Culture in the Global Age* (pp. 355–370). Hershey, PA: IGI Global. doi:10.4018/978-1-5225-8491-9.ch021

Page, M. C. (2019). Cultivating Visual Analysis and Critical Thinking Skills Through Experiential Art. In A. Cartwright & E. Reeves (Eds.), *Critical Literacy Initiatives for Civic Engagement* (pp. 123–140). Hershey, PA: IGI Global. doi:10.4018/978-1-5225-8082-9.ch006

Pineda, R. G. (2018). Remediating Interaction: Towards a Philosophy of Human-Computer Relationship. In M. Khosrow-Pour, D.B.A. (Ed.), Enhancing Art, Culture, and Design With Technological Integration (pp. 75-98). Hershey, PA: IGI Global. doi:10.4018/978-1-5225-5023-5.ch004

Pinheiro, J. A., & Tavares, M. (2019). Meta-Remediation as a Mechanism to Address Crowd Decision-Making in the Context of Media Art: The uTurn Case. *International Journal of Creative Interfaces and Computer Graphics*, *10*(1), 43–55. doi:10.4018/IJCICG.2019010104

Piscitelli, M. (2019). Multimedia Experiences for Cultural Heritage. In E. Simão & C. Soares (Eds.), *Trends, Experiences, and Perspectives in Immersive Multimedia and Augmented Reality* (pp. 80–101). Hershey, PA: IGI Global. doi:10.4018/978-1-5225-5696-1.ch004

Romero, C. S. (2018). Culture Industry: A Contemporary Revision of the Term of Theodor Adorno. In M. Khosrow-Pour, D.B.A. (Ed.), Enhancing Art, Culture, and Design With Technological Integration (pp. 1-24). Hershey, PA: IGI Global. doi:10.4018/978-1-5225-5023-5.ch001

Related Readings

Rymbayeva, A. (2019). TV Soaps Influence on the Attitudes of Kazakhstani Women Towards the Represented Turkish Way of Life. In O. Ozgen (Ed.), *Handbook of Research on Consumption, Media, and Popular Culture in the Global Age* (pp. 105–122). Hershey, PA: IGI Global. doi:10.4018/978-1-5225-8491-9.ch007

Schettino, P. (2020). Where Is Hanuman?: Hindu Mythology, Transmigration, and the Design Process of Immersive Experiences in Museums. In G. Guazzaroni & A. Pillai (Eds.), *Virtual and Augmented Reality in Education, Art, and Museums* (pp. 311–323). Hershey, PA: IGI Global. doi:10.4018/978-1-7998-1796-3.ch015

Silva, H., & Simão, E. (2019). Thinking Art in the Technological World: An Approach to Digital Media Art Creation. In E. Simão & C. Soares (Eds.), *Trends, Experiences, and Perspectives in Immersive Multimedia and Augmented Reality* (pp. 102–121). Hershey, PA: IGI Global. doi:10.4018/978-1-5225-5696-1.ch005

Soares, C., & Simão, E. (2019). Immersive Multimedia in Information Revolution. In E. Simão & C. Soares (Eds.), *Trends, Experiences, and Perspectives in Immersive Multimedia and Augmented Reality* (pp. 192–210). Hershey, PA: IGI Global. doi:10.4018/978-1-5225-5696-1.ch009

Tan, S. F. (2019). Beyond Words: Arts-Based Assessment of Post-Traumatic Growth. In J. Bopp, A. Grebe, & J. Denny (Eds.), *Healing Through the Arts for Non-Clinical Practitioners* (pp. 250–275). Hershey, PA: IGI Global. doi:10.4018/978-1-5225-5981-8.ch015

Teles, P. C. (2019). "Hi-Tech + Low-Tech": Aesthetic Reframing Processes Through Brazilian-Nigerian Art Literacy. In E. Simão & C. Soares (Eds.), *Trends, Experiences, and Perspectives in Immersive Multimedia and Augmented Reality* (pp. 52–79). Hershey, PA: IGI Global. doi:10.4018/978-1-5225-5696-1.ch003

Tezcan, U. T. (2019). Popular Culture and Peer Effects in Consumption: Survey of Economic Consequences. In O. Ozgen (Ed.), *Handbook of Research on Consumption, Media, and Popular Culture in the Global Age* (pp. 11–35). Hershey, PA: IGI Global. doi:10.4018/978-1-5225-8491-9.ch002

Tollefson-Hall, K. L. (2019). Learning Together: Intergenerational Experiences for Pre-Service Art Educators. In J. Bopp, A. Grebe, & J. Denny (Eds.), *Healing Through the Arts for Non-Clinical Practitioners* (pp. 56–73). Hershey, PA: IGI Global. doi:10.4018/978-1-5225-5981-8.ch005

Trentin, L. (2020). Any Colour You Like: Considerations on the Surface of Things – Color, Matter, and Architectural Space. In L. Crespi (Ed.), *Cultural, Theoretical, and Innovative Approaches to Contemporary Interior Design* (pp. 355–366). Hershey, PA: IGI Global. doi:10.4018/978-1-7998-2823-5.ch016

Turanci, E. (2019). Consumption in the Digital Age: A Research on Social Media Influencers. In O. Ozgen (Ed.), *Handbook of Research on Consumption, Media, and Popular Culture in the Global Age* (pp. 266–286). Hershey, PA: IGI Global. doi:10.4018/978-1-5225-8491-9.ch016

Tuzlukaya, S. E. (2019). Popular Culture Discourse and Representation of the Organizations' Dark Side. In O. Ozgen (Ed.), *Handbook of Research on Consumption, Media, and Popular Culture in the Global Age* (pp. 328–338). Hershey, PA: IGI Global. doi:10.4018/978-1-5225-8491-9.ch019

Urbano, I., Marques, A. C., & Milanez, M. (2018). Dance as a Supplementary Instrument for Cardiac Rehabilitation: An Integrative Literature Review. *International Journal of Art, Culture and Design Technologies*, 7(1), 17–29. doi:10.4018/IJACDT.2018010102

Ursyn, A. (2020). Inquiries about Art and Graphics. In *Graphical Thinking for Science and Technology Through Knowledge Visualization* (pp. 237–259). Hershey, PA: IGI Global. doi:10.4018/978-1-7998-1651-5.ch004

Whittenberg, R. L. (2019). Music, the Arts, and Healing. In J. Bopp, A. Grebe, & J. Denny (Eds.), *Healing Through the Arts for Non-Clinical Practitioners* (pp. 1–7). Hershey, PA: IGI Global. doi:10.4018/978-1-5225-5981-8.ch001

About the Author

Janez Strehovec, PhD, is Associate Prof. of New Media Art Theory and director of Institute of New Media Art and Electronic Literature in Ljubljana. He was the principal investigator at the European research project Elmcip (HERA, 2011-2014), teacher of Erasmus program at the Complutense University of Madrid, and principal investigator of national research project Theories of Internet Culture and Internet Textuality. He is the author of seven scientific monographs in the fields of cultural studies, digital literature, e-literary criticism, and aesthetics. The most recent is Text as Ride (2016). His English essays are included as book chapters in several reference books and published in scientific journals (e.g. Digital Creativity, CLC Web, CTheory, Journal of Popular Culture, Afterimage, Cybertext Yearbook, Electronic Book Review, Cultura, Technoetic Arts, First Monday, Teksty Drugie). His recent research includes philosophy and theory of contemporary art, phenomenological aesthetics, e-literary criticism, theory of art activism, and digital humanities.

Index

A

academic fascism 54, 142, 144-145, 147, 149-150, 154-155, 159-160
aestheticization 30, 34, 39, 45, 64
Alfred Rosenberg 149, 154
algorithmic trading 34, 37, 43, 56, 60, 113
autonomous 2, 55, 65, 69, 111-112, 160
autonomy 1, 24-25, 39, 53, 56, 69, 81, 103, 135, 137
auto-poetic 112

B

Beletrina publishing 98, 108
Berlin Wall 35, 69, 97, 146, 151
building blocks 56, 63, 81, 103

C

citizen science 15, 18, 23-26, 72
civil society 25-26, 67, 96-97, 100, 103, 116, 118, 158
computer game 5, 13, 24, 98
contemporary art 1-4, 14-16, 18-27, 30-31, 33, 37, 39-43, 48, 53-56, 59-61, 66, 68, 84, 97-98, 112-113, 117-118, 120, 155-156, 160
critical theory 4, 100, 108, 142, 159
cultural contents 27, 32, 38, 73-75, 78, 82, 120-122
cultural studies 97, 99, 108, 120, 138, 151

D

digital textuality 74, 120, 130, 155

E

Electronic Disturbance 35, 37, 55-56, 114
electronic literature 4-6, 8-9, 33, 39, 44, 48, 62, 81-84, 88, 120, 122, 127, 137, 155-156
e-literature 8, 12, 40, 44, 46, 48, 62-63, 81-85, 122-124, 130-134, 136-137, 156-158
ethnic cleansing 109, 114, 117, 143, 145, 149-150, 159
expanded concept 2, 54, 65, 77, 86, 91, 96, 118, 123
extra-artistic 43, 55-56, 59, 64, 111, 118

F

financial markets 21, 26, 34, 39, 43, 53-54, 58, 60-61, 63, 80

H

Hakim Bey 2, 55, 65, 111
historical fascisms 145, 149-150

I

ideological state 96, 99-100, 106, 154, 159
in-between spaces 14, 17, 32, 39, 43

Index

J

Janez Janša 56, 99, 111, 114-118
Joseph Beuys 55, 62, 65, 111, 118, 156

K

knowledge society 3, 15, 17, 21, 26, 30, 54, 99

L

literary nationalism 96, 98-109, 116-118, 149, 159

M

media art 2, 4-8, 13-15, 19, 21-22, 24-27, 33, 39, 44, 46, 48, 61-62, 98, 103, 122-123, 131, 134, 139, 155-156
molecular biology 15, 26, 98
multiculturalism 112-113, 136
multinational corporations 35-36, 113-114

N

networked economy 2, 15, 21, 24, 32-34, 39, 43, 57-58
new media 2, 4-8, 10-16, 18-19, 21-22, 24-26, 30-31, 33, 37-41, 43-44, 46-48, 56, 61-62, 72, 75, 78-81, 83-84, 86, 98, 103, 114, 120, 123-126, 128, 131-134, 136-139, 142, 155-157
non-artistic 16-17, 22, 24-25, 35, 42-43, 48, 53, 64
non-verbal signifiers 74, 78, 123

O

ontological status 4, 9, 102

P

parliamentary 113, 118, 148
political engagement 54-55, 111

popular culture 38, 42, 53, 56-57, 59, 73-74, 85-86, 130, 135
post-aesthetic 35, 37, 39, 58, 97, 118, 156
post-political politics 91, 112, 114

R

right-wing politician 115-116
Russian formalism 73, 82

S

self-feeding 60, 112
self-referential 33, 112
short-cut music videos 72
smart machines 7, 20, 155, 158
social media 2-3, 21, 24, 26, 32, 37, 43, 53, 58-59, 72, 74-76, 78, 80, 83-86, 90, 97, 114
social sciences 18, 69, 118, 138, 148, 150, 153

T

techno-imaginary 34, 42, 59
technoscience 2, 16, 34, 43
theoretical devices 15, 27, 123, 129, 137
Third Reich 38, 100, 107, 145, 147, 154-155
Tone Pavček's 98, 102
Transborder Immigrant Tool 37, 44

U

utopian projects 55, 111

V

video games 3, 6, 14-15, 20, 47, 62, 76, 87, 125, 142

W

Wall Street 55, 66, 116

Purchase Print, E-Book, or Print + E-Book

IGI Global's reference books can now be purchased from three unique pricing formats:
Print Only, E-Book Only, or Print + E-Book.
Shipping fees may apply.
www.igi-global.com

Recommended Reference Books

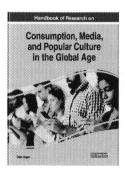

ISBN: 978-1-5225-8491-9
© 2019; 454 pp.
List Price: $295

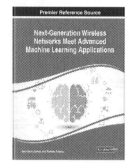

ISBN: 978-1-5225-7458-3
© 2019; 356 pp.
List Price: $195

ISBN: 978-1-5225-6023-4
© 2019; 384 pp.
List Price: $195

ISBN: 978-1-5225-5715-9
© 2019; 273 pp.
List Price: $175

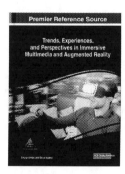

ISBN: 978-1-5225-5696-1
© 2019; 277 pp.
List Price: $185

ISBN: 978-1-5225-9369-0
© 2019; 358 pp.
List Price: $205

Looking for free content, product updates, news, and special offers?
Join IGI Global's mailing list today and start enjoying exclusive perks sent only to IGI Global members.
Add your name to the list at **www.igi-global.com/newsletters**.

Publisher of Peer-Reviewed, Timely, and Innovative Academic Research

www.igi-global.com Sign up at www.igi-global.com/newsletters facebook.com/igiglobal twitter.com/igiglobal

Ensure Quality Research is Introduced to the Academic Community

Become an IGI Global Reviewer for Authored Book Projects

 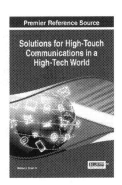

The overall success of an authored book project is dependent on quality and timely reviews.

In this competitive age of scholarly publishing, constructive and timely feedback significantly expedites the turnaround time of manuscripts from submission to acceptance, allowing the publication and discovery of forward-thinking research at a much more expeditious rate. Several IGI Global authored book projects are currently seeking highly-qualified experts in the field to fill vacancies on their respective editorial review boards:

Applications and Inquiries may be sent to:
development@igi-global.com

Applicants must have a doctorate (or an equivalent degree) as well as publishing and reviewing experience. Reviewers are asked to complete the open-ended evaluation questions with as much detail as possible in a timely, collegial, and constructive manner. All reviewers' tenures run for one-year terms on the editorial review boards and are expected to complete at least three reviews per term. Upon successful completion of this term, reviewers can be considered for an additional term.

If you have a colleague that may be interested in this opportunity, we encourage you to share this information with them.

IGI Global Proudly Partners With eContent Pro International

Receive a 25% Discount on all Editorial Services

Editorial Services

IGI Global expects all final manuscripts submitted for publication to be in their final form. This means they must be reviewed, revised, and professionally copy edited prior to their final submission. Not only does this support with accelerating the publication process, but it also ensures that the highest quality scholarly work can be disseminated.

English Language Copy Editing

Let eContent Pro International's expert copy editors perform edits on your manuscript to resolve spelling, punctuaion, grammar, syntax, flow, formatting issues and more.

Scientific and Scholarly Editing

Allow colleagues in your research area to examine the content of your manuscript and provide you with valuable feedback and suggestions before submission.

Figure, Table, Chart & Equation Conversions

Do you have poor quality figures? Do you need visual elements in your manuscript created or converted? A design expert can help!

Translation

Need your documjent translated into English? eContent Pro International's expert translators are fluent in English and more than 40 different languages.

Hear What Your Colleagues are Saying About Editorial Services Supported by IGI Global

"The service was very fast, very thorough, and very helpful in ensuring our chapter meets the criteria and requirements of the book's editors. I was quite impressed and happy with your service."

– Prof. Tom Brinthaupt,
Middle Tennessee State University, USA

"I found the work actually spectacular. The editing, formatting, and other checks were very thorough. The turnaround time was great as well. I will definitely use eContent Pro in the future."

– Nickanor Amwata, Lecturer,
University of Kurdistan Hawler, Iraq

"I was impressed that it was done timely, and wherever the content was not clear for the reader, the paper was improved with better readability for the audience."

– Prof. James Chilembwe,
Mzuzu University, Malawi

Email: customerservice@econtentpro.com www.igi-global.com/editorial-service-partners